Phone Sex

Aural Thrills and Oral Skills

Miranda Austin

greenery press

Cover: JohnnyInk, www.johnnyink.com

Published in the United States by Greenery Press, 1447 Park Ave., Emeryville, CA 94608, www.greenerypress.com.

ISBN 1-890159-48-4

Contents

Acknowledgments

Sincere thanks to my terrific bunch of kinky, sex-positive pals, who encouraged me, read everything I wrote, and never told me I was insane.

Thanks also to Rachel, my comrade in smut, who's gone through it all with me; also to my fellow phone sex workers, who turned out to be a smarter, sexier, and more supportive group of women than I would have believed possible.

And of course, special thanks to the more than 600 men who have called and shared their lives and fantasies with me.

Note

Throughout this book I generally refer to phone sex operators as female, and phone sex callers as male. This reflects my personal experience as a female phone sex worker with a primarily male clientele. However, phone sex services exist that employ and cater to all combinations of genders and orientations.

All accounts herein are of actual calls, though some names and personal details have been changed to protect the privacy of the individuals involved.

Introduction: A Day in the Life

Ring. "Hello."

"I want to lick your pussy."

"Who's this?"

"We met online."

"Oh, great! Who's this?"

"Are you a natural blonde?" (My phone sex persona, Kristi, is a redhead.)

"I'm not going to talk to you until you tell me who this is."

"We've talked online. In a chatroom."

"That's nice. Who is this?" *Click.*

Ring. "Hello."

"Kristi?"

"Yes, this is Kristi." *Click.*

Ring. "Hello."

"Is Kristi there, please?"

"This is Kristi."

"Hi, this is Rob."

"Hi Rob, nice to meet you."

"Same here."

"Rob, how did you find my number?"

"On the Internet."

"Well, great. Have you ever called a phone service before?"

"No."

"Okay, let me tell you how it works."

"Okay."

"First I have to get all the information the credit card company requires. Then I put you on hold, click over on my three-way calling, get authorization for the card – you're not charged for any of that time – and then when I get back, I'm all yours."

"Sounds good."

"Great, well let me get some information." Name, address, phone number.

"Okay, and what's your credit card number?"

"How much does it cost?"

My ads are all of six lines long, one of which is the price.

"It's $1.99 a minute with a minimum of ten minutes."

A low, unintelligible whisper.

"I'm sorry, what did you say?"

"I said, 'Do you have any guys there with you?'"

"Oh. No, sorry. I live alone." *Click.*

Ring. "Hello."
Click.

Ring. "Hello."

"Kristi?"

"Yes, this is Kristi."

"Hi, this is Edward."

"Hi Edward. Have we spoken before?"

"No, I just saw your ad on the Internet."

"Well great. Did you want to do a call, or did you have a question?" This is my line for the procrastinators.

"Well, what do you look like?"

"Oh, you didn't see my website?"

"No, I liked the ad so much I just called." Aw, okay. That's reasonably charming. Worth a description of myself. Er, of Kristi.

"I'm really into panties. How much do they cost?" Damn. I hate doing panties.

"Well they're free with a 20-minute call the first time."

"Ohhh, cool. No more jerking off into my sister's."

I paused. "Let me just get the information out of the way first, then

I'll be happy to tell you all about mine. What's your last name, Edward?"

"Not that my sister minds."

"Your last name? Edward?"

"I'd love to fuck my sister."

"Edward, I need to get the credit card information before I can talk to you."

Heavy breathing. "I wish you could see me in these panties."

Click.

(That time it was me.)

Ring. "Hello."

A fierce whisper. "I want to sit on your *mumblemutter...*"

"What?" *Click.*

1. Diary of a Phone Sex Girl

So there I was, 33 years old, with a brand new graduate degree, a fulfilling job in the non-profit sector, and a debt the size of the federal government's.

A friend of mine, Rachel, who was in the same financial boat, confided that she was thinking about moonlighting as a phone sex operator. She had a friend who worked for a good company, she said, and the extra paycheck would really help.

Even though I had the same stereotypes that most people have of phone sex – a woman breathing heavily into the phone while doing the laundry, or filing her nails – I found the idea oddly appealing. All my life people have complimented me on my sexy voice, and said that I should be doing radio or voice-overs. "You could even do phone sex," they would smirk.

I did, in fact, work for a community radio station years ago, reading the news and recording promotional announcements. Because my voice was low and husky even as a teenager, the people who wrote sexy ads always wanted me to read them.

"Hi there," I'd whisper into the microphone, "my name is Sheila, and every night at ten I turn my radio on..."

I always had to be alone in the studio in order to do it. I couldn't deal with people watching me put on that deliberately seductive voice; I'd get completely flustered and inhibited. But no one would be watching during phone sex.

So Rachel and I had dinner with her friend, Donna, and we showered her with questions. The job sounded flexible and fun, and the pay was definitely good. Donna put us in touch with Trisha, the owner of

the phone sex company, and the next thing I knew I was picking out a name and getting my own toll-free number and – OH MY GOD – I'm a phone sex babe!

☎

My first task was to choose pictures of "me" and write an enticing profile for the company website. (Some girls use their real pictures, but I wasn't interested in doing so.) I knew right away that I wanted to be a redhead, so Trisha e-mailed me an assortment of pictures of girls with red hair.

When I saw Kristi, I fell in love with her immediately. She's very pretty but she also looks shy and innocent. Her pictures show lots of skin and are suggestive, but she doesn't look lewd and she has no beaver shots. It was easy to imagine her as my prettier, sexier, thinner, more adventurous alter ego.

There was no training, unless you count bombarding Donna with hysterical questions day and night, but after a few days of that, I felt like I was ready. All I needed were some horny boys.

If I thought that I could just turn phone on and I'd have naked men begging to stroke off into my ear, I was sadly mistaken. It takes time and effort to get any new business off the ground, and this was no different. But I felt confident that I could do it. After all, as Trisha says, "If you can't sell pussy, you can't sell anything."

So how does one get callers? The first way is through the main website, which the company advertises on the web and in magazines. Second, I post ads with the website and my phone number to Internet newsgroups – public discussion areas devoted to specific topics – that cater to phone sex.

Before I starting writing my own ads, I glanced through the competition. Most of the ads were appallingly illiterate:

Subject: CUM On Baby... Let ME Sex You UP Right Now!!!! I'm right here at home ready to stroke with you until we both explode with pleasure! Yes boy I want to hear your kinkiest desires!! We can have a very Satisfying talk with no limitations!! CALL ME ANYTIME ... I will be laying in my bedroom waiting for your calls!! Let me become the women of your naughty dreams!!!

Subject: Original Nasty Girls Is Wet & Ready To Play Tried the rest, NOW try the best... Im the your girl mommy warned you about, you didn't listen then so don't listen now! You will Submissive? I can bring you to your knees with just the tone of my voice or let you take control if this pleases you Sir. I AM the best you will ever have! I do it all and I do it the BEST!

Some of the girls do niche marketing. Those ads are, at least, amusing.

Subject: Phone Sex Psychologist Talk about your kinky sex problems on the phone with Dr. Liz. She will delve very deeply into your mind until you both reach the ultimate climax! Let Dr. Liz free you of all your nasty little sexual traumas so that you will be a complete man again.

There are numerous "Daddy's Little Girls," "Teen Fuck Toys," and (my personal favorites) "Cum Guzzling Sluts." And in case you were wondering if anyone ever calls those sleazy-looking phone sex ads, they do. In droves. At least half my callers come from Internet newsgroups, though I can't figure out which groups. I ask clients where they saw my ads, but they never remember. Or maybe they just don't want to admit that they read alt.sex.sissy.sluts.

The third way to find callers is to prowl around the chatrooms on America Online, which, though adult-unfriendly in the extreme, is apparently full of phone sex operators. There's a complicated protocol, which Donna explained to Rachel and me over dinner.

You can have a personal profile, but it can't have adult content. It can link to your own personal AOL website, which can have pictures, but not adult pictures. You also can't link to any other site with adult content, and you (theoretically) can't solicit for an adult business.

To get around all the restrictions, you need to build layers. A person online sees you in a chatroom or finds your profile in the directory. The profile leads him to the AOL website, which gives him an e-mail address hooked up to an "auto-responder," which sends him your real website address.

(Confused? I was.)

My AOL profile gives my location as "right here waiting for you," my hobbies as "erotic games and red hot talk," and my occupation as "discreet adult phone entertainer." Other phone sex operators bill themselves as "telecommunications experts," "phone fantasy artists," or

"professional telephone actresses." Potential callers search the directory for key phrases like "adult phone" or "erotic talk." It's all part of a big game.

"Don't worry about having to say that your calls cost money," explained Donna. "The ones who are looking for phone sex already know. The real callers ask straight out – how much?"

I was online for less than ten minutes as Kristi before I started getting Instant Messages. I didn't even have a phone number yet, but the "IMs" came fast and furious.

"u so hot baby"

"Hey, Kristi, just how bad are you?"

"Hello, Kristi, link please"

"Link with rate info, honey"

"24/m for link"

"baby your hot how about you an me"

All this before I went into a chatroom and before I ever posted an ad. Amazing.

One of the first people I met was a 20-ish college kid. He messaged me politely the first day, explaining that he had never called a phone sex girl before because he was much too shy.

Since my phone wasn't working yet, I continued chatting with him online for the next few days. Every time he signed on, he'd send me a "Hey, sexy." He was a pretty good speller and he never said "u r so hot." I liked him.

Finally my phone was hooked up. I saw him online that night, and invited him to call me. He said he couldn't because his roommate was home. I suggested that he close his bedroom door, ignore his roommate, and call me anyway.

"Not tonight, baby. Can't have him hearing me stroking my hard shaft for you. Tomorrow, I promise."

Oh my. Maybe not so shy after all.

I liked the idea of him being my first call. He was young and inexperienced, someone I could handle easily. We made a date for 8 p.m. the next night, when his roommate would be gone. Excellent.

In the meantime, I got ready. I printed out my little forms for taking credit card information. I practiced using the three-way calling, and tried out all the merchant phone numbers.

I set up Kristi's voicemail.

"Hi there! <*Ooh, I'm SOOO perky!*> This is Kristi! <*bounce bounce*> I'm sorry I missed you <*pout*>, but I hope we'll have a chance to talk soon. Please try me back later <*Aren't I just adorable?* > or leave your name and number and the time you can be reached and what time zone you're in and I'll be really, really happy to call you back. Bye!"

Blech. *Way* too perky. And too many "and"s.

Press "d" to discard this message and record again. *Beep.*

"Hey, this is Kristi. I can't come to the phone right now..."

Beep.

"Hey there, it's Kristi. I'm on another call..."

Beep.

"Hi! You've reached Kristi. The best time to call me is between 8 p.m. and midnight. But I'm sometimes home at other times. Oh, and I'm on Eastern Time."

Beep.

"Hey baby, it's Kristi. I'm soooooo sorry I missed you. I can't wait to talk to you..."

Beep.

Arrrrrrrrrgh.

Beep.

"Hi, this is Kristi. Sorry I missed you. Please try again later, or leave me a message and I'll call you back."

What the hell, it only took 24 tries.

I ate chocolate and tried to calm down. *I'm doing phone sex.* It's going to be fine. I can do this. *I'm a phone sex operator.* Breathe, breathe, breathe.

Advice from Donna: "You're totally in control. These guys call you and they're a little horny and a little nervous, and all you have to do is say two words and you have them in the palm of your hand."

Advice from Trisha, the boss: "Men are dogs. Hey, I gotta go. Pussy boy on the line."

By 9:30 p.m. the next night I was in total despair. My first phone sex call, and I'd been stood up. By a 20-year-old kid! That's it, I'll never ever make it as a phone slut.

But at about 10 p.m. the phone rang, and a nervous and apologetic college boy was on the other end. A nervous college boy with a sweet, sexy voice.

It was a lovely phone call. When I asked him what he wanted to talk about, he gave a little laugh and said that I could probably say anything I wanted and I'd make him happy.

He talked like he'd read too many *Penthouse* stories ("Oh, baby, I'm gonna put my rock hard prick in your hot tight little pussy....oh yeah... oh baby...") but he had a good time and I did too. 23 minutes' worth.

When it was over, he whispered, "Thanks, Kristi," and hung up.

Kristi. I'd almost forgotten.

2. She's a Very Kinky Girl

Kristi's Profile

Hi, I'm Kristi, and I'm not as sweet and innocent as I look. I'm 22 years old, and yes, I'm a natural redhead. From the time I was young, I was always sneaking out with boys and letting them kiss and touch me. I knew I was a bad, bad girl, but I couldn't help myself – it just felt so good!

When I was 15 my parents came home early one night and caught me in their bed with my boyfriend. When my Daddy saw me sucking my boyfriend's cock he just about went crazy. He dragged me out of bed, put me over his knee, and spanked me until I was kicking and crying. Just when I thought he was done, he pulled off his belt and whipped my ass, all the time telling me what a little slut I was. I begged for mercy, but he didn't stop until my burning butt was redder than my hair.

But he didn't know that being spanked wouldn't make me a good girl – it just made me hotter. Late that night I fingered my pussy until I came about a dozen times, dreaming that I was back sucking my boyfriend's prick, but this time with my bright red bottom sticking up in the air.

Now I work in an office and I have to wear a suit, put my hair up, and be proper and professional all day long. Most days I get so horny and distracted that I can't stand it. Sometimes the urge is just too bad, and I end up sliding my hands under my skirt and into my panties right there at my desk.

I fantasize what would happen if my hot boss came in and found me playing with myself in the office. I imagine that he'd

make me bend over my desk, lift my skirt, and yank my panties down to my ankles. Then he'd call in his assistant and lock the door. One of them would grab my hair, yank my head back, and ram his thick, hard prick into my mouth, while the other would spread my hot ass wide open for his cock.

As you've probably guessed, I like it rough. I can be a naughty cheerleader, or a rebellious niece, or just the girl next door that you happen to catch sunbathing in the nude. One of my hottest fantasies is to be overpowered and held down and raped - to beg for mercy knowing that you'll do exactly what you want with me no matter what I say.

I'd love to hear about your fantasies, too. I'm waiting for you.

It didn't take me long to be able to tell a first-timer from an experienced phone sex caller. The first-timers say something like, "Hi, uh, is Kristi there?" And when I say, "This is Kristi," they awkwardly spit out, "I, uh, saw your, uh, picture on the, uh, thing…" and wait for me to rescue them.

On the other hand, the veterans know that no one else answers the phone. A quick, "Kristi?" is followed by a polite, "Are you available for a call now?" or "I saw your ad and I'd like to do a call." The industry has a language all its own.

It took me a few calls to figure out a comfortable way to start. With the experienced guys, I usually ask if they've talked to any of the other girls on the site, and almost all of them have. It's a good hook, because knowing which girl they've chosen before gives me some idea of what they're looking for.

Some of them just like to talk, to ask questions about me (or rather, about Kristi). The classic "What are you wearing?" is popular. Also "What are your measurements?" or the very subtle, "Tell me about your pussy," are favorites. Some of them say straight out, "I like to role-play," and they know what they want.

One of the first calls I took is still one of my favorites. After the small talk, the caller began with, "So two things interested me about your site, Kristi."

I liked this guy already. We had chatted a bit, and he was direct, but with a nice sense of humor. He obviously didn't take this all that seriously.

"The first is the small tits."

Like I said, direct. I laughed and he laughed with me.

"What's so funny?"

"I was worried that no one would like them because they were too small," I replied. "But the boss told me I was wrong, and I guess she knew what she was talking about."

"Oh yes, she did," he said, and his voice became just a little huskier. "I love your small tits and your perfect little nipples."

I looked down at my own more-than-ample endowment and grinned to myself.

"And the other thing?" I asked.

"Ah, the other thing. Yes. Well, you said... that you like it rough."

Quick decision. Shy? Sultry? Sophisticated? I went for sultry. "Mmmmm, yes, I do."

"How rough?" he asked.

"Oh, you know, um, I like spanking, bondage, um, that kind of thing..."

Damn. How sultry of me. I still find that part awkward.

Now, just to set the record straight, I really am kinky. Long before I ever did phone sex, I was already much kinkier than the average bear.

(By the way, if you're related to me, you might not want to read this part. If you're a member of my immediate family, maybe you'd like to try the new John Grisham book about now.)

All that stuff in the profile about liking rough sex, spanking, rape fantasies – that's all true. I mean, I don't masturbate at my desk and my parents never caught me in bed with a guy, but the fantasies are mine. So when the guy on the other end of the phone asks if I really like to play rough, I can truthfully answer that, well, yes, I do. I wrote that profile specifically to attract callers with fantasies like mine. Hell, if I was going to do this, I might as well enjoy it.

After a few minutes, we got down to business.

"I like to role-play," he said, "I especially like office settings."

"You mean, like, you're my boss..."

"Or just your co-worker," he replied. "And maybe I'd catch you doing something wrong."

"Something really bad?" I asked. "Or just something little?"

He thought about that for a moment. "Just bad enough that you wouldn't want anyone to know about it."

"Such as, maybe I was looking at porn websites on company time? Maybe kinky websites?"

He was enthusiastic about the idea and we set out imagining the possibilities. He suggested that he come in behind me and watch me look at illicit websites without my knowing he was there. I protested that I wouldn't be so stupid as to surf porn sites with my screen facing the door. He laughed and allowed that maybe he would sneak in behind me somehow.

And so it went, a delightful, teasing scene, very playful and very hot. He confronted me in my office, and threatened to reveal my interests to the entire company unless I undressed. When we got to my bra I protested that this was blackmail, a complaint to which he cheerfully agreed.

I moaned as he described pinching my nipples and I whimpered as he bent me over the desk and spanked me. I denied enjoying any of it, but I think he knew I was lying. Especially when he commented so smugly about how wet I was. I refused to dignify that with an answer.

Soon he made me beg to be fucked, teasing me the whole time about how he knew I'd hate it. I expected that the spanking was over but I was wrong.

Just when I thought we were nearing the end, he unexpectedly described pulling my arms behind my back and tying them together with my bra. He made me sit on the edge of the desk with my legs spread, pulled off his belt, and snapped it against my inner thigh. I shrieked – realistically, I think – and pressed my thighs closed.

"Open your legs," he warned, and I shivered and begged him not to make me. I couldn't have been more turned on if this was a lover instead of a customer.

I whined, but opened my legs, and he brought the belt down on the other thigh. I cried out again, and closed my thighs once more. I wanted to hear that threatening tone in his voice again.

"Open them," he said dangerously.

"I don't want to," I pleaded.

"Open them. Right now."

Yum.

"Good," he murmured. "Now ask me for another."

"No!"

"Yes," he replied, stroking my thighs.

"Please..." I whispered.

I could hear the smile in his voice.

"Please what?"

"Please, give me another." I was flushed, and close to orgasm myself.

"I will," he murmured. "Right on your wet pussy."

I moaned.

It was a lovely scene. He came hard – I could hear it – and rather than hanging up like lots of these guys do, he stayed on the phone for another minute or so, catching his breath and thanking me.

"That was...really great," he breathed.

"For me, too," I said honestly. "And I don't say that often and mean it."

We laughed again, this time together.

"I hope you call me again sometime," I said.

"You bet I will."

A really good call like that can make my week. Sometimes it's so much fun that I can't believe I get paid for it. Even if I'm in a terrible mood, an exciting call can get me right out of it.

For instance, one night I was having trouble with my phone line. The phone would ring, and it would be fine for about a minute but then the static would start. It would get worse and worse, and by approximately four minutes into any call it was impossible to hear a thing. For someone who makes part of her living talking on the phone, this was bad.

First I thought my cordless needed a new battery, but a standard phone wasn't any better. And it was Sunday, so although I called the phone company right away, there was nothing they could do until the next morning. I shouted through one call and lost the next two. So when Jeremy called, I was cranky.

But he was immediately distracting, with a fantastic deep voice and an amused manner. I liked him right away. I mournfully explained my phone troubles and he was happy to give me his number and let me call him back on my other line.

Jeremy is in his 30s, married (his wife was out shopping) and he was the first caller ever to specifically identify himself as African-American. I'd never really thought about that before and certainly never asked

a caller his race. I did have one stereotypical "shake that white ass for me, bitch" caller early on, but no one else ever used an ethnic descriptor. I don't know if they're all white, or if it's simply not an issue.

In any case, I asked Jeremy what he does for a living, and he explained that he works for the Department of Corrections. Immediately all sorts of prison fantasies flashed through my head. I shoved them firmly aside. He was probably an accountant for some white-collar day camp facility and wanted to wear my panties.

"So what do you do for them?" I asked, sincerely interested. Most of the guys who call me seem to be either lawyers or computer programmers, so the occasional bomb disposal technician or bartender or bra company salesman is a welcome change.

"I'm a Medium Security State Corrections Officer," he replied impressively, and then laughed. "Well, I'm a guard."

I laughed with him, and pointedly ignored my increasingly insistent "poor, mistreated captive" fantasies as he described himself to me: 6'2", solidly built, medium-dark complexion with short-cropped hair. (And a uniform with a big nasty belt, I thought. I told my brain to shut up. This is about his fantasy, I reminded myself, not mine.)

After a pleasant few minutes chatting, he ventured, "I noticed on your website that you said you like to be dominated."

Hot damn! Oh yes, yes! I was so excited that I nearly missed the next sentence.

"Well, as I said, I'm a guard, you know," he began. "And I've always had this fantasy about what terrible things I'd do to a pretty new prisoner..."

"Oh my...." I breathed, very excited now.

"You like that idea?" he asked.

"Very much," I answered. "I have lots of fantasies about things like that."

He was delighted, and we had a terrific time. He was cruel, dragging me down the hall to the cell at the end, way past the others. I threw myself into the role of the scared, whimpering prisoner with relish.

There's something very special about a participating in a fantasy involving a caller's own profession. I've noticed the unusual feeling once or twice before, particularly once when I played Haughty Hotel Guest with a real bellhop. It was so vivid that time, like stepping right

into his mind. When he described walking me through the lobby of the hotel and up to my room, I knew that he'd really done it hundreds of times. He really did have to carry the bags of beautiful women, and he really did look at them and fantasize about being ordered to put the suitcase down and strip. It made the whole game that much more intense.

Likewise, Jeremy really spent his days dealing with prisoners. It felt natural to him, and incredibly convincing to me. As he described my prison uniform (jeans and a light blue button-down shirt), and lectured me about how I'd have to earn my keep in *his* prison, I felt as if he was almost living his fantasy. He didn't have to make up fake prison guard dialogue, because he really was a prison guard.

I had such a good time with this guy, and the fantasy was totally hot to boot. He yanked me into the cell, threw me across the bed, and started growling orders at me. I begged him not to hurt me, but he just laughed. He told me if I was very submissive, he might not hurt me "too much." He forced me to unbutton my shirt and take it off, which I did with trembling hands. When I hesitated to get down on my knees and suck his cock, he ripped my jeans and panties off, thrust me down on the bed, took off his belt, and whipped me with it.

I cried and kicked and sobbed and promised to be good.

"Yes, I know you'll be good," he soothed, and struck me again.

After that I was an obedient little slut who sucked his cock and bent over so he could fuck my sore ass. He moaned appreciatively and complimented me.

As brutal as his fantasy was, his whole manner crackled with intelligence and good humor. Several times he called me his "little red-headed bitch," but it was almost a term of affection.

Afterwards we both caught our breaths and giggled. When I told him how much I'd genuinely enjoyed myself, he mused about the possibility of sharing me with his fellow guards next time. I oohed and ahhed and confessed to him how many of my darker fantasies centered on just that concept – being captured and tormented by a bunch of nasty guys.

"I know, I know, and I seem like such a nice, sweet girl," I teased.

"You *are* a nice, sweet girl," he answered. "And also a hot nasty slut. Best kind."

"When's the wife going shopping again?" I asked.

"I'm not sure, Kristi, but believe me, you'll be the *first* to know."

As much as I could wish they were all that much fun, the kinky profile also attracts some fetishes that don't necessarily appeal. I knew that. I was prepared, I thought, for the Daddy callers. Somehow I never realized that these daddies would want to fuck their little girls after they spanked them. Of course it should have been perfectly obvious – maybe I just didn't want to think about it.

When I was about 19 and in college, I studied psychology with plans to become a therapist. During a social psychology course there was an entire section on sexual deviance. The professor warned us that parts of the upcoming weeks might shock and disgust us. That was fine for now, he said, but once we left school we could never show that shock or disgust again. When someone comes to you for therapy, he went on, they have the expectation and the right to be accepted. As therapists we needed to be able to talk comfortably with someone about, say, their shoe fetish without shouting, "Ewww yuck!"

I've never forgotten that lecture, and even though I didn't become a therapist, the warning has stood me in good stead, particularly with my dealings in the kinky sex world. When I started doing phone sex, I knew I would have to keep it clearly in mind.

Martin was my first Daddy, and he knew just what he wanted. After a few initial questions, he started right in.

"I like role-play. I like to play with Daddy's little girl," he said. I steeled myself. I had known it would happen eventually.

"All right," I agreed. "And how old is Daddy's little girl?"

"About 15," he replied, and I breathed in relief. I could handle 15. I had been afraid he would say eight.

"And…am I Daddy's good little girl? Or Daddy's bad little girl?"

"Baaaaaad little girl, definitely." His voice had changed, gotten darker, slightly menacing.

I murmured affirmation, but he didn't really need it. He was ready.

"I come into your room at night, and what is it you're doing, baby?"

How did I know what he wanted me to say?

"Touching myself…"

Was that my voice? It was high-pitched and shy. Almost against my will I sounded incredibly childlike.

"We talked about that, didn't we, Kristi?" Emotionless.

"I'm sorry, Daddy, I didn't mean to..."

"We talked about that, didn't we?"

"Yes, Daddy, I swear I'll..."

"Kristi, what did I say I'd have to do if this happened again?"

"Please, Daddy, I'm sorry! I'll never do it again!"

I was stunned at how easily this dialogue was coming out of my mouth.

"Kristi," he said sternly.

Barely a whisper. "You'd spank me."

I heard him exhale in excitement. "That's right, baby, Daddy has to spank you. Now get over my knee."

"Daddy, please!" I started to beg and cry.

"Now Kristi, right now."

He went on to describe putting me over his knee, pulling my panties down and spanking me hard, all the while lecturing about how this should teach me not to be such a little slut.

I don't remember exactly how it happened, but suddenly Daddy was grabbing my hair and shoving his cock in my mouth, murmuring, "That's Daddy's good little slut. Suck Daddy's cock good, baby."

I hadn't expected it, but surprisingly, it didn't bother me. It was sort of hot, in fact, since I knew I wasn't 15 and he wasn't my father. I moaned and sobbed and pleaded, until finally Daddy pushed his little slut onto the bed on her back and asked harshly, "Have you still got your cherry, you little whore??"

I wasn't sure which answer he wanted to hear, so I whimpered. No good. "Tell me, little slut, did you save your cherry for Daddy?"

"Yes, Daddy," I whispered. "I swear I never let anyone..."

"That's good, Kristi," he growled, "because Daddy's going to fuck his little girl now, and he wants it to hurt."

This went on for a bit, and I moaned, sobbed, cried, begged. I didn't actually say much, but he seemed to be having a good time. In fact, I was actually enjoying it myself, until:

"You like being Daddy's little whore, don't you, baby?"

"Ohhh, yes, Daddy, yes!"

"Beg me to fuck you harder, little bitch."

"Ohhhh, yes Daddy, please fuck me harder!"

"I will," he growled menacingly, "and you know what else Daddy's going to do?"

"What, Daddy?" I asked. I figured anal sex was on the horizon.

"Daddy's gonna get you pregnant."

Shit! He might as well have thrown icy water in my face. I went rigid, thinking, what kind of sick fuck is this guy? (So much for being non-judgmental.) Who even *fantasizes* about getting their daughter pregnant?

But of course, as my psychology professor taught me all those years ago, I couldn't show it. I kept whining and moaning, and even managed to answer, "Yes, Daddy," when he asked me if I'd like that.

He hung up happy, and I hung up disturbed. I do genuinely believe that no fantasy is wrong, but I had a feeling that wasn't the last time the belief would be tested.

My next Daddy wanted his ten-year-old daughter to bring home a bad report card. (Oh, gee, I wonder what he'll do?) I was resigned to the age, and decided I would just picture myself as me, and let him fantasize a kid if he liked.

That one started off easy. The dialogue was simple ("Daddy, I swear, I'll study harder. I'll go do my homework right now...") and the spanking was good. Daddy wanted to fuck his little girl in the ass, and she was agreeable (amazing how easy it is to say yes when you don't actually have to *do* it). All was well until he decided that his little girl got Daddy's dick "all dirty" and she should "lick it clean."

How I got through that one I just don't know. It wasn't easy, especially because he really wanted me to say certain things that disgusted me, but it wasn't actually as difficult as I expected. The phone, the distance, and the fact that this was a perfect stranger all helped give me the buffer I needed.

When I sent that day's billing in to Trisha, I got a note back. "Did you have to lick Daddy's dick clean?" She knows them all, I guess.

A more recent Daddy aficionado was different. He called and asked me to tell him a story about a little girl, maybe to describe another call I'd done with my Daddy. Or if I didn't have one, he said, he was also interested in hearing a story about my boyfriend and me with a little girl.

I must have sounded horrified (which I was) because he immediately said, "Only if you're comfortable with that. Actually, I'd love to hear a Daddy story."

I didn't mean to react that way, and I don't even think I said anything aloud, but I was absolutely appalled. Fantasizing myself as the bad little girl victim is one thing. I can eroticize that. But imagining myself molesting a child? No. I don't think I could even pretend that.

In any case, I began telling him the recent story of how I was ten and had to bring Daddy my bad report card. This turned out to be a completely different kind of call for me, because this guy wanted to be entertained. He wasn't passive – he was clear about what he liked and subtly guided me in those directions – but I got to make up the story myself. It was fun listening to his gasps and moans and figuring out just what would make him hot. I thought he was going to lose it when Daddy made his little girl take off her uniform after her spanking and stand naked in front of him wearing only her knee socks.

He got himself under control to hear the rest of the story. Really getting into it now, I told him all about seeing Daddy's cock for the first time, how big it felt in my tiny hands, and how Daddy taught me to move my hands up and down.

"But don't make him come yet," he gasped.

"No," I agreed, "because Daddy wants to show me where his big cock really goes."

I had a blast. I don't know why. He was clearly aroused, and somehow I knew just how to push his buttons. And since it was my story I didn't have to deal with anything beyond what I could handle.

When Martin, my first Daddy, called back a few weeks later, he didn't remember me. I think he calls lots of girls and does the same scene with all of them. Of course I remembered him clearly. One doesn't easily forget one's first "Daddy's gonna get you pregnant" call.

Strangely, I wasn't anxious. I'd grown much more comfortable as a phone sex operator than I had been, and I'd learned to dissociate a bit.

A couple of odd things happened. I didn't let on that I remembered everything he'd said to me last time, but I knew exactly what turned him on. In this fantasy I was fourteen and I got caught smoking in the bathroom at school.

Daddy put me over his knee, flipped my skirt up, yanked my panties down, and spanked me hard. The last time I'd talked to him I'd been too scared to relax into it, but this time I found that he was a good talker. The dialogue was hot, and I was reasonably turned on.

Then he started fingering his little girl while she was still over his knee, and suddenly, unexpectedly, I was *very* turned on. I'm not accustomed to enjoying the incest scenario, but picturing Kristi across his lap, panties down, legs spread, being finger-fucked by this guy with the menacing voice really excited me.

Much too soon we got around to the "Daddy's gonna break your cherry" part, just like last time.

"Do you want Daddy to fuck you, little slut?"

I knew all the right answers this time.

"Ohhh, yess," I responded. "Please, Daddy, please fuck me!"

"But you know what might happen if I do that?" he growled.

I didn't wait for him to say it.

"Yes, Daddy, I might get pregnant."

He nearly bellowed his excitement. "Yesss..."

I felt exhilarated. I wasn't scared anymore. I knew what he wanted and I gave it to him. It felt good. It felt as if I'd shifted the balance of power somehow, as if I conquered something.

And when I hung up with him a few minutes later, I discovered to my surprise that I was itchy and aroused, and I wanted to finish what he'd started for me. It was a bit disturbing to me to have gotten off on this guy's scene. But what the hell. I tell my callers all the time that it's just fantasy, so I might as well enjoy it myself.

Well, I did mention that I was kinky.

3. Regular Guys

Don't get the wrong idea about phone sex callers – they're not all crazy kinky lunatics (as much as I might wish they were – crazy kinky lunatics are generally the most fun). Some of the callers – lots of them, in fact – are just regular guys. Even some of the ones with the outrageous fantasies turn out to be pretty much, well, just regular guys.

The Garrulous Gourmet

When Jeff's name popped up on my caller ID, I knew it sounded familiar, but didn't immediately recognize it.

"Have you ever called a phone girl before?" I asked.

"Ohhhhh, well...once or twice," he answered. "Or ohhhh, about a million times." He had a deep, hearty laugh.

I hate asking that question, by the way. "Phone girl" doesn't seem like the right term. But I like "phone service" even less, and "phone sex operator" least of all. Phone woman? Phone slut?

Anyway, after I said that I realized that this was a guy that Rachel had told me about. She did a long call with him, over an hour, and he was talkative and friendly.

Well "talkative" doesn't begin to describe it. I would guess we yammered about nothing for 45 minutes. We discussed the telephone company, cable vs. satellite dishes, cooking, marriage, debit vs. credit cards, stay-at-home dads, the phone sex industry, you name it. We talked about cooking quite a bit, since he fancies himself an amateur chef, and my best friend is a professional chef.

At one point reasonably early in the conversation, he mentioned how amusing he found it to be "naked with my dick in my hand," only to talk about the relative merits of different kinds of paring knives. I immediately felt badly and tried to apologize, but he insisted that he just loved to talk.

"I'm a Chatty Cathy," he said cheerfully. An odd way to describe someone with such a deep, masculine voice.

He loves phone sex, but also just generally loves talking to cute, smart girls on the phone. He got married recently, he said, and he adores his wife, but he still makes time for the phone calls.

So we yacked. He told me about making gourmet baby food from scratch, and I told him about the time my friend forced me to help cook Chinese dumplings when I had the flu. We got to talking about soup, somehow. I told him about my favorite cold carrot dill soup. He started raving about a pepper pear soup that he makes.

I perked up. My chef friend loves peppers and she loves pears. And I've learned my lesson. The last time I did a call with a chef, he told me about a fabulous dish he makes with Häagen Dazs ice cream. I, ridiculously, proceeded to give him a blowjob instead of asking for the recipe. She was mad at me for days.

So I obediently asked Chatty Cathy what was in the soup. He didn't seem to mind and started naming ingredients. I heard sounds in the background, and he said, "Hang on, wait just one minute..."

Paper rustling.

"I know I have it here somewhere... I think it's in this notebook..."

Rustle, rustle.

"You know, this would be much easier if one of my hands wasn't covered in Vaseline."

I couldn't help it. I burst out laughing, and he did too.

"I'm on my hands and knees," he gasped, giggling, "naked... in my dining room... talking to you... looking for a recipe...."

We just roared. I tried to apologize again, but he said he was having a great time.

We decided this ought to be the opening for a movie. A shot of the phone sex operator saying, "Oh, honey, that would be great." A shot of his face, "Oh, yeah, just one more minute..." Maybe a shot of his hand on his dick. Then the camera pulls back to reveal him naked on the floor looking for recipes.

I suggested Tom Cruise for him, but he said that Cruise is too short. He wants to be Robert Urich, when Urich was younger – the *Vegas* years. Of course, Julia Roberts will play Kristi.

Eventually we did get around to the sex part, and he wanted to play with a teenage girl, a high school cheerleader type. I suggested a slutty cheerleader with a push-up bra and high heels and he loved it. He was my Home Ec. teacher who made me stay after class for not paying attention, and I seduced him over a cake batter. Good clean fun.

I didn't expect to hear from him again soon, because he said he'd call me in a couple of weeks. So I was surprised to see his name pop up on my caller ID about midnight a few days later.

He was whispering. "How are you, Kristi?"

I whispered back. "Pretty good. Why are we whispering?"

He laughed low. "My wife's in the other room. I won't be able to talk a long time like I usually do."

Oooooh, naughty.

"She doesn't know you're calling, does she?"

"Are you kidding? No way! Oh god, I'm so horny!"

"So why don't you go jump her bones?"

Look, I know it's probably not good for business, but I always encourage them to go to their wives. I push them to tell their wives about their fantasies. I can't help it. I approve of happy marriages.

"Nah, she's not feeling well."

Ahhh, in that case....

"Ohhh, so we'll have to be very quiet..."

"Yeah," he said softly. "Maybe you could just, like, talk about sucking my cock."

"Someplace where we might get caught any minute now?" I asked mischievously.

I could almost hear him get harder.

"Oh god... yes..."

"Like maybe in the kitchen... or a closet off the kitchen..." I teased.

"Oh yeah... in the storeroom next to the kitchen," he moaned.

"I'm a cute waitress," I said, " and the minute they're out serving the first course, you grab me and practically drag me into the storage room."

"Yesss...kiss you hard...push you down to your knees..."

"Shhhhh," I cautioned. "Quiet, they could come back into the kitchen any second now..."

It didn't take but three minutes. But it was a hot, hot quiet quickie. And very satisfying. And hell, his wife got left alone when she didn't feel well. It was practically community service.

Just One of the Crowd

I was warned both by Donna and by Trisha to limit my online chat time. I know from my own experience how easy it is to get sucked into that black hole of online chat, and how enticing and attractive people can be on the other side of the electrons. With pictures of Kristi-the-Gorgeous in my profile, it's not surprising that I was quickly overwhelmed with would-be chatters.

I decided early on to approach this whole thing like what it was – a business. It's much easier to keep customers than to get them, and most of any business's time is spent trying to attract the new people.

I decided that I'd put in the time chatting online for a while, to get to know some people and, I hoped, entice callers. I wasn't going to chat with people who were clearly not interested in calling, but I'd make the effort to cultivate some regulars early on.

I read through the AOL profiles of all the other girls, and they seemed so rude.

> NO cyber! I don't chat so DON'T ASK! No, you CANNOT HAVE A FREE SAMPLE so DON'T ASK! NO FREE PHONE!

I decorously left such items out of my profile.A few days later, in slight annoyance, I added a polite, "Please don't take the time to chat if you're never interested in calling. Thanks!" A few days later I changed it to, "No cyber! Please don't IM if you're never interested in calling!" and today it reads:

> NO cyber and NO samples. DON'T IM if you don't want to call.

Well, I tried. But there are so many men online, all looking for hot babes, and so few who are actually potential customers.

Several of those early online chats paid off, though, and I developed a modest regular caller in Drew. His calls are always around 20 minutes, spaced out every few weeks.

Drew is in his early 20s, a kink-curious computer programmer with no one to play with. We chatted online, and he confided that had never

called a phone sex girl before. I didn't really believe him when he said he was getting off-line to call. I get that all the time, and it's just usually an excuse to end the conversation. I was surprised when the phone rang a few minutes later.

We talked easily and played a light spanking-in-the-office scene. His desires were simple – a beautiful co-worker, dressed to tease, whom he could blackmail and turn over his knee. He only gave me a few swats (complete with sound effects, which were kind of sexy) and then went directly to the hot fuck. Short and sweet.

One of my other marketing ploys has been to write little thank you e-mails to the callers I meet online. So I wrote him a flirty note, telling him how much I enjoyed talking to him and suggesting a "cop stops sexy speeder" fantasy for the next time. Might as well get him thinking about calling me again.

It worked. He wrote back agreeing that he'd love to stop me for speeding, especially if I was wearing a low-cut outfit. I wrote back describing the outfit in detail. He sent back a warning against trying to bribe him.

We teased back and forth for a couple of days, and about two weeks after the first call, I approached him online. He seemed happy to hear from me, and the call started hot and heavy about the proposed police scene.

I had the feeling that he was interested in playing a little kinkier but needed some direction, so I made some noises about being handcuffed and bent over the hood of the squad car. He perked up right away, and suggested that other people might see me being punished as they drove by.

I responded with the appropriate "oh nooooo, noooo" pleadings, but he was having none of that.

"Maybe I'll radio for some backup," he suggested, "and let all my buddies fuck you one at a time. How would you like that, you little slut?"

Hell, I was game for a phone gangbang. Why not?

The conversation just about exploded. The somewhat-shy guy disappeared. He pulled me over, dragged me out of the car, frisked me, spanked me, bent me over the hood, and invited the entire police squadron from three counties to have their way with me while he watched.

At the last moment, he even got some female officers involved, and that seemed to send him right over the edge.

Since then we've spoken often, always in the same pattern. He won't generally call me out of the blue, but if I approach him online and get him worked up, he's happy to talk to me.

Both recent calls had themes similar to the second call. Once he spanked me in a boat, stripped me, tied me to a log on the beach, and put me up for grabs for anyone in the area. Again he just watched without participating, and I ended up covered in the ejaculations of dozens. He really seemed to like that part.

The last time we spoke he actually approached me online, on a weekday afternoon when I was working from home. He started teasing me about skipping out on work, and wondering if my boss would approve. He called, and his naughty secretary received a nice, mild spanking followed by a full-scale office orgy.

In the aftermath of that last call, I teased him about his transformation from innocent computer guy to raging macho orgy pervert.

"Only around you," he answered. "Somehow you bring it out in me."

He's not the first caller to say that to me, and in a way, it's very flattering. These guys feel comfortable enough around me to play with their deeper, darker fantasies. And it's amusing to know that I've been creating these lusty kink-monsters all over the country.

But lots of these guys are in their early 20s, just exploring their sexuality for the first time. It's not really a game. In a way, these experiences are helping to shape their sexual identities. Sometimes it feels like an awesome responsibility.

Cindy

When I was about 20, I bought one of those trendy pop-psychology games that you were supposed to play in order to start interesting conversations. It was kind of a cross between "Truth or Dare" and Ethics 101.

It asked things like, "If you found a wallet with five thousand dollars in cash and no identification, what would you do?" or "Would you have sex with your spouse's best friend if you knew for sure you'd never be caught?" The basic idea was to bare your soul to your pals and

to get the dirt on everyone else. My friends and I played it obsessively one summer. We'd get together, wave around clove cigarettes, drink wine, and have pretentious discussions.

I don't really remember where I was kink-wise back then. Certainly I was nowhere near putting my fantasies into practice, but I do recall smugly feeling like the rest of the gang were a bunch of prudes. Threesome? Sure, why not? Lesbian experience? Bring it on! Anonymous sex? Is there any better kind?

The only question I actually remember is the one that stopped me dead. It's still with me, in fact, even ten years later. "If you were engaged to a man you loved, and the week before the wedding you found out that he was a cross-dresser, would you still marry him?"

The question disturbed me greatly. I stuttered around, tried to just wave it off and answer yes, but I couldn't. Everyone was looking at me strangely; I'd participate in an orgy, but a little harmless cross-dressing would bother me? But it would. I had to answer, "I don't know."

A friend, who was totally vanilla but reasonably adventurous, asked, "But don't you think that if you loved him and that's what he was into, you could somehow make something sexy out of it?"

I was shaking my head. He was right, of course. I could do that with most things. If my lover had a thing for knee socks or sex on the floor or latex, I could make it work. And lord knows, with my sexual proclivities, I should be the last person on earth to be judgmental.

But I was horrified at the very idea. And to this day, I still don't know why. Genderfuck scenes don't put me off – I find the idea sort of hot and fun. I think most transvestites (the ones who really look like women) are gorgeous. Even transsexualism doesn't bother me. But simple cross-dressing – a straight, generally masculine man who likes to wear pretty, feminine things – makes me uneasy. It's one of those irrational impulses, I guess. I can think of no actual reason to be upset by it.

As I've explored the kinky world, and gotten more comfortable with my own sexuality, this reaction has eased somewhat, but it's still there. The discomfort with that question all those years ago has been with me ever since. It's always bothered me that it bothered me.

So imagine what ran through my mind when this IM popped up on my screen:

Instant Message from: Cindy1234
"Hi! Would you consider phone sex with a cross-dresser?"

Sheer terror. Irrational panic, but only for a moment. I realized I was being utterly ridiculous. How could I be afraid of talking to a cross-dresser *on the phone*? I decided it was time to get over it, or at least try.

"Sure, why not?"

We had a nice online chat for a few minutes. He loved my high black stockings. He was twice divorced and very, very shy. He told me he couldn't call me because he was old and fat and ugly. Suddenly I felt deep empathy.

"You're not putting yourself down, are you? Because I hate that." And I gave him a smile.

"Well, maybe a little..."

"Well don't," I typed. "I bet you look beautiful."

"No," he corrected. "*You* are beautiful."

Damn. Kristi is beautiful. I wanted so badly to tell him that I'm not the gorgeous twig in the pictures. But I didn't. I thanked him. He asked if he could tell me what he was wearing. I pushed away a twinge of distaste, and told him to go ahead.

He told me he was wearing red satin panties and a matching bra. And silk stockings with a garter belt, and high heels. And that his cock was hard for me in his panties. What a strange juxtaposition.

Well, in for a penny, in for a pound. "Honey, are you interested in giving me a call?"

"I want to."

"Great!"

"But Kristi, I'm 58 years old."

"So what?" I certainly didn't care about his age.

He was silent a moment. "Okay," he said, "I'm going to call right now." I wasn't sure he was going to, but he did.

"Hi Kristi, this is Cindy." The voice sounded like your typical middle-aged teamster. Cindy.

"Hi, Cindy, I'm really glad you decided to call." Not bad. I called him Cindy and didn't waver.

"So am I," he said, and I could hear the relief in his voice, relief at finally being able to talk to someone.

We chatted for a little while. He told me about sneaking into his mother's lingerie drawer when he was five, and being married twice but never telling either of his wives. I told him about being interested in S/M, and sneaking off to read spanking letters in my dad's *Penthouse*.

He was not at all feminine. He just likes feminine clothes. A paradox. He was interested in both my tits and my bra. I asked him if he ever wore panties under his regular clothes to feel naughty. He said he loved doing that. I told him how I sometimes don't wear panties at all. We decided it was probably the same sensation. We discussed the relative merits of stockings vs. thigh highs. It was *fun*. I admit, I was still a little freaked out, but I enjoyed it anyway.

When we finally started to play, he wanted me to talk about the lingerie. I described having him on his back and crawling on top of him, rubbing my bra against his bra, my wet pussy rubbing against the hard cock under his slip. But other than the references to his underwear, he was no different from any other guy I've talked to, right down to him pulling down both of our panties and fucking my ass. Go figure.

I can't say I'm over it, but it's a step. A high-heeled, silky step.

4. Phone Sex Basics

If you've never called a phone sex service and you're hesitant to try, the first thing you should know is that phone sex is legal in the United States. It's regulated because it takes place over a phone line, but it is not considered sex-for-pay or prostitution. So you don't have to worry about entrapment or undercover cops – what you're doing is perfectly well within the law (assuming you don't try to solicit a phone sex girl to meet you and have sex with you for money, of course).

When you call a professional phone sex line, you will probably be dialing one of three types of numbers:

International Number Services. If the number you dial begins with 011, you are calling outside the U.S. The only cost for these calls is the long distance charge to your phone line. Be warned, though – that doesn't necessarily mean your call will be cheap. Check with your long distance company first and ask what the per-minute charge is to the area code you're calling. (Don't worry, your phone company won't know that you're thinking about phone sex – lots of different businesses operate from outside the U.S.)

There's one other thing to watch out for. Some phone numbers outside the U.S. don't begin with 011. Some numbers in Canada, for example, and some places in the Caribbean look just like regular ten-digit U.S. numbers. If you don't recognize the area code, check it out before you call. It will only take you a few minutes, and could save you hundreds of dollars.

Advantages to International Number Services:
- No credit card or checking account required.
- No need to give out your personal information to the phone sex company.
- The per minute charge may be very low.

Disadvantages:
- The call and number will appear on your phone bill.
- The per minute charge may be very high.
- Rumor has it that the workers in many of these services speak very little English.

900 Number Services. The old-style phone sex lines use 900 numbers, which charge your phone bill by the minute. The Federal Trade Commission heavily regulates this style of phone service under what is known as the "FTC 900 Rule." According to that rule, when you call a 900 number you should first hear a recording, which must explain the service and the pricing. Then it has to warn you that the billing will start at the sound of a tone, and it must give you at least three seconds to disconnect before the tone. If you hang up at that point, you should not be charged at all.

One of the disadvantages of a 900 number service is that, due to Federal Communications Commission (FCC) obscenity regulations, there are certain topics that the operators will not be able to discuss with you. The difference between "indecent speech," which is protected under the First Amendment, and "obscene speech," which isn't, is complicated and heavily debated. The bottom line for phone sex is that 900 service operators cannot talk to you about anything illegal. This includes fantasies like incest, rape, or sex with underage persons, and could even extend to more conventional acts like anal sex (sodomy), which are still illegal in places.

If your fantasy involves anything kinky, you will probably have better luck with a toll-free phone service. Since you usually have to give a toll-free service your credit card number, your call is considered a private transaction between individual adults, and is exempt from the 900 Rule.

Advantages to 900 Number Services:

- No credit card or checking account required.
- No need to give out your personal information to the phone sex company.

Disadvantages:

- The call and number will appear on your phone bill.
- Regulations against "obscene" speech.

Toll-Free Number Services. When you call a service with a toll-free number (one with an area code like 800, 888, 877, or 866), nothing appears on your phone bill. Be aware, however, that most times your number will appear on the operator's phone bill, so there's no guarantee of anonymity. (Not all numbers beginning with "8" are toll-free, either. For example, 801 is not toll-free, it's Nebraska. If you don't recognize the area code, check it out before you call.)

Credit Cards and Check by Phone. The most common way to pay for a toll-free phone sex call is with a credit card. Most services accept Visa and MasterCard, and some accept American Express and Discover as well. One advantage to these payment methods is that you can just call anytime you feel the urge – you don't need to prepare anything in advance. Also, you don't need to decide ahead of time how long you want to talk.

Because of the high cost of accepting credit cards for adult businesses, most toll-free services have a minimum fee (usually equivalent to about ten minutes) that you will be charged even if you hang up before that time. Expect the person who answers the phone (who may be the phone sex operator or may just be a dispatcher) to ask you for the following information:

- your full name the way it appears on your credit card
- the billing address of the credit card
- your phone number
- your credit card number
- the expiration date
- the card verification number, which is found on the back of your card (This is a relatively new feature designed to make sure you

actually have the card in your hand, and aren't using a slip you found in the trash.)

Some companies also ask for your e-mail address, but you should be able to decline to give this to them if you prefer.

On the other hand, if you're not picky about who has your e-mail address, this is probably where they'll announce sales and specials, so go ahead and get on their list!

If you aren't comfortable giving out all this information, you probably need to find an alternate way to pay for your phone sex. Don't bother asking the operators to run the charge without your address – they can't even if they want to. They have to enter the information into a computer, and if the address doesn't match the credit company's records, the call won't get paid.

Questions you should ask if you're doing a credit card transaction:

How will this charge appear on my statement? Generally the charge will look innocuous, like "Smith and Associates," so you won't have to worry about "Hot Cum-Sucking Sluts" appearing on your statement. On the other hand, it never hurts to ask. Keep in mind that your statement will probably include the Customer Service phone number for Smith and Associates, and the person answering that phone won't lie about what kind of business it is. If you're worried about someone else checking your bill, an innocent name might not be enough protection.

Who has access to my credit card information? The best answer is, "No one but me sees your credit card information, since it goes directly into a computer, which encrypts it." Not all phone sex companies are this technologically sophisticated yet, but you should expect some reassurance that your credit card information is kept secure.

What is your policy about using my contact information? The best answer is, "We will never use this information to contact you unless you request it. We never lend, rent, or sell our mailing list to anyone, and we don't do mail-outs." (The exception here would be e-mail updates if you've given them your e-mail address.) Be aware that even if the company says they won't contact you, there is always an unspoken exception: a problem with your credit card. If your bill isn't paid, your phone is going to ring. Be careful.

Some companies also accept checks-by-phone, which debit your checking account directly. These transactions are risky for the phone sex company, because there is no way to verify that the money will still be there when the check goes through. Some companies will only accept checks by phone if your bank has a 24-hour verification phone number, and some add a small service charge (normally five dollars or less) to each check they process. If you want to pay via this method, make sure you have a blank check with you when you call – the operator will need information from it.

Advantages to Toll- Free Number Services:
- No record of the call appears on your phone bill. (Important note: if you use a cell phone, the number may show up on your bill even if the call is toll-free.)
- As a private transaction, conversation is unregulated.

Disadvantages:
- Credit card or checking account required.
- You must give out your personal information to the phone sex company.

Pre-Pays. If you don't have or don't want to use a credit card, most toll-free companies will accept advance payment for a call. The traditional way to pre-pay is with a check or money order. Money orders work especially well for people with snoopy housemates, as there doesn't need to be any paper trail on your end. It's generally considered inadvisable to send cash through the mail. Some people do it, though – I know of a client who regularly sends out a 20-dollar bill in an envelope, and has never had any trouble.

Advantages to Pre-pays:
- No record of the call appears on your phone bill (unless you use a cell phone).
- No need to give out your personal information to the phone sex company (if money order is used).
- No credit card required.
- No paper trail (if money order is used).

Disadvantages:

- Can't call on the spur of the moment.
- Must decide in advance how much time you want to purchase.
- If your money order payment gets lost in the mail, you have no real proof that you sent it.

Third Party Billing. A relatively new method of payment is a third party billing service like PayPal. Originally developed for use in online auctions, these services act as a conduit. You pay them (with a credit card or checking account), and they pay the phone sex company. Unlike an auction, in which you would send money after the auction is over, for phone sex you would usually decide in advance how many minutes you want to purchase and send the appropriate payment.

Advantages to Third Party Billing:

- No record of the call appears on your phone bill (unless you use a cell phone).
- Only need to give out your personal information to the billing company, not the phone sex company.
- No credit card required (can use your checking account).
- Your statement will show only the name of the billing company, not the phone sex company.

Disadvantages:

- Possible delays – individual phone sex workers generally need verification from the main office that your payment has been received.
- Must decide in advance how much time you want to purchase.

Of course, once you become known as a regular customer, the phone sex service will probably be happy to work out comfortable payment arrangements with you. Some of our clients call first and write checks afterwards. Some send us a large payment in advance, and we let them know when they're almost out of money. If you're a good customer, it's in the company's best interest to be flexible with you.

Tips. Tipping is not universally assumed the way it is with, say, waiters, but an occasional tip will be much appreciated. I make sure to take extra care of my tippers. There's no set percentage, and no stan-

dard way to do it. You might tell the operator, "Go ahead and add a $5 (or a $20) tip to this call." If you feel funny saying it directly, call the main office and ask them to run a tip charge.

Your phone sex worker will probably not receive the entire tip if you charge it to a credit card. The credit card company keeps a percentage of each sale – sometimes as high as 15 percent – so it's likely that the phone sex company will deduct that fee from the tip.

Many phone sex callers prefer sending gifts to tipping. Clothing (mainly lingerie) and sex toys are common, especially because the operator can wear or use your gift during your next call. You will probably need to send your gift via the phone service. This protects the worker from having to give out her address, and protects the service from being taken advantage of by workers accepting money on the side. Many phone services will fire a worker who gives out her personal information.

In this age of computers, there's a wonderful alternative way to tip – electronic gift certificates. Often you can send one to an e-mail address without any other identifying information. A caller once sent me an e-gift certificate to Amazon.com at Kristi's e-mail address, and I was delighted. I picked out my own gift and had it shipped right to me without compromising my privacy.

Chargebacks. A chargeback happens when a caller contacts his credit card company and disputes the charge on his bill. Of course, sometimes legitimate mistakes do happen. If you genuinely have a problem – if you feel you were charged in error or overcharged – contact the phone sex service *first*. A legitimate company will make every effort to resolve the problem, either by providing evidence of the basis of the charge, by crediting your credit card, or by offering you a free call.

All too often, though, a caller either decides that he can get away without paying because it's "just phone sex," or the caller's curious partner questions the charge on the credit card bill. Rather than angering his wife (or girlfriend, boyfriend, or whomever) by admitting that he called a phone sex service, the guy declares that it must be a mistake on the bill.

The credit card companies inflict heavy fines on the services for chargebacks. Some phone sex companies will pay the chargeback fees, but some make the operators pay them. If the worker has already been

paid for the call itself, she'll have to re-pay it.

Many phone sex sites now contain warning statements like this one: *This service is a member of an anti-fraud coalition, committed to putting a stop to fraudulent credit card and check transactions in the phone sex industry.*

Think hard before you dispute or deny a valid charge. First of all, it's a really lousy thing to do to a worker who gave you good service in good faith. Second, doing so constitutes credit card fraud, which is a felony (and a federal offense, at that) in the United States. Many phone sex services *will* report you to the authorities, and they *will* press charges.

If you do a chargeback on a valid call, expect the service to fight back. Be prepared to explain why your phone number appears on the operator's phone bill, and how she got your card verification number. Prepare to be invoiced for at least a 25 dollar chargeback fee plus interest, and prepare for that invoice and other documentation to show up at your home address.

Also expect your name and personal information to be added to a "loser" database circulated to other phone sex companies and even posted on websites. The industry is smaller than you might think, and the one thing all the services agree on is the need to get rid of the losers.

If you genuinely have a problem – if you feel you were charged in error or overcharged – contact the phone sex service *first*. A legitimate company will make every effort to resolve the problem, either by providing evidence of the basis of the charge, by crediting your credit card, or by offering you a free call.

Choosing a Service

So how do you find an honest, legitimate phone sex company? There's no sure way, but there are a couple of reasonably reliable indicators.

First, look for companies that advertise in magazines, particularly national magazines like *Hustler*. Even better, look for companies that advertise in multiple magazines over multiple issues. It costs a small fortune to advertise in these kinds of periodicals, and it usually takes at least three or four months for the ads to appear, so this kind of advertising indicates a commitment from the phone sex company to be around for a while.

Don't base your decision on how slick or professional the website looks. If you have the right skills you can get online in only a few days with very little cash, and advertise on newsgroups for next to nothing. A company with a fabulous website could be gone in days.

Second, look for choices in the kinds of payment the company accepts. Be wary of companies that only accept one type of payment like PayPal. It's not that they might not be honest, but legitimate vendors form ties with billing companies; for example, accepting multiple credit cards means the company has been approved by a bank for a merchant account, and accepting payment by mail means they have a post office box. The more ties they have in the merchant community, the less likely they are to disappear.

Only you can decide if you feel comfortable with a service, and there's no sure way to tell the legitimate from the scammer. Go with your gut – if it doesn't feel right, it probably isn't.

5. Poor Little Rich Boy

One of the questions I'm most often asked is if I ever fall for the guys I talk to, or if I ever feel like I make real connections with them. Sometimes I do. The relationships actually become quite complex; the callers know that I'm a phone sex operator and that they're paying customers, but the intimacy is real nonetheless. They are not just clients – they're friends and even lovers.

Paul was my first regular caller, and the first person I ever spoke to for an hour or more at a time. He's in his late 20s, divorced, no children, and he's apparently obscenely wealthy. At first I was skeptical when he told me about his money, but now I'm not so sure. He spent well over a thousand dollars talking to me in the first few weeks, and never batted an eye.

I met him in a chatroom. He seemed nice enough, though a little dull. No, he'd never called a phone sex girl before, he said. I tried to ease my way out of the conversation.

"You're leaving?" he asked.

"I'd love to stay and talk to you," I answered without any real conviction, "but you don't seem very interested."

"How do you know that?" he shot back. "Maybe I'm just shy." He had a point there.

He did call that night, and he was extremely quiet. He was fine when we were just chatting, but once we started on the actual phone sex, he said almost nothing and made almost no noise. I could barely tell when he climaxed. The few comments he made were all about how beautiful I was and how much he liked a woman to be in charge.

I couldn't read him at all. He was clearly aroused, and I led the way without being especially domineering, which he also didn't want. He was essentially passive throughout the experience, and when at one point I suggested that he might want to pull me down and fuck me, he said softly, "If that's what you want me to do."

I sensed somehow that it was *not* what he wanted, so I quickly suggested that I could instead take him in my mouth. He seemed relieved, and agreed that yes, he would like that better.

It was a somewhat sweet, somewhat awkward call – the early conversation had been pleasant – but I didn't expect to hear from him again. Nonetheless, I sent him my standard little e-mail thank you note and a sexy picture, teasing him just a bit about how quiet he'd been.

I got an unexpected e-mail message from him the next day, doubly surprising because he was supposed to have left on vacation for the weekend. He'd been in a car accident and was stuck at home with no car, and a mass of cuts and bruises. In the note he thanked me for taking his phone virginity, and ended with, "Know any nurses who might be able to take care of me this weekend?"

Hmm. So he enjoyed himself after all. I figured that a nurse fantasy might be right up his alley because he's so passive. I wrote him back a teasing e-mail about how he should come in for a check-up and a sponge bath, and that the procedure was so delicate that I might need to tie him with bandages to the bed just to insure that he didn't injure himself. In the letter I addressed him as "Mr. Johnson," as if I were his nurse.

He wrote me back, practically panting, making an appointment with Nurse Kristi for treatment later that evening. He was also mightily impressed that I remembered his last name. I decided not to point out that I had just talked to him the day before and I had his name and credit card number written down in my notebook. But I smiled, enjoying the idea of talking to the same person two nights in a row, and feeling more comfortable that he liked me.

Suddenly I had a panic attack, realizing that I had no idea what a typical nurse fantasy would be like. Most of my life I've been medical-phobic. Medical talk makes me nervous to the point where I've even refused to watch television shows like *ER*. Doctor sex scenes have always been on my "no way" list, so my medical-fantasy imagination file

was mostly blank. And with Mr. Passive, I knew I'd need to do most of the talking.

I decided to take a look through the alt.sex.stories newsgroup on the Internet – surely there would be medical fantasies there! I'm creative, and I figured that if I could read a hot one or two, I could wing it.

It turned out to be much more difficult than I expected. Most of the medical stories I found involved lots of torment and humiliation. I found *Sadistic Nurse* (Parts 1-13), *Doctor's Torture Chamber* and assorted stories about painful medical experiments. Not one single sweet, caring-but-sexy nurse.

I'm not good at this. I don't generally associate sex with nurturing. I like it hot and rough. I stumbled on a bit of temperature taking and filed it away in the back of my head – I didn't know if he'd like that. I also wrote down "latex gloves" and "ice bath" on a notepad, and then shut down the computer. I'd just play it by ear.

The call itself was uneventful for me, though a milestone, I think, for him. He enjoyed being completely quiescent, with no pressure to participate. In fact, I told him *not* to participate, but just to relax and accept the treatment. If I'd thought about it at that time, I would have pretended to give him an injection of a muscle relaxant to help him along.

Basically I described giving him a full body massage, using lots of fake medical dialogue, followed by nurse-on-top sex. He even let me take his temperature and seemed to enjoy it. At the same time I encouraged him to verbalize, to moan, to make some noise. I told him how sexy I found it to listen to his arousal, and how much I wanted to hear him come. He wasn't exactly talkative, but he relaxed a little, and I did hear his orgasm. I counted that as a major victory.

Just after we were done, I said, "Well, I think that went well, Mr. Johnson, but you will definitely have to come back for a follow-up treatment." He burst out laughing, that exhausted, sated, lover's laugh.

For the next week we chatted online whenever we saw each other. I teased him and turned him on, and generally considered it my duty to leave him with a raging erection every time he got onto his computer.

☎

After the Nurse Kristi scene, Paul loosened up considerably, and we started chatting online on a regular basis. I was a bit concerned about spending non-paid time online, but as someone who had called two

days in a row, he was the closest thing I had to a regular caller. He deserved some slack.

It's an interesting thing, this being a professional friend. I've met a couple of people I genuinely like, and a lot of people I like reasonably well. Paul is not someone I'd choose for a friend in my everyday life, but he's amusing and intelligent, so he's easy to entertain. He's constantly amazed at how well we get along; of course we do – I only show him the parts of myself that I know he'd like.

He has attributes I can't stand – he's got a big male-chauvinist streak, and if I were able to be myself, I'd never let him get away with some of the crap he spouts. His loves to watch wrestling and porn, and he thinks that only people with absolutely perfect bodies should allow themselves to be seen undressed. He also seems to be stuck in that college phase of "let's go out drinking with the guys" as his major form of entertainment.

On the other hand, he seems to be a genuinely good-hearted person, reasonably charming, sad about his marriage ending, sorry he and his wife had no children, considerate of his employees, and concerned for his parents.

He fell head over heels in love with Kristi, to the point where I started to worry. He told his friends about me and showed them pictures. He started dropping "If you ever came up here..." references into conversations.

I wrote to Trisha, the boss, for advice, because I didn't know how to react. I didn't want to give him the impression that a real-life meeting was even remotely possible. But if I did what my honest gut told me to do – interrupt and remind him that it's absolutely never going to happen – I'd probably lose him as a client. And it might be losing a client for no reason. Maybe he was just enjoying the fantasy, not becoming a stalker.

She was helpful. Lots of guys fall for phone sex girls, apparently. There are men who call her for hundreds of minutes a week, she said. If he keeps mentioning real life, she suggested that I just don't react – keep talking as if I didn't hear him. That's pretty much what I'd been doing. If it goes further, explain that my contract forbids me to meet clients. If that doesn't work, remind him that what I do is about fantasy, not reality.

Do not under any circumstances tell him the truth about the pictures, she warned. The guy might say that he doesn't care if it's really you or not, but he does. Telling them the truth is the quickest way to get a whole bunch of charge-backs.

I kept ignoring Paul's comments, and after a short time he re-connected with the boundaries. He started to tease me about wanting to be my official favorite client. That was easier to handle.

In some ways I still felt an occasional twinge about lying to him. Don't get me wrong, I know that it was me – the real me – that he was interested in talking to, but it was some combination of Kristi and me that he liked. He's a very visual person, and he was obsessed with Kristi's body, muscles, flat stomach, and fabulous red hair. I may have been the one who fulfilled his fantasies, but Kristi *was* his fantasy. The look was very, very important to him. But even so, I became his phone lover and confidante, and I enjoyed it. He paid, and he was pleasant, and the sex was *hot*. This was a good customer.

Amusing story: he went out with an ex-girlfriend one night, slept with her, and as they were falling asleep, he called her Kristi. He's lucky she had a sense of humor about it.

Anyhow, back to our encounters, which grew more erotic and wild each time.

The third time he called was the real breakthrough. We spoke for over an hour, the first time I'd ever done a call that long. We just chatted for at least 30 minutes, about life, phone sex, his ex-wife and what went wrong with his marriage, his business, his tattoos, how hot my red hair makes him – lots of things.

I asked him about his fantasies. He'd been insistent that he doesn't have many wild fantasies, but I never believed him – he's too sexually open for that to be true. He doesn't seem to have any particular fetishes, but he's certainly interested in all things kinky.

I coaxed a bit, and he admitted he had a recurring fantasy about being picked up by a gorgeous woman in a bar. I asked him to describe the setting, and to my surprise, he did so eagerly and in detail. He was sitting on a barstool, in faded jeans and no shirt (hell, it's a fantasy), on a warm summer night.

"Then what happens?" I asked softly.

He started telling the story, and it was vivid. A tall, slender, beautiful woman approaches him, lures him away from the bar, and makes love to him, mesmerizing him somehow.

His description was erotic; I enjoyed it and told him so.

I caught a low mumble. "You know how much I like to be..."

I kept my voice soft, persuasive. "Like to be what, sweetie?"

"Bitten," he answered low.

I remembered. He'd reacted intensely anytime I mentioned biting. I made encouraging noises.

"And so... I've always fantasized... about meeting..." he trailed off again.

I got it. "A gorgeous vampire."

He breathed sharply. "Yesssssss."

"Mmmmmmmm, that sounds sexy to me," I whispered.

He didn't answer.

"So go on," I said. "You're sitting at the bar. And then?"

It sounded as if he shook himself off. "I hear this clicking noise behind me, like high heels."

If I've noticed one near-universal so far about submissive or passive men, this is it: the clicking sound of high heels. One guy asked me to "please please please put on a pair of high heels" so he could hear me walk. I obliged, and the sound really sent him.

"I feel a presence behind me. And I turn around on the stool," he continued, "and I see... you... your red hair..."

"What am I wearing?" I encouraged him.

It's difficult to convey the intensity of this conversation. Neither of us was speaking in our regular voice. It was low and husky and intimate.

"Boots," he said, gasping a bit. "High boots."

"Yes," I agreed. "Shiny black leather boots that come up to mid-thigh...."

He moaned.

"With high spiked heels," I went on.

His breath rasped. "Oh god," he said. "I can just see you there."

I kept talking, slowly, softly. "I'm wearing a short black dress, sleeveless and clingy... you can see that I'm not wearing a bra..."

We were both heated up by then.

"And your hair..." he said. He's obsessed with the hair.

"Yes," I agreed. "My long, red, hair falling all over my shoulders, my skin looking so pale..."

Unintelligible noises.

"You feel me coming up behind you... and you turn and see me there...watching you..."

"Yes, yes, I see you...." he whispered.

"I take a step closer," I said, "and reach out one hand towards you, towards your chest. Then I run my fingers up, and tease your nipple with a long, red nail."

"Oh god..."

"I step even closer, and slide my other hand up your bare chest... feeling your warm skin, trailing my hand up your chest to your neck, your chin, your lips..."

"I'm paralyzed," he whispered. "I want to touch you, kiss you, but I can't move at all."

"I lean forward," I said. "Even closer, and you can smell my perfume and me, and my lips are only a few inches from yours..."

Inarticulate moans across the phone line.

"I want to taste you," I murmured.

"Oh yes, god yes," he said.

"I lean forward and brush your lips with mine...letting my tongue snake out to lick your lips...kissing you softly...and then pressing my lips harder against you, letting you feel my teeth...and then...I press my teeth into your lower lip, cutting your lip, letting your blood spill over my lips into my mouth..."

"Ahhhhhhhhhhhhhhhhhhhh..."

I've never found vampire erotica appealing, but at that moment I was right there with him. At that moment, biting his lip and licking the blood seemed like the most erotic thing in the universe to me.

I had an image in my mind, from a movie I saw about ten years ago. I think it was just called *Gothic*. It was about Mary Shelley and it was halfway between pornography and horror. I remember absolutely nothing about the movie except one image of a man leaning down to kiss a woman's neck and then opening his mouth to the camera to reveal his teeth covered with her blood. In the context of the movie, I found the image incredibly erotic. It was the first time I'd ever found the blood/sex combination to be exciting, and a friend and I had a long talk about it. I remember it clearly.

That was the image I had in my mind that night on the phone: a handsome young actor with teeth covered in blood, in bed with a beautiful young woman.

"You're mine now," I murmured to my own young, handsome victim. "I have your blood inside me."

Where did I get this dialogue? I have no idea. But it was really doing it for him, and truth to tell, it was giving me a charge as well. All I know is, at that moment our relationship changed. I was no longer just a phone sex babe. I took this secret wisp of a fantasy from his head and made it real for him. Not only that, it made me hot too, and he must have known that.

"Shall we... go somewhere more private?" the vampiress suggested.

A long moment.

"Yes," he whispered. "Yes, I know the perfect place."

"Mmmmmmm," I whispered. "Let's go then."

He described taking my hand, bringing me outdoors to a secluded field by a lake. His words made me visualize the darkness, the enormous tree, the moon, the sounds of birds and animals, the wind. I was completely caught up in the fantasy with him. As I'm writing this, I realize that I invented an image in my head – a ramshackle and abandoned farmhouse in view, something he and I never discussed.

He kissed me in the moonlight, wrapping me in his arms, touching my body and my hair feverishly. I stepped back from him and pulled my dress over my head, tossing it aside.

"I stand in front of you," I murmured, "just in my boots, hair falling down over my nipples."

Memory is a strange thing. I don't have any idea how we got from there to the ground, with him facedown and naked in the grass.

"I approach you," I said, "and stand over you, straddling you...I drop to my knees, pressing my wet pussy against the small of your back."

He moaned louder.

"Can you feel me?" I asked. "Can you feel against your bare skin?"

"Oh yes, oh god, oh yes..."

I described running my hands up and down over his back, gripping his sides hard, digging my nails in, and scratching. I told him how I leaned forward and rubbed my hard little nipples against him, sliding my arms around his chest and squeezing him.

He had been an active participant in the description earlier, but he was less than coherent now.

"I let my hair fall forward all over your bare back and neck. And I lean forward, open my mouth, and sink my teeth deep into your shoulder."

He groaned loudly.

"I dig my teeth into you, scraping and scratching you with my nails...then I raise my head and sink them hard into your neck..."

I could almost feel him rocking and bucking underneath me.

As I said, memory sometimes fails, even the most intense memory. I remember nothing of that conversation past that image – Paul naked and facedown on the grass in the moonlight, with Kristi straddling him, wearing just her boots, pressing her chest into his back, her red hair streaming, and teeth sunk into his shoulder.

There must have been more, but I don't remember any of it.

He told me later that it was one of the most erotic experiences he ever had, bar none. I have to admit, I feel the same way myself.

More and more, Paul became comfortable about the idea of my being a phone sex girl whom he was paying. I was glad because I'd been feeling so guilty about him liking me so much.

He was opening up a new branch of his business and moving to a new state. He had a great time telling me about his going-away party and the little surprises his partners and friends kept sending him for the last few days.

"Besides the silly going-away gifts, I also made some new friends this week," he said, too casually.

"What kind of friends?" I asked.

"Um, naked friends."

We laughed. His partners sent him three strippers, three nights in a row. He's your basic red-blooded American boy with raging hormones. Loves his beer, loves his truck, loves those naked babes.

"And last night they sent Jackie to my house," he said.

"Jackie?"

"Yeah, Jackie is a dancer, a stripper..." he replied, "We, um, know her pretty well."

"Oh really?" I grinned. "Just how well do you know her?"

"Well, she works in this club, you know, and we go there once in a while..."

"Ohhhh," I teased. "Once in a while."

He laughed loud and long. "She gets almost as much money from me as you do."

I giggled too. Actually that comment made me feel better about the whole relationship. I'm just one of the sex indulgences. He buys porn videos, he stuffs money down g-strings, and he calls his favorite phone sex operator. All of a piece. I haven't bewitched a poor, innocent boy into running up his credit cards.

"Does Jackie do lap dances?" I inquired.

"Oh yes."

"Oooh, tell me about them!"

One of the hottest scenes Paul and I had was about money, in a sense. He just loves sex and all the associated toys, and he talks a lot about wanting to buy me this or that.

One night he revealed that he loves idea of watching someone masturbate, or having someone watch him.

"Did you and your ex-wife do that?" I asked. He'd often spoken about their sex life and how adventurous it was.

"Yes," he said quietly. "A little bit."

"Did you like it?"

"Oh yes."

"Mmmm, I think it's exciting to watch."

"Yes," he said. "I think that's so hot. Actually, I have this fantasy..."

I tuned in right away. He rarely said that – he usually liked to let me create the scene. "Tell me."

"I've always wanted to see a woman use a... you know, like a dildo... I've never seen that."

"Mmmmm," I answered. "I just happen to have one of those."

"No," he said. "Not that one."

"No?"

"No. Let me tell you my fantasy," he began. "I want to take you to an adult store and hand you $5,000 in cash."

"Oooh," I said. "I like that. And..."

"Yes," he went on. "And I want you to spend every dollar, on anything in the store you like."

"Oh my... what a choice!"

"But of course, there's a catch."

"Oh?"

"Yes. Anything you buy you have to demonstrate for me."

"Ohhh, that's not much of a catch," I said. "I'd do that anyway."

He liked that.

I think I'd actually be hard-pressed to spend that kind of money in a sex store. I'm not a person who buys recklessly, and it was difficult to spend even an imaginary $5,000, though it was easier to imagine buying for Kristi – everything looks good on her.

I started easy: clothing. Lots of latex and leather and high heels. A full catsuit. A satin corset. A leather bikini. A big feather boa. A pair of black silk boxers for him, which he obligingly donned.

Then I moved to leather floggers, which would truly be my indulgence if I had $5,000 to spend. One heavy, one light, one soft, one stiff – I described the texture of each one, and what it would feel like on the skin.

Think expensive, I told myself. Videos of all kinds, one for every fetish we both liked. Some books of hot stories for me to read him. And then toys: clips and clamps, dildos and vibrators of varying sizes, a rainbow of flavored lubricants, and some big, soft feathers.

Neither of us was actually keeping track of the dollars, and soon we gave up on shopping and got to the good stuff. I ran my hands over his black silk-clad erection, and then stripped off everything I had on. I asked him if he wanted a lingerie fashion show, but he said no, he'd pick out something for me to wear this time. He held out a pair of white thigh-high stockings, but I shook my head.

"You put them on me."

He knelt down in front of me and slid the stockings up my legs. He spent far longer than was technically necessary adjusting them, smoothing them, and letting his fingers wander. Then he slipped a pair of high-heeled shoes onto my feet. I almost lost my balance and had to hold on to his shoulders for support, accidentally pressing my hips against his face. Oops.

When the shoes were on, he sat back and just gazed up at me.

I gestured to the pile of expensive lingerie. "What next?" I asked.

"Nothing else," he said. "I like you just like this."

"I just picked out $2,000 of lingerie!" I protested.

"Later," he said. "This is all I want you to wear for now."

I felt unaccountably shy and told him so. I think he liked that best of all. He stood up and crossed the room, leaned against the wall, and watched me.

"I want to see you touch yourself," he whispered.

Talks with him always created vivid pictures for me, and I could see him clearly, standing in the shadows, leaning back against the wall, arms crossed, eyes fixed on Kristi running her hands over her body.

Like a long-time lover, I knew what excited him. I knew which places to touch, what words to say, exactly what buttons to push to make him helpless to his own lust.

So I knew that approaching him, turning away, and grinding my ass against the front of his boxers would drive him wild. I knew that watching me suck on my finger would almost overwhelm him with lust, especially if I reminded him that he could be doing that to my nipple, or I could be doing it to his cock.

"Now," he said. "Now use the dildo."

I wanted to lie down on the bed, but he wouldn't let me. He wanted me to stand in front of him. I described running the piece of silicon up and down my body, and finally pushing it inside myself little by little, working it in and out for several long, slow minutes.

He sounded as if he was in pain. He could barely speak as he told me to push it inside myself as far as it would go, and then he came up behind me and bent me over the bed. He reached inside me to pull it out, fucking me with it, making me groan and thrash, holding me down so I couldn't move.

I don't know why I didn't guess his intention, but at last he pushed the dildo deep inside me and slid his cock into my ass. Anal sex turns him on almost irrationally, so I should have known. People had talked about fucking me while a dildo was in my ass before, but never the other way around. It was a wild image, and we both enjoyed ourselves tremendously.

In the quiet aftermath, as we both caught our breaths, he said softly, "I don't care if you *are* faking this, it's still incredible."

"I'm not faking it," I whispered back.

Not exactly. The orgasm, yes. But money or no money, the sexual excitement, the heat – that was real.

Sometime after that I was telling him that I bought a new bed. He likes to chat about homey things like that. He asked if the new bed included a nice place to strap me down to.

"Of course!" I said, and indeed it does. I bought a headboard and footboard, both with lovely metal bars. Nope, not kinky, not me, just a regular bed from a regular store...

"Good," he said. "I was going to be upset if you'd forgotten that."

"Me too!" I exclaimed. "I've always wanted a bed like this one that I could get tied to."

He started to say something, then stopped.

"What?" I asked.

"I'm glad you got it," he said. "I feel like..."

He stopped again.

"Feel like what?"

"Like I sort of paid for part of that bed."

I was uneasy, not sure if this was good or bad.

"Um, a big part of it," I told him, giggling a little. It was true. As my best customer he probably paid for most of it.

"Cool," he smiled. "I like that. Now I feel like my phone sex money has gone to do something worthwhile for you."

6. Playing Rough

While I've always had rough fantasies, and wanted to attract callers that do, I went back and forth about whether to actually use the word "rape" in my profile. It's a highly charged word, and I worried that it might turn off the people who had rape fantasies but didn't want to admit it. Eventually I realized that I had to say it directly – after all, if I couldn't offer it, how could they ask for it? It was a good decision, I think, because many callers have mentioned specifically noticing it.

My first rape call was with a chatty, friendly guy who began by telling me that he usually speaks to Sally. This was a big clue for me. Sally is the barely-legal babe who just adores her Daddy. I resigned myself to another incest scene.

"How old is the girl in your fantasy?" I asked. He suddenly became uncertain, and stammered.

"16?" I asked.

Silence.

"It's okay," I coaxed. "14?"

"Yes," he said softly, "14 is good."

"Okay," I agreed. "14."

"It doesn't have to be a Daddy thing," he rushed to say. "Maybe a neighbor?"

I was enthusiastic about that idea, since neighbors are more to my taste than daddies. I started suggesting scenarios. He didn't seem interested in catching the neighbor girl sunbathing, nor in helping with her homework.

"How about if you caught her peeking at you through your window?" I suggested.

Ah yes, he liked that.

"What would you be doing?" I asked. "Undressing?"

"No," he said thoughtfully. "Maybe looking at dirty pictures."

He still seemed hesitant, though, and I wondered what he was embarrassed about.

"What if...."

He stopped.

"Yes?" I prompted, trying to sound warm and understanding.

"What if... when... we started getting... involved...."

He was having a lot of difficulty with this, which was surprising for a regular phone sex caller.

"What if... almost near the end... she... changes her mind?"

"Yes?" I asked, still waiting for the problem. He seemed surprised that I didn't already get it.

"But what if I did it anyway?"

Ah, that was it. Rape.

"Yes," I said cheerfully, "That would be fine."

He sounded startled. "What do you mean, fine? That would be okay with you?"

"Sure," I said. "In fact, I have lots of rape fantasies that I've never gotten to play with."

He didn't know what to make of this. I'm not sure he believed me.

"But... but... that's wrong... and... I mean..."

"Karl," I interrupted him. "Do you know the difference between fantasy and reality?"

"Of course I do!"

"And are you interested in really raping the neighbor's kid?"

He sounded appalled. "Of course not! Oh my god, of course not."

"So what's the problem, then? Fantasy is fantasy."

He took that in. "Do you really have...rape fantasies?"

"Really," I assured him. And then I knew what I needed to do to convince him. "Let me tell you about one of them."

And I did. I told him one of my oldest and darkest kidnap and rape fantasies, in enough detail to convince him that I wasn't making it up on the spot. He was fascinated. And aroused. He particularly seemed to like the part when I got bent over a chair and caned.

We talked for a bit, and he started to sound more comfortable, so I said, "If I were there with you, and I was bent over a chair and totally helpless, what would you do to me?"

"Are you sure?" he asked.

"Yes!" I answered. "I'm at your mercy. I hate you. All I want is for you to let me go. But you're not going to let me go, are you?"

"No..." he said quietly.

"Please, please...." I said equally quietly. I didn't want to scare him. "Please let me go. I'll do whatever you want, just don't hurt me."

He moaned.

"You're not going to hurt me, are you?"

He came alive, suddenly. "Oh, only... a lot." And he laughed – a sexy, evil laugh. Immediately we were in the fantasy, and it was hot stuff.

He tied me up, caned me all down my thighs, then threw me on the bed, and re-tied my hands to the headboard. He straddled my chest and fucked my mouth, then lifted my feet, still bound together, and caned me again with my legs up. I begged and pleaded and sounding convincingly like I was crying, because I somehow almost was. And then when, in the fantasy, I was broken and unable to resist anymore, he cut the bonds on my ankles and raped me, repeatedly, harshly, and with great relish.

This was the first time I'd ever played out a truly non-consensual rape fantasy myself, and I was relieved to confirm that it turned me on as much as I'd expected. When it was over, he was stunned, because I laughed and told him how much fun it had been. And meant it. He couldn't believe it. He couldn't believe that someone else could enjoy that fantasy with him – not just put up with it, but actually get into it with him.

I felt great about it.

I've had many other rape scenes since then, and some were easier than others. One guy wanted to be hiding in my closet as I was getting ready for bed, jump out and slap me around, cut my clothes off, and force me to do all manner of nasty things. (Comment from Trisha on the invoice: Ooh, did you get raped by Mr. Edwards, you bad girl?) Another guy wanted to watch a teenage Catholic schoolgirl take a nap. He undressed me in my sleep, fondling me until I woke up mostly naked with a strange man looming over me. Nice.

After a time, some rape fantasies became commonplace, even boring. Once I was supposedly tied facedown on the bed while the caller was describing what he was going to do to me. There was something about his voice that rubbed me the wrong way. I just didn't like him, and I was doing the phone equivalent of filing my nails during sex, waiting for him to be done.

"You can't see what's going on," he hissed. "You have no idea what's going to happen."

"Ooh," I lied. "Ooh, I'm sooooo scared."

"Suddenly you hear the door squeak open. You strain to listen, but all you can hear is faint footsteps."

Uh huh, yeah, fine, let's GO already.

"Your legs are spread wide, and soon you feel a warm, wet tongue licking at your pussy."

Time to switch on the heavy breathing noises.

"Ooh, yes..."

"And then, unexpectedly, you hear me whisper in your ear, feel my lips on your neck. Who is licking your pussy, you wonder?"

I had a little flicker of interest, but just a little.

"I yank off your blindfold, and you turn your head, desperately trying to see who is between your legs...when suddenly...you see...an *enormous German Shepherd licking your cunt!*"

I had to stick my head under a pillow to muffle my burst of semi-hysterical laughter.

If he'd asked me at the beginning if I'd do a scene with a dog, I would have said no. (This sort of "K-9" fantasy is actually quite common, it's just not to my taste.) If I'd been into it and had a dog sprung on me, I might have been upset. But as it was, it seemed pretty funny.

I managed to get back and keep my composure all through the description of being fucked by the dog. Luckily the caller was the talkative type. He didn't need me to answer him. As long as I moaned, he was happy.

But the prize for the most bizarre call so far goes to a guy known among the phone sex girls as "Demon Dan." I don't know how to begin to describe him.

Dan sounds like he's in his 50s or 60s, pleasant and articulate, and he called to ask if I really liked all those things I said in my profile. When I said that I did, he asked if I could scream. Screaming women, he said, make him come really hard. He said it casually, the same way you'd say that onions make you cry.

I told him that I was pretty loud, and he wanted clarification.

"But is it really screaming? Or just moaning?"

Hmm.

"Because I like real screaming, very loud."

I looked at my watch. It was after midnight.

"You mean, like, 'wake the neighbors' screaming?"

"Yes, exactly," he said. "You don't live in an apartment, do you?"

"Well, yes, I do."

"Oh."

He paused.

"Maybe this isn't such a good idea right now. Maybe I should call you back during the day sometime?"

"Yes," I agreed. "I can definitely scream louder during the day."

"Good, good," he said. "I'll call back on Saturday maybe. I wouldn't want someone to call the police or something."

He hung up. The police?

The phone rang on Saturday night.

"Hi Kristi, this is Dan. Remember me? I called a few days ago and…"

"Dan! Yes, of course. Did you find someone to scream for you?"

"Well, actually, no, I didn't."

I looked at my watch. After midnight again.

"I was going to try to call you back during the day sometime, but… how close are your neighbors?"

I considered. "Well, my bedroom is well insulated. I can probably stick my head under the pillow and shriek, but I don't think I can scream really loud," I said.

"It might work," he said. "Listen, are you really into those wild things your page says? I mean, rape and…"

"Yes," I said. "Really."

"Because what I like is really crazy."

"How crazy?"

He laughed nervously. "I've been doing this for twenty years. And let's just say that no one who talks to me ever forgets it."

I laughed with him. I was very curious now.

"It's okay," I assured him. "Tell me."

I hadn't gotten his credit card number or anything, I realized. But I knew he was a regular to the service, so I decided to just listen for a bit.

He hesitated.

"How about if I tell you what I don't do?" I suggested.

He sounded relieved. "Great, yes, that's great."

"I don't like blood. I don't do scat, or golden showers, and I'm not into animals, or stuff like that."

"That's fine, I'm not into anything like that. But I *am* into heavy pain, torture, that sort of thing."

"You don't want to cut pieces off me or anything, right? Not bloody torture?"

"No, no, nothing like that."

"Well then, I think we're fine."

"Well," he said, "have you ever had a thong burned off of you?"

"No," I said, "but it sounds interesting to me. Burned off with what?"

"A candle, probably," he said.

That didn't sound so bad. I've heard of people playing with fire and flash cotton. I pictured being face down on a table, him pulling up the string part of the thong and burning through it with a candle. It sounded scary and exciting, and I told him so.

He seemed less skeptical then. "Maybe," he said. "Maybe this could work. Do you have any toys?"

"Sure," I said.

"One more question," he said. "Do you like the Catholic school uniform thing?"

Oh, good, I thought. I'd been nervous, but if he was into schoolgirls then I could definitely handle it.

"Love it," I answered. "I even have a plaid skirt."

Okay, that was a lie, but I do *like* plaid skirts. I've thought about buying a plaid skirt, and even tried them on in stores. That counts!

He was quiet for a long moment. "Do you want to give this a try?" I asked.

"Yeah, why not?" he said. I could hear him smile.

"Great!"

"I have some stuff to do to get ready," he said. "I want to play you a tape of a scene I did once. I have this specific fantasy – kind of a ritual, a vigil."

"Ummmm…."

"Don't worry, you'll be fine. The tape was a scene I wrote and e-mailed to the two girls. It was the hottest thing I ever did."

"Okay, sure, I'll listen to it."

"Great. Let me give you the credit card stuff now, so you can run it while I'm getting my things together."

I was glad to hear that. I had been talking to him for far too long already. "Perfect."

He gave me his information, and then said, "I'll call you back in 15 minutes. Here's what I want you to wear: a tank top and skirt, with no bra, and a thong underneath. And socks and sneakers. Okay?"

"Sure," I said. Yeah, right.

"And I allow one candle, but otherwise the room has to be dark. Do you have a candle?"

"Yes."

"Great. And I want you to have a vibrator ready. I'll call you back in 15 minutes."

"Sounds good. I'll be here."

We hung up.

I called in for the credit card authorization and got out the vibrator. I figured out what I was supposedly wearing, and then decided to play along and light a candle.

I waited. It was sexy, waiting like that in the near-dark. I don't usually know when the phone is going to ring, so I'm normally going about my regular business. This was different, and I liked it.

I didn't have to wait long.

Ring. "Kristi?"

"Hi Dan!"

"Ready?"

"I think so."

"Great. Tell me what you're wearing."

"A light blue tank top and matching skirt. It's two pieces, but they match, so it looks like a dress when I'm standing still. But when I move, you can see skin."

I saw one of those on someone the other day. Why not appropriate it for myself?

"Oh, that sounds nice. Bra?"

"No."

"Good. And a thong?"

"Yes, dark turquoise."

"And shoes?"

"Yes, my Keds, with white socks."

"Perfect. Okay, and you have the vibrator and all?"

"Yes."

"Good. That's for you to use when you want. But first I want you to hear my tape, okay?"

"Sure."

"I made this tape with two other girls. I sent them the script. It might scare you a little bit. Or who knows, if you have rape fantasies, it might even turn you on!" He laughed a little bit. "But don't come or anything! Save that for later."

I giggled and promised.

"Here we go."

Scratchy tape noises. Then a girl's voice.

"I'm walking home from the gym. It's starting to get dark out, and I'm a little worried because I'm late. I have to be home before curfew! But I don't want to go back, because I hate having to wear my uniform. I like wearing these clothes with my cute little ass hanging out in back."

I didn't think this was very realistic dialogue, but I suppose that's a matter of opinion.

"I'm almost home now. Oh, no! There are lit candles in the windows. I'm scared of candles, because whenever the candles are lit, strange things happen. I've heard screaming and crying from other girls those nights, but it's never happened to me. I'm really, really scared, because all the other girls are gone for vacation, and I'm afraid that it's my turn."

Hmmmm. This was not quite what I imagined.

"I'm at the stoop now. Oh, I'm so scared! I'd better kneel down and say my prayers before I go in."

Then I heard the girl's voice start to pray. I recognized the prayers, but I didn't know any of them. After several minutes she stopped and said, "I have to go in, now. I just hope I survive."

Then the screaming started. I don't remember exactly what happened, but Dan was yelling ("Little bitch, where the hell have you been?") and the girl was crying, and a loud, strident woman's voice was directing the girl ("Get down the stairs to the basement, fucking slut, right now you little cunt!").

Most of the tape was of the two women, and the older, whom the girl addressed as "Blessed Holy Mistress," did the majority of the screaming. The girl mostly cried and begged and pleaded. It was all fuzzy, but they were beating her, shouting at her, and at one point apparently choking her with a rope; the girl coughed and sputtered convincingly.

I felt detached from the scene, and actually almost laughed a couple of times. It was too outrageous and bizarre to disturb me, but it certainly didn't arouse me. It was so strange and alien.

He didn't play me the whole scene – only a few minutes, enough to give me an idea of what he liked.

"You still there, Kristi?"

Dan had turned off the tape.

"Yes." I laughed weakly.

"You still game?"

Was I? Surprisingly, yes. I knew it wasn't going to turn me on, but I could do it. The really nasty stuff on the tape was from the woman, anyway, and she wasn't there.

"Um. Sure, Dan. One thing... I don't think I could really deal with the choking stuff."

"That's okay," he said. "We can leave that part out."

"Okay, great. Thanks."

"Let me tell you a little bit about my fantasy first. You're 15 and you go to Catholic school. You live in a house with other girls, and you all live with a retired priest, who acts as your mentor and disciplinarian. That's me."

"Yes, all right."

"I am to be addressed as 'Blessed Holy Master' and nothing else."

Oh my god, oh my god, just don't laugh, just *don't laugh!*

"You're walking home from the gym, and you're nervous because you see the candles in the window. And before you go in, you stop to kneel and pray. Do you know the Catholic prayers?"

"Ummm..." No, because I'm Jewish. Can't say that. There are no Jewish girls named Kristi. "No, I'm afraid I don't."

"Not Catholic, huh? I should have e-mailed them to you. No problem, just stop at the stoop and kneel down, and say a silent prayer."

"Sure, yeah, okay."

"And then you come in the house, and go up to your room... and then, well, then you'll see."

What the hell. I'm getting paid for this. He can't really hurt me no matter what he says. Go for it.

I started talking. I was walking home from the gym. I embellished a little bit, but since I didn't know his triggers yet, I told the story as closely to the tape as I could remember. I left out the part about my cute little ass hanging out of my clothing.

I knelt to pray, doing my best to keep my voice steady and not have a fit of giggles. He was breathing harder on the other end of the phone.

He spoke softly, "Now come in and go up to your room."

This was slightly different from the tape, so I started to improvise.

"I'm coming through the front door, slowly. I'm nervous, but nothing seems to be happening inside. All I want is to go upstairs to my room and take a shower. I'm walking up the stairs, still very scared, and then I open the door to my room and..."

He interrupted at that moment. "And I grab you, yanking you by the arm into the room. Where have you been, you little bitch?" he bellowed.

I thought I was prepared, but being shouted at was still unexpected, and I reacted involuntarily. My little girl voice came out.

"I... I was at the gym."

He didn't let me finish. "And what the fuck are these clothes? Where's your uniform, you fucking slut? Bitch, you'll pay for this."

He was shouting and I was trying to explain at the same time.

"I'm sorry... I just went to the gym, I was working out...I couldn't wear my uniform to the gym, I'm sorry, I'll never do it again..."

"I don't care what the fuck you were doing, you little whore! I don't ever want to see you dressed like a slut again. Look at you. I can see your tits, you fucking slut whore bitch. Get that fucking shirt off now."

And so it went. He continued to scream, I continued to cry and apologize. I can't say I remember most of it, because I didn't hear half of it anyway. He got my shirt off, slapped my breasts and my face, and dragged me down the stairs to the basement, all the while telling me how he was going to beat the hell out of me and teach me a lesson.

This was quite definitely not erotic to me. It wasn't upsetting, because it was so outrageous that I couldn't even identify with it. It was almost like watching a horror movie that's so awful that it isn't even scary.

When we got down to the dark basement, he ripped my skirt off and started shouting even louder. "What the fuck is this, you little cunt whore? Who the fuck told you to wear this fucking thing?"

"I'm sorry, I'm sorry, Blessed Holy Master <silent snigger>, all my other panties were in the laundry, please don't hurt me, I'll never do it again, I swear, I'm sorry..."

"You're damn right you're sorry, you'll be so sorry you'll never disobey again you little bitch, you little whore..."

He described dragging me over to the center of the room and put a large, lit candle down on the floor.

"Get that fucking thing off you right now!"

I reached for the thong to take it off, but he stopped me.

"Not like that, bitch. Stand over the candle, I want to see that goddamn thing burnt off you, little whore."

Whoa. This is not what I thought he meant by "have a thong burnt off me." Obviously it wasn't real, but for the first time I started to feel a little weird and anxious.

"Please," I begged, sounding more realistically upset. "Please, I'll take it off, I'll take it off, don't make me..."

"Too late, little cunt. Stand over the fucking fire *now!*"

He dragged me by the hair and held me over the flame. I stuck my head farther under the pillow, and screamed loudly. Louder than I expected to.

"That's right, that'll teach you, bitch. You feel that fire blistering your cunt? Yeah, you'll never disobey again, will you, you little whore? And I'm not through with you yet."

The next few minutes were hazy. He threw me down on the hard concrete floor and raped me, all the while yelling and beating my head against the floor. I said very little, just continued to beg and sob.

Most of it was just white noise to me. I really couldn't hear him that well over my own screaming anyway. At one point I sobbed, "Why are you doing this to me?" and he immediately shouted back, "Because you need to learn a lesson, bitch!" I was surprised – I hadn't realized he was still with me. I thought he was off in his own world.

More screaming, crying, shouting, and then unexpectedly, "You still got that vibrator, baby?"

Sob, sob, whine, "Yes!"

"Good, because we're gonna come now, you ready?"

Well, one of us is.

"Yes!"

"Here we go baby!"

If I thought he had been shouting before, that was nothing compared with this yell.

Whew.

It took a few seconds for everything to calm down.

"You okay there, Kristi?" Back to Dan the Nice Cheerful Guy.

"Sure." I laughed. "But now I see why you said no one ever forgets you."

He laughed too. "Well now you can say you really do all those wild things your website says. How are we doing on time?"

I checked. "32 minutes."

"Not bad for a first time," he said. "Have a good night, kiddo."

"You too, Dan."

I put the phone down and turned it off. That was plenty for one night.

7. Obsession

My first real feeling of failure as a phone sex operator came during my third or fourth call, from a company regular named Bill. He told me right off that he calls all the girls on the site, and he always looks forward to talking to the new girls. He seemed ordinary (most of them do, I've noticed) and he told me he had a specific fantasy. He wanted to watch another man fuck his wife.

That seemed pretty regular to me, and I asked, "What does she look like?"

"Who?"

"Your wife."

"Oh. I'm not married."

Ah. Not married, but his fantasy is to watch another man have sex with his wife. At the time it seemed strange to me, but I soon found out that it's common. People fantasize about non-existent sisters, girlfriends, bosses, and aunts all the time.

"Tell me about the fantasy. Are you there in the room with your wife and the other man?"

He described the fantasy as this:

He and his (fictional) wife are at a party. A large and very handsome man starts flirting with her. At first she seems uninterested, but he charms her until she agrees to go into the bedroom with him. Bill is either hiding in the closet or standing outside the bedroom window watching them from the shadows. He watches his wife get fucked by this gorgeous guy with an enormous penis, and watches her respond the way she never responded to him, her husband. He listens to her tell the guy over and over how good he is, how much bigger he is than her

husband, and how her husband will never satisfy her the way this guy does.

The telling, up until the last bit, was sort of sexy. I talked with him, asking him questions like, "Is it dark where you are?" and "Does it make you hot to watch them?" At the end of the story I asked, "And then what? Do you join them, or confront her, or masturbate watching them or...?"

"No," he said. "I just watch."

I was at a total loss. What do you say to that? I didn't know if he wanted to role-play with me being the wife, or what. Before I could say anything else, he hung up.

Now, it's not that unusual for guys to just hang up without saying goodbye once they're done. Donna warned me about that. But I didn't think he was done; I was pretty sure I just hadn't understood what he wanted. I felt badly about it.

I called Rachel and told her about it. Her number is right after mine on the site, and I suspected that she would be his next call. I hoped that being prepared might help her.

It did. He called her the next night with the same story. Having already heard the whole thing from me, she figured him out right away. He wanted to be humiliated. She asked him how he felt watching that huge cock sliding into his wife, knowing that he could never do that for her, and suddenly he was turned on.

Panting, he asked her what was the biggest she'd ever had, and she made up a story about her experience with a football player with an 11-inch prick. Apparently he went nuts at this, and spent the next few orgasmic minutes listening to her tell him how tiny he was and how he could never satisfy her as much as the football player did.

She called me later to tell me about it. It made her feel a little sad, she said. She didn't want to humiliate him. She wanted to give him a hug and tell him that everything was going to be fine. But no, he wanted to hear how insignificant and tiny he was.

"How did you know what to say?" I asked, amazed. "I would never have come up with that in a million years."

"Just a feeling," she answered. "I don't really know."

We were quiet for a minute.

"By the way," she asked. "How big is the average guy's penis? I mean, was 11 inches a good guess for a big one?"

I started to giggle, and a minute later I was laughing so hard that I couldn't stop. I managed to gasp out that, really, five or six inches is average, and that 11 inches is a freak of nature. She laughed too, and it was that sort of hysterical laughter that you just can't control. I guess both of us had been stressed from our first few days as phone sex operators, and this was the first chance we had to stop taking it so seriously.

We finally got ourselves under control.

"No wonder he was drooling," she snorted. "If he wanted humiliation, I did it even better than I thought!"

That caused a fresh burst of hysterical giggles, and I hung up promising to rent her a Jeff Stryker movie for our next "Phone Chicks Night Out."

My first real clue to this type of guy came when Trisha sent me an Instant Message one evening asking if I was available for a two-girl call.

Oh my god. My first two-girl call, and with the boss! Oh god. What do I say? I'll totally freeze up, she'll hear that I have no idea what I'm doing...

But I gamely said yes, and gave her my number. The phone rang almost immediately, and I jumped. I was scared, really scared, but it was just Trisha on the phone, by herself. Thank goodness.

"I thought I'd fill you in first. Matthew is in a hotel; we'll call him when we're ready."

Matthew is the classic powerful businessman/closet submissive, she explained. He calls Trisha about three times a week, and will do anything for her. He tells her all about his partners, his business dealings, his wife – anything she asks. If she wanted to, she said, she could take down his business with the information he's given her. I believe her.

"He's in love with me," she said, matter-of-factly. "He thinks I've hypnotized him. Wait until you hear his voice. He almost goes into a trance when he talks to me."

"Wow," I said. So articulate. Sigh.

She assured me that I could just follow her lead, and he would love me too.

"We'll tease him, mostly. I'll make him kneel down and do things to you, and touch his cock while we watch. Okay?"

"Sure," I replied. "That sounds easy enough."

"Yes, he really is easy," she said. "Probably we'll make him sit and then we'll stroke his cock between our feet. Matthew likes pretty feet. Ready?"

"Er...."

"Great, hang on. By the way, he doesn't know you'll be with me, so don't say anything until I introduce you."

She dialed the hotel and asked for his room. A self-assured guy in his 30s or 40s answered, the way you'd answer a business line.

"Matthew Elliot."

"Matthew, honey, it's your Trisha."

His voice altered radically.

"Hiiiiiii Triiiiiiiiiiiiisha."

He really did sound trance-like. He drew out his words, in a nice, soft, low voice, sounding for all the world like he was hypnotized or drugged. I don't think he was faking it. It was some sort of deep subspace.

"How are you, honey?"

"Gooooood, Triiiiiiiiiiiiisha."

"Did you miss me?" she demanded.

I learned so much from her on this call, and the first thing was that she wasn't emotionally involved. She didn't sound turned on at all, and she didn't relax into the scene. She sounded like a teacher dealing with a slightly difficult student – one she liked, certainly, one she had affection for, but one that needed a tight rein to keep him in line.

"Ohhhhh, Triiiiiiiiiiiiishaaaaaaaaaaaaaa, I missed you so much. I always miss you so much."

"That's my Matthew, such a good boy."

He moaned in pleasure. Matthew was very responsive, though not particularly verbal.

"Are you touching yourself Matthew? Are you nice and hard for me?"

"Yes, Triiiisha, oh yes."

"Kneel down on the floor, Matthew. Kneel with your knees apart and your hard cock in your hand."

There was a rustling sound, as if he was moving to the floor.

"Are you kneeling?"

"Yesssssss, Triiiiiiiiiiiisha."

I stayed quiet, listening.

"Matthew, you've been such a good boy lately that I have a surprise treat for you."

"Whaaaaaat is it?"

"Say hello to Matthew, Kristi."

My cue! I kept my voice smooth and low. "Hello, Matthew. I've heard a lot about you."

"Hi Kriiiiiisti."

"Have you seen Kristi's pictures on the site, Matthew? She's the very beautiful redhead."

He became very excited. "Yes, Triiiisha, yes I have. You're soooooo beautiful Kristi."

"Thank you, Matthew."

"Kristi," said Trisha politely, "stand in front of Matthew. Matthew, I want you to lick Kristi's pussy."

"Ohh, yesss Trisha."

I obligingly made little gasping and moaning noises, while Matthew obeyed. She continued talking to him the whole time.

"I'm taking the tip of my shoe, Matthew, and putting it right in the crack of your ass, pushing you forward against Kristi. Lick her faster, Matthew, do a good job for Trisha."

A few minutes of that, of me encouraging him and Trisha describing what she was doing to him, and Matthew started to groan loudly and continually.

"How do you feel, Matthew?"

"Fiiiiiiine, Trisha."

"Then why are you moaning, Matthew?" There was definite amusement in her voice.

"I need to come, please, please."

The voice became soothing, sympathetic. "You need to come, Matthew? You ache, my baby?"

"Yesssss, Trisha."

"What do you think, Kristi?"

"Oh, I think he can wait a little longer." I was getting into it now.

"Noooooo Kriiiiiiiiiiiiiiiiiiisteeeeee..."

"Turn around, Kristi, let Matthew lick your ass."

Eventually she let him come, and he moaned and groaned and laughed. "How do you feel, Matthew?" she inquired.

"I feeeeel wooooonderful. The twooooo of you aaaaaaaaarrrrrrre wooooonderful."

"Who do you love, Matthew?"

"Triiiiiiiiiishaaaaaaaaa. I loooooovvvvve Triiiiiiiiiishaaaaaaaaa."

It was a little creepy. But I smiled, figuring we were done, and I'd survived.

He was breathing deeply, recovering from his orgasm, when Trisha said, "Matthew, why don't you tell Kristi about your dream."

He didn't say anything right away, so I chimed in, "Oh, yes Matthew, tell me about your dream."

"Welllllllllll I dreamed that Trisha and Donna and Sally came into my room while I slept and hypnotized me. They implanted things in my brain."

"What kind of things?"

"Welllllllllll like if I light Trisha's cigarette and she blows the smoke in my face..." he trailed off.

Trisha broke in. "Go ahead, Matthew. Light my cigarette right now, let's show Kristi what happens."

He groaned.

"Light my cigarette, Matthew."

"Yesssssss, Triiiiiiiiiiishaaaaaaaaaaa."

She made the sound of inhaling deeply, then blowing out air. Matthew reacted strongly, moaning loudly, almost as if he were in pain.

"Matthew, tell Kristi how you feel."

"Ohhhhh, Kriiiiiiisti, I'm so haaaaaard."

"Mmmmmmmmmm," I said. "I like that, Matthew."

He moaned again. "And then the woooooord," he said. "Whenever I hear the woooooord..."

"What word is that, Matthew?" I asked.

"She knows," he gasped. "Trisha knows."

"Yes," Trisha answered. "I've implanted a word in Matthew's brain. A post-hypnotic suggestion. It makes him need to come, doesn't it, Matthew? And not just if *I* say it."

Matthew agreed. "Because Triiiisha isn't always home. And now if aannnnyyyyyy of her girls says it..." He didn't finish the sentence.

"Maybe I'll say it now, Matthew. But don't come until I let you."

He made a strangled sound.

"Sssssssex," said Trisha.

"Oh god..." Matthew moaned. I could almost hear him writhing around, trying not to come.

"Ssssssssex, Matthew," she repeated. "Do you want to lick my ssssssex?"

"Oh Trisha...oh please..."

"Doesn't that work nicely, Kristi?"

"It certainly does," I replied, bemused but somewhat fascinated. "Matthew, would you like me to say it?"

"Ohhhh....ohhhh Kristi..."

I took that as a yes. I imitated Trisha's inflection carefully. "Ssssssex."

He was gone so deep that he couldn't even answer.

"Now before I let you come, Matthew," Trisha said, "I want you to do something for me."

Silence.

"Matthew!" she said sharply.

It was obviously difficult for him to focus. "Yess, Triiiiiisha."

"Aren't Kristi's toes pretty? Kristi, put your foot in Matthew's lap."

"I just had a pedicure, Matthew. Do you like it?"

"Ohhhhhh god... yesssss...they're beautiful... Triiiiiiiiiiiishaaaaaa, pleeeeeease!"

"Be a good boy, Matthew, and suck on Kristi's toes."

He was gasping as he made sucking sounds into the phone.

"Oh, that's lovely, Matthew," I said. "Such a good boy."

I didn't know it, but that's another of Matthew's triggers. Call him a good boy and he just about goes insane.

"Yes, he's a good boy," said Trisha, "and now he'll be rewarded. We're going to take your cock between our feet, Matthew."

He was groaning, thrashing around.

"Sssssssssex, Matthew," she said.

"Sssssssssex, Matthew," I said.

"I.... I... can't... can't... oh... god..."

"Come for us, Matthew. Come all over our pretty feet."

Twice in 15 minutes. Impressive, I thought.

Trisha laughed. "I think poor Matthew needs a rest, don't you, Kristi?"

"I suppose that's fair," I conceded.

"Matthew, how are you feeling?" she demanded.

"I...I... am the luckiest man in the wooooooooorld," he said. "Thank you Trisha. And thaaaaaank you, Kriiiiiisti."

"My pleasure, sweetie," I smiled.

Matthew called me directly once or twice. The first time we only spoke for a minute or two. Someone was at the door, he said. We didn't get very far into the call, and he never slipped into his hypnotic state. I had trouble equating that confident business voice with Trisha's little slave.

The second time he called I asked him to tell me about himself. He was pleasant and articulate, and more than happy to oblige.

Matthew is married. He and his wife have grown apart, and haven't had sex in a long time. I asked whether he'd ever approached her with his submissive fantasies. No, he said, never. I suggested that she might actually be interested if he gave it a try.

"She's interested in spending my money," he replied tightly. End of subject.

He told me a bit about his business, which he started with a partner only a few years ago. Something to do with computers. We quickly got onto the subject of Trisha and his fantasies.

"It all started a few years ago," he said. "I was on the Internet and I found a story about a man being hypnotized by a woman. She took total control of him."

Unlike most submissive men I've talked to, his desires don't go back as far as he can remember. He told me that he'd never even considered being dominated before he read this story. It changed his whole perspective on life.

No wonder his relationship with his wife changed, I thought. I didn't say it.

"I became obsessed with this story," he went on. "The woman dominated him intellectually, sexually, and in every other way. She hypnotized him so that he couldn't resist. Eventually she had him so deeply

under her spell that she made him sign over his business and all his assets."

I giggled a little at that. He didn't.

"After that I started looking around, reading other fantasies, trying to find ways to enact that story. Eventually I met Trisha and she... well, she's pretty amazing." I dutifully agreed.

"I dream about living that story," he said.

"But it's a game, right?" I asked. "I mean, being dominated is hot, but you don't actually want a woman to make you sign over your assets or anything..."

There was a long silence. He spoke softly, and I could tell he was almost embarrassed. "Actually, that's why I started my own business. So it could really happen."

Oh, dear god, I thought, he's serious. I'm a firm believer in everyone's right to explore his or her fantasy, but this man has all sorts of obligations – a wife, business partners, and multi-million dollar government contracts. Trisha told me long ago that she knows more than enough about his business to blackmail him if she wanted to. He has no idea how lucky he is that the woman he chose to play with is honest.

Or maybe he'd rather she wasn't. I really don't know.

Anyway, the call was actually sort of sexy. The hypnotized voice made its scheduled appearance, but it didn't seem nearly as weird when I was in control of the situation rather than an observer. Or maybe I was just used to it by then.

Trisha called a few weeks later.

"I have Matthew on the line," she began. "But it's different this time. He doesn't know I'm talking to you. He thinks I'm in the bathroom." She paused for a second. "At least, I didn't tell him I was calling you. He might have guessed."

"Yes?" I encouraged, wondering why she sounded so nervous.

"You're going to be Sandra," she said. "Matthew's wife."

Oh god.

"His wife?"

"Yes. You're going to walk in and catch him in bed with me."

"Ummmmmm. All right. Am I... angry? Or turned on?" I asked, grasping for the basics.

"Angry," she answered. "The classic irate wife. But then I'll probably make you my slave, too, and make you watch us or something." She laughed.

Talk about edgy! But then, no one ever said the life of a phone slut would be conventional. I wanted to ask more questions, but she didn't give me time.

"Remember," she warned, "don't say anything yet. He doesn't know you're here."

The phone clicked, and we were on.

"Sorry, Matthew, honey," she cooed. "I just had to pee."

"Hiiiiiii Triiiiiiiiiiiisha."

I was quiet. I didn't know exactly when I was supposed to break in, so I listened, hoping for some sort of signal.

"Matthew," she said softly. "Make love to me, Matthew."

It was a very different kind of scene. She was tender and loving, guiding him gently. I didn't know if this was entirely new for him or not.

I also didn't know when to jump in. I didn't want to break the mood too soon, but I didn't want to make her wait too long either. Damn, why hadn't I asked her for a signal?

I let them go on for two or three minutes, and then finally decided that I could wait no longer.

"Matthew!"

My voice was sharp, strident.

"Yessssssssss?"

He thought it was Trisha talking to him.

"Matthew, what you doing with this woman?"

He was disoriented.

"Whaaaaaaa?"

Trisha answered. "Ignore her Matthew."

"Matthew, stop it this instant. How can you do this to me?"

"Who... whooo's that?"

"What are you doing with that slut in *our bed*?"

There, that ought to clear that up.

Pause.

"Sandra?" he asked, timidly.

"Well, well," I answered, my voice dripping with sarcasm, "I'm glad to see you still remember."

"Don't listen to her, Matthew," urged Trisha. "Make love to me."

"I just can't believe this. I come home a little early, and what do I find in my own house?"

He was flustered. "Sandra, I..."

Trisha broke in. "If you knew how to take care of him, he'd be with you right now. But you don't, and now he's mine."

I really didn't know where this was going. Was I supposed to beg Matthew to come back to me? Storm out in a huff? Join in? Become a domme wife and whip him into submission?

Trisha's voice softened. "Matthew, my sweet, don't listen to her. Stay with me."

I took that as a cue to keep going. "How long has this been going on?" I demanded. "How could you bring her here to our house, to our bed?"

"Well," he answered softly, "we never use it."

My heart contracted for him. So much pain everywhere. I went on, but I really didn't want to.

"That's not the point. We're married and..."

Luckily Trisha rescued me. She laughed a nasty laugh. "He belongs to me now, Sandra. There's nothing you can do. You can't touch him now."

Matthew's breathing got louder.

"He's all mine. Maybe I'll make you mine, too."

I gave a little moan, feeling on safer territory.

"You'd like that, wouldn't you, little bitch?"

It went on from there. He was her slave, I was her slave, we were all one big happy dysfunctional slave family. She directed us to serve her for the next few minutes, treating him lovingly, and me contemptuously. I thought she was going to force me touch him, but she didn't.

This was actually my first two-girl call that involved direct sexual contact with another woman, but it turned out to be no big deal. Trisha doesn't require articulate responses, just moans. I've gotten very expressive with my moans, I think, and faux-moaning for her felt no different from faux-moaning for a guy.

In due course Matthew was finished. I was quiet again as he said goodbye to his Trisha. Just before he left, he asked, "Triiiiisha? Who...who wasss that?"

"Why, what do you mean? That was Sandra, Matthew."

"Ohhh. Ohhhkaaaaay."

And he hung up. Trisha and I remained to chat.

"Quite a scene," I observed.

"Yeah." She laughed. We talked about inconsequential things for a few minutes, and then she said, "Matthew told his wife about me."

I was stunned. "What?"

"That's what he said. He told his wife he's in love with me."

"Oh my god. Do you think he really did something that stupid?"

She fretted. "I don't know. God, I hope not."

I couldn't get over it. "He told his wife that he's in love with a phone sex girl?"

"Yeah. That's what he told me, at least. He said she thinks he's gone insane."

I exploded. "Of course he's gone insane! "

"I know."

"I mean, doesn't he understand that you aren't the girl in the pictures?"

"I don't know if he does or not," she said. "I just don't know."

Addendum

An afternoon a few days later.

"Hello?"

"Kristi?"

"Yes, this is Kristi."

"Kristi, this is Matthew. Um, Trisha's Matthew."

"Oh! Hi, Matthew, how are you?"

"Fine, thanks. Listen, Kristi, the reason I was calling is that I wanted to thank you. For...well, for the other night."

"Oh. I..."

I was totally flustered. The whole experience had been weird for me, and I didn't know what Trisha told him afterward. I had no idea what to say. I had one of those "extended time" moments where I ran through 15 possible answers in my head and finally ended up with:

"You're welcome." (Classic, no?)

"I didn't know it was you at the time and... well... it was pretty incredible."

I was getting more and more uncomfortable. It crystallized for me at that moment. I didn't think that it was right for Trisha to have brought me in on that call as Sandra. I was surprised to discover myself feeling that, but somehow it felt like a crossing a line I shouldn't have crossed. I didn't feel right about it at the time, and I felt even less right about it now that he was calling to thank me.

"Matthew, I..."

I hesitated again, not knowing quite what I wanted to say. "I wasn't sure if it was okay or not."

"What do you mean?" he asked.

"The call. I wasn't sure it was okay to do it or not."

"Why?"

"Well, she's a real person," I said. "Your wife, I mean. I didn't know if... I mean, I trust Trisha and all, but still, I wasn't sure..."

I was babbling. I didn't realize until afterwards that Kristi and I were both trying to talk at the same time.

"No, no," he assured me, "Don't worry about it. It was great. Trisha always knows just what to do."

"Okay," I said.

I was silent for a minute.

"Is everything all right?" I asked.

It just came out. I don't know what I was trying to do. I'm not sure if I wanted him to tell me about his wife, but even as I said it, I knew it was stupid. His marriage is none of my business. It has nothing to do with Kristi, and it *certainly* has nothing to do with me.

"Yes," he said. "Yes, everything is fine."

Somehow there was a genuine moment of connection there. Two real people. I could feel the difference. Maybe he's not insane. Maybe he really is aware of the game.

I knew better than to push it any further.

"Okay. Good."

Who knows? Maybe from his point of view, everything *is* fine.

8. The Telltale Panties

From: Sally
To: All Operators
Subject: Mailed-Out Panties

Just to let you guys know, I mailed out a pair of panties about a month ago, and as usual, I didn't use a return address. I just wrote "Sally" in the corner of the envelope like I always do.

Well, anyway, my poor guy finally got them, after waiting a very long time. It turns out that the post office decided it was a suspicious package and opened it! They sent him a big envelope, containing my original envelope placed in a plastic bag and my panties in a separate plastic bag, all repacked. How embarrassing.

From: Trisha
To: All Operators
Subject: Reminder

Girls, if you sell things (toys, panties, bodily fluids) make sure you write a nice little note thanking the customer for their order. Also say that the item is for entertainment purposes only and not to be used orally.

One of the things that freaked me out the most when I started this phone sex stuff was a mention on the company website of panties. "Yes! We have panties!" and "Free panties for first time callers with a 20-minute call!"

I just don't get that at all. I have *never* had the desire to own a guy's used shorts. I just don't understand why anyone would want my worn panties. I suppose there's a fetish for everything, but is it a common enough interest to be "free for first time callers?" Apparently so. Lots of other websites say the same thing.

I was worried about it, but Donna assured me that she's never had to do it. No one is interested, she promised. One guy asked once, but she never sent them, and he didn't seem to care.

A college kid mentioned it to me online. Kristi isn't wearing panties in many pictures and he wanted to see one of her wearing them. I obliged, and he was ecstatic. He wanted to call me and have me send him the panties I was wearing when we talked. Warily I agreed that I could do it, and prayed that he would never call. He didn't.

Nonetheless, I was worried. Someone was interested in my panties. Let's forget for a moment that I couldn't get a leg into a pair of panties the size that Kristi would wear, I just thought it was gross. I don't like the way my dirty laundry smells. Why would I want to send it to someone?

I was a bit panicky about it, and a friend suggested a solution. Go to Wal-Mart, she said, and buy a cheap pair in Kristi's size. Then rub some musky perfume on them and leave it at that.

Good idea. I knew I couldn't just send a clean pair, and I surely didn't want to send a used pair. Musky perfume seemed like a good compromise. It would give the guy something sexy to smell that wasn't me. Perfect.

I relaxed. Then the phone rang a week later.

"Hi Kristi, this is Charles."

"Hi Charles!"

"Kristi, Trisha gave me your number. I talk to her often, but she's gotten busy lately and she recommends you highly."

"Oh, wow, that's nice of her!" I was incredibly flattered, actually. The boss recommends me highly! I'm a *good* phone slut!

"I usually order panties from her. I love the way she smells. But she said she's busy these days, so I thought I'd call you instead."

Oh god, my worst nightmare. Someone calling specifically for panties. Worse yet, a self-proclaimed "panties connoisseur" who would definitely not be fooled by a little perfume.

I don't remember much of the call. Lots of it was spent with me frantically trying to figure out how to not offend him and not offend Trisha and also not send him my panties. Er, Kristi's panties.

It was a long call, and he was fairly chatty. I did tell him that I'd never done panties before, and he was delighted. He had specific instructions about them:

• The panties have to be cotton. Any color is fine, and some lace trim is fine, but no nylon and no silk.

• Wear the panties for as long as I can. Days. Ideally for three days.

• Sleep in them. Go to the gym in them. Sweat as much as I can.

• Try not to shower.

• Masturbate in them at least a couple of times.

• When they're ready, and I look at them and feel that they're too icky to send, don't get scared. That's just the way he likes them.

Once they're sweaty and wet and ready:

• Wrap them tightly in plastic wrap (*not* in a plastic bag, then they'll smell like the bag) and make sure all the air is out.

• Put them in the freezer for an hour or so. Yes, the freezer – it helps to preserve the aroma.

• Take them out of the freezer and put them – still wrapped in the plastic wrap – into a ziplock bag, and then into an envelope.

• Send them via overnight mail and bill him for it. If he's lucky, when he gets them, they will still be damp.

We talked for almost an hour, and I felt more and more trapped. The longer we talked, the more I felt like I couldn't turn him down. He asked me lots of personal questions, particularly about pubic hair (did you know that pubic hair holds the sweat better?) and he kept asking me to describe my pussy in more detail.

I find this to be a difficult question in general. Lots of guys ask it, and I never really know what to say. How many different attributes does a pussy have? I can talk about the color of the hair, I can talk about its state of wetness, and then I'm pretty much stumped. Once a guy asked me how deep my pussy is. I wondered if there was an official unit of measurement for this. (When I asked one of my friends, she suggested using a carrot.)

I always suppress the urge to put on my best Valley Girl voice and say, "Well, it was born in West Virginia, it's a Gemini, and it likes long walks on the beach..."

We did get more sexual near the end of the call, and I did enjoy him. He turned out to be a macho type – Harley, leather jacket, lots of guns. I don't know what I expected from a guy who wanted my panties, but that wasn't it.

Anyhow, I wrote to Trisha afterwards, thanked her for the referral, and asked if she really did all that stuff about the freezer, hoping against hope that she'd say no.

She wrote me back and confirmed that I should do exactly what he said. (Shit!) She also mentioned that he's a very regular customer. He'll call back and check on the panties a few times, she said, and I should charge him for those calls too, just as regular calls. He's a pain in the butt sometimes, she said, but a good caller.

Shit. A real dilemma. I can't begin to explain how much I did not want to do this. I hated the idea with a passionate intensity. First there was the problem of sending a package from my local post office. I had figured to forward panties through Trisha, but if he wanted overnight delivery I couldn't do that. It wasn't a huge problem, really. I'd use the company's return address, and the only really trouble might be the postmark. But he wouldn't be able to find me from a postmark.

The real problem was that I was just repelled by the idea. I don't consider myself a prude by any means, and I suppose if I analyze my absolute mental rejection of the concept, it was the fear that he wouldn't like the way I smell. I mean, I didn't like the idea of sending a piece of myself and my DNA to a stranger halfway across the country, but the real reason is that I was terrified he'd call back and say, "I love the way most women smell but you're the exception." Or something.

I sought advice from my oh-so-helpful friends.

"Don't think of them as used underwear," suggested one. "Think of them as frozen pantysicles."

Another's advice: "Buy a three-pack and wear them all at once. Then you can just freeze all three pairs and defrost the other two when you need them."

Charles called the next night to "check on his panties" for another hour, and by that time I knew I was committed. I didn't want to disap-

point him, but even more, I didn't want to let Trisha down. I wanted her to continue to recommend me to people.

I found myself promising him that I'd buy a new pair the next day, Memorial Day, at one of the sales. I pushed the distaste away, and concentrated on trying to eroticize the idea with him. It worked for a little while, until he mentioned putting them in his mouth.

Oh. My. God.

I freaked out at dinner with Rachel and Donna. *I do not want to send my panties to this guy.* We half-hysterically tried to think of some concoction in which to soak the fabric. Pickle juice? Perfume and cantaloupe? Donna was sure we could find something, but I knew we couldn't. In a semi-irrational moment, I actually considered trying to *hire* someone to wear the panties. Rachel suggested that I fold them up and just wear them inside my own panties, and as horrified by the idea as I was, I knew that's what I was going to have to do.

I made Rachel go panty shopping with me. There was a wide selection of lingerie, and I picked out a pair of cute black undies – cotton, with two little elastic straps at each hip. Conservative, yet sexy. In...what size? I had absolutely no clue. I was never Kristi's size. But hell, I made up a height, age, and measurements for her, why not a panty size? I bought a size five, having no idea if I was even close.

Surprisingly, he didn't call that night, but I was glad. I wasn't ready to start dealing with the reality yet. I dropped the panties on my desk next to my computer and tried to ignore them.

Tuesday morning they were still looming at me. I picked them up and sniffed them. Plain new cotton smell. I put them down and went to work.

Tuesday night I was determined to make progress. It was a hundred degrees out and I came home from the office sweating. I picked up the panties and wiped my forehead with them. Enough progress for one day.

I saw Trisha online and asked her if she really wore the panties for three days. My eyes swam with relief when she said she didn't actually wear them at all. Hallelujah! Saved! I looked anxiously at the screen to find out her secret.

"I never wear them. I just stick them up inside myself when I go to sleep one night."

So much for salvation. I picked up the panties and sniffed them delicately. A barely perceptible, very faint sweat smell. I probably imagined it, but it was encouraging nonetheless. I wiped my forehead once again and headed for bed, leaving the panties in their regular spot on the desk.

Wednesday. The panties mocked me from their resting-place. "You don't have the guts to take me with you," they whispered. They were right.

I determinedly ignored them.

He was going to call that night. I just knew it. And he'd want to hear about the panties. I couldn't tell him that they were still sitting on the desk. And once I was supposedly wearing them, the clock was ticking towards three days and overnight mail.

I burst into my apartment after work, ripped the panties from their spot on the desk, and boldly blotted my entire body with them. I discarded my work clothes, put on a pair of shorts and a t-shirt, and defiantly stuffed Kristi's panties down inside my own before I could change my mind. I was on the job.

I wouldn't actually have to wear them outside, I decided. I could just wear them around the house, maybe for a few calls, and that would have to do. Yes, perfect, that would work.

The phone proceeded not to ring for the next five hours.

At one point I popped online hoping to drum up some business, but all I found was Donna with her latest "kootchy formula" suggestion of olives and tuna fish.

Finally at 11 p.m., the phone rang. Charles. Of course.

"Charles, I'm wearing your panties!" I exclaimed triumphantly.

I thought he was going to have an orgasm right then. "Tell me about them," he said excitedly.

I described the fabric, the design features, and my experience picking them out with Rachel. He listened politely and then said, "No, *tell* me about them. Pull them down and tell me what they look like."

Bleh.

I'd been shy and reserved through all our calls, and I think he found my embarrassment to be charming. I managed to stumble my way through a description of what I thought they'd look like if I'd really been wearing them all day, and then the conversation turned to sex.

He talked about how eager he was to get the panties, how he was looking forward to touching them, holding them, and smelling them. None of this appealed to me. But then he mentioned how aroused he was talking to me while I was wearing them, how he wanted to hear me touch myself while I was wearing them, and then call me once he got them. Something clicked just a little bit for me – not about the panties themselves, but about the idea of talking to someone who was holding a piece of me at that moment.

I started to find the idea just a tiny, tiny bit sexy. He must have sensed the change, because he shifted into high gear. He was really getting off on the idea of my touching myself through the panties I was about to send to him, and I suggested that he might touch himself with the panties when he got them. Maybe he could call me, I suggested, and talk to me while he touched himself with my panties.

This apparently never occurred to him before, and he loved the idea. I kind of liked it too. For some reason it didn't give me the same sense of distaste that the idea of him smelling or licking them did. We had a nice, sexy time talking about him masturbating with the panties while on the phone with me, and I was relieved to finally find a way into this kink.

For about five minutes. Until he mentioned sending me back the results of his, ah, labors. And then we were back to repelled.

He left me that night with endearments, and directions to wear the panties to the gym the next day and get them really sweaty. He gave me "Overnight Saturday" shipping instructions and a promise that he wouldn't call me if he didn't like the final product. (Okay, so I'm paranoid, but I just did *not* want to hear about it if he hated them.)

Thursday. I absolutely could not bring myself to wear them during the day. They really were starting to smell distinctive, and surprisingly, it was not an unpleasant aroma. But I felt like if I took one step out of the house with them on, every person for miles around would know what I was doing. I could picture it. Kids pointing. Dogs barking and jumping on me. No thanks. I left them home.

Thursday night. Crunch time. They had to go in the mail Friday morning. I took a few calls, some of them even quite erotic, but I unaccountably developed shy glands. I've heard that some men can't urinate in public restrooms; perhaps this was a similar phenomenon. In des-

peration, I took Trisha's advice and, not quite believing I was doing it, pushed them inside me before I went to bed.

I tossed and turned and restlessly didn't sleep. At 3 a.m., I'd had it. I yanked them out and tossed them across the room. I needed my rest. And I had to get up early to go to the post office.

Friday morning. Time for the freezer. I was worried that they were just not sweaty or wet enough – since the middle of the night they seemed to have lost the little wetness they possessed, though they still retained my, ah, aroma.

Whatever. They'd have to do. I went into the kitchen to discover... no Saran Wrap! Yes, I swear. Could this happen to anyone but me?

I considered. There was no time to go out and get some, come back, and put them into the freezer. Could I stop at the store on the way to work and then put them into the freezer no one uses in the office? God no.

I looked frantically around the kitchen. *Something* must be wrapped in plastic wrap! It was totally ridiculous. I found a packet of Friskies dry cat food – a bunch of little boxes wrapped up in plastic. I sniffed the plastic. It didn't smell like cat food. It wasn't exactly Saran Wrap, but I couldn't be choosy. I turned it inside out, chucked the panties into it, and threw the whole thing into the freezer.

I showered, got dressed, and gathered my supplies. I still had to stop at the store to buy Saran Wrap – I couldn't send them in cat food plastic – but I put together the addresses, a ziplock bag, an envelope, and my "nice little note" reminding my customer that the panties were for entertainment purposes only.

I pulled the packet out of the freezer and sniffed cautiously. I was surprised – the freezer actually did do something. The smell was the same but somehow more intense. I'll be damned.

I was only worried because they really didn't smell sweaty. I mean, this guy thinks I went to the gym in them. Why was I obsessing this way? I had no idea.

It had been a hundred degrees all week. I tried not to think about what I was doing as I stuffed the panties inside my bra underneath one breast. Sweat, here we come. But of course, for the first time in a month, the temperature was a brisk 60 degrees.

I walked into the supermarket, certain that everyone there was staring at me, knowing that I had panties in my bra. Used frozen panties. I grabbed the Saran Wrap and realized that no one buys *just* Saran Wrap at eight o'clock in the morning. It makes no sense. But I couldn't think of anything else that I needed.

I walked back to the car in the lovely, cool breeze. Fuck it all. I whipped the panties out of my bra, not caring who was watching me through the window, Saran Wrapped 'em, ziplock bagged 'em, enveloped 'em, and set off for the post office.

I carefully perused the choices and settled on the Express Mail envelope, squishing my little package inside. I screwed up two labels by writing part of my real return address on them, and then messed up a third by signing my real name on the "leave without signature" line.

But I did it. I sent them.

Saturday. Charles said he wouldn't be home until about 5 p.m. I paced anxiously all day long, waiting for the review. By midnight he still hadn't called. I was starting to get worried.

Sunday. No call. I rationalized. Did I really want him to like my panties and continue ordering them from me every month? No, of course not. It's better this way. Why do I care what some stranger-pervert thinks of my panties? Good riddance.

Oh god, he hates my panties.

Monday. Still no call. My worst nightmare. I am the least sexy person in the entire universe. My panties are disgusting. How could I have sent them to him? I bet he's calling Trisha right now, warning her not to let me send my toxic underwear to any other unsuspecting customers. I ate chocolate.

He finally called on Tuesday, apologizing profusely for the delay, and telling me how much he loved my panties. They smelled wonderful. He was very happy. He was calling from his office, but he couldn't wait to get home and call me while holding the panties in his hand.

I was relieved and embarrassed and annoyed all at the same time. He teased me about being the only person in the entire world whom I've never met who knows my scent. That was half-sexy again. We talked about what we'd do when he got home later. He mused about the idea of ordering panties from me and from Rachel at the same time, and seeing if he could tell them apart just from the smell. (Oh great, I thought.

She'll *love* me for that.) He hung up promising to call as soon as he got home.

Oddly enough, I haven't heard from him since.

Though his name and number did pop up on my caller ID a few days later.

"Hello."

"Rachel?"

"No, this is Kristi."

"Oh." (Silent thought: Charles, I know this is you. I have caller ID.)

"This isn't Rachel's number?"

"No, this is Kristi." (You remember, the person whose panties you have...)

"Oh."

"Would you like Rachel's number?" (You bastard who can't even admit that you made a mistake and say hello like a civilized person?)

"Sure, thanks."

I gave it to him, and he hung up. I didn't embarrass him by letting him know that I knew it was him. He's a customer, after all. And besides, now that I knew that my panties were acceptable, all I really wanted was for him to go away. And now he's going to be Rachel's problem. Oh darn.

9. More Bang for Your Buck

In order to get the most from your phone sex experience, you as the customer have a few responsibilities. (Yes, yes, I know you're paying, but you still have to help.)

First and most important, *tell the operator what you want.* It sounds simple enough, and for some people it's easy. Some callers just go ahead and say, "Hi Kristi, I'd like for you to role-play that you're Mother Goose and I'm a firefighter, and when I come over to put out the fire in the giant shoe, you recite nursery rhymes as I eat your pussy."

Great! Fantastic! Now I know exactly what to do. If you have a fantasy like this and you're too shy to tell me about it, it's likely that you'll have a tough time having it fulfilled. Face facts – no one is going to be able to guess that one. Try writing your fantasy down and reading it to your phone sex girl, or sending it to her in e-mail. She probably won't find it as strange as you might think.

For some people verbalizing their fantasy is next to impossible, mostly because even they're not sure what they want. I've had my share of these calls too:

Me: What would you like to talk about?

Caller: Oh, I don't know, I'm just horny.

Me: Great! What do you like to think about when you're horny?

Caller: Oh, I don't know. Just sex and stuff.

Me: Well, honey, what kind of sex do you like?

Caller: I like all kinds of sex.

Now imagine this scenario with the same dialogue, only imagine it happening in Home Depot:

Salesgirl: May I help you?
You: Yes, I want to buy some stuff.
Salesgirl: What kind of stuff?
You: Oh, I don't know. Stuff for the house.
Salesgirl: Where in the house?
You: Oh, I don't know. Anywhere.
See the problem?

If you talk to a dispatcher, it's particularly important to tell her what you want straight out, because she'll be routing your call to a specific worker based on what you say. If you want a naked teenage girl to stomp on your balls wearing stiletto heels while chewing bubble gum, say so! Don't be embarrassed – the dispatcher has definitely heard it (or something kinkier) before, and there's no point in her sending you to someone who won't talk about what you want.

Once you get started, *be an active participant in the call.* You may not want to talk much, and that's fine. If you'd just like to listen, we don't mind. But it really helps if you let your phone sex girl know that the call is going well for you. A simple "mmm, yeah" or a moan now and then tells her that she's on the right track. Some guys are so quiet that I literally don't know whether they're blissfully stroking their cocks or have gone out for a snack.

If the operator says something like, "How're you doing, sweetie?" or "Still with me?" that's probably a clue that she's wondering if you've fallen asleep. You might want to give her some direction, like: "Oh yeah, this is great" or "Tell me more about your tits." This is also the perfect opportunity to let her know if the call is *not* going well. It's completely within your rights as a customer to ask her to go in another direction ("Nah, this dominatrix thing isn't doing it for me, let's pretend you're my ex-wife instead,") or talk dirtier, or move the call along faster. Most phone sex workers will welcome the input.

In fact, do that anytime you feel things aren't going quite right. You don't ever need to continue a call that isn't working for you. There's no blame attached – sometimes personalities just don't click. You're paying for this, so if you're not enjoying it, hang up. Try another girl, or call the dispatcher back and ask for someone else. No one will be offended.

There have even been times when I was relieved that the caller hung up. One guy kept asking me to be meaner. No matter how mean

I thought I was, he said, "No, *meaner*." Nothing I did worked, and I was really at a loss. When he hung up after a few minutes, I was glad.

Set the boundaries on small talk. Many phone workers will start a call with a few questions about you. This isn't about her trying to keep you on the phone longer – early conversation serves an important purpose. It lets the worker get to know you just a bit, and helps nervous callers to relax. But you're not required to make small talk if you'd rather not. It's perfectly acceptable for you to say, "If you don't mind, I'd rather just tell you about my fantasy."

Respect her limits. Remember, the phone sex operator is a human being too, and she has limits of her own. Just because you're paying her, doesn't mean she's required to do anything you ask. Common fantasies that some operators will refuse include rape or other violence, sex with children or animals, and bathroom calls. If your phone girl has a website, you can probably get a good idea of her limits from that. If not, just ask. At the beginning of the call, try something along the lines of, "I'd like you to pretend to be screwing a giraffe. Is that something you can do?" If she says no, ask her to recommend someone, or just try another number.

Don't just hang up at the end of the call. I say this with some hesitation, because it doesn't actually bother me all that much, but most of my fellow phone workers find it extremely annoying. I certainly appreciate callers who say, "thanks" or "that was great" or even just "Bye, Kristi" before they hang up. Otherwise I occasionally find myself asking the dial tone if it came yet.

On one memorable occasion, I was doing a two-girl call in which the client wanted to hear us pleasuring each other. He was quiet, but that isn't unusual in that sort of call. Well, we were huffing and puffing and moaning and screaming and then suddenly we both realized that it was just a little *too* quiet. It was somewhat embarrassing for us to realize that we had been performing for ourselves for we didn't know how long.

Don't try to wangle a free call. I can't tell you how many ploys and excuses I've heard. The phone sex operator is not going to give you a freebie because it's your first time, or it's your birthday, or your wife

is sick, or you just retired, or you're about to get your paycheck, or you swear you'll send the money tomorrow, or the boss said it's okay, or all the other girls give you free calls. No matter how charming you think you are, you're not going to sweet-talk your way into free phone sex.

The operator is also not going to give you her private number and do a free call with you on the side because you're so hot and you just want to get *her* off. I hang up on guys who say things like that. If you are a steady caller you might end up with a birthday call or some free minutes, but if you're a stranger, forget it.

Along the same lines, don't try to take advantage. Don't call to fuck her voicemail when she's out (think I'm kidding? I was once on vacation and called in for messages to discover a 14-minute recording from a caller who "missed me.") Don't jerk off and try to finish quick while she's taking your credit card number. It's tacky, and we know exactly what you're doing. If you sound like you're already stroking yourself when you say hello, and you don't indicate in 10 seconds or less that you're serious about paying, you and your big hard cock will be listening to a dial tone.

Don't expect anything beyond the phone call. While the occasional phone sex operator does personal sessions or appearances, the vast majority would never consider it. I suggest that you don't even bring up a real life meeting, but if absolutely can't stop yourself, ask once. When she says no, move on.

But, you wonder, why wouldn't a cute 24-year-old phone sex nymphomaniac want an all-expenses-paid weekend fuck vacation with you in Hawaii? Well first of all, you're a client, not a boyfriend. A phone sex call is a short-range fantasy, not a dating service. If you want an escort, call an escort service. If you want a girlfriend, try the personals.

But, you protest, you're an incredibly sweet and handsome and rich and charming stud-muffin! You and she get along so well on the phone. You'll treat her like a queen! You won't expect her to cater to you – you want to pamper her!

When you call a phone sex line, you're buying an exciting phone fantasy with someone willing to play your games. The worker you're talking to might be married, a lesbian, or otherwise unavailable in real life. She might not be the girl in the pictures, and it's very doubtful that

she's really a nymphomaniac. If you're in love with her, you're in love with a fantasy.

Don't try to turn professional phone sex into something it isn't. Enjoy it for what it is – a sexy, seductive break from reality!

10. Becoming a Dominatrix

Relatively early in my phone sex career, I received a note from Dave out of the blue. He had seen my website, liked my pictures and personality, and thought I might be the right person to play out his particular fantasy.

He described the fantasy in detail: He's a state trooper, and I'm a gorgeous bitch with a rich husband. He stops me for speeding, and although he's polite and apologetic, I verbally abuse him and threaten to have him fired if he gives me a ticket. He tries to explain that he's just doing his job, but I pay no attention. He gives me the ticket, and just before I drive away, I promise him that I'll "have his ass."

I'm infuriated of course, and immediately get one of my rich, powerful friends to toss the ticket out. But I'm still not satisfied. I'll get that insolent little trooper who dared to give me, Kristi Forbes-Trump-Rockefeller, a speeding ticket. I use my contacts to find out where he hangs out after work. I disguise myself as a cheap tramp, with lots of makeup, a blonde wig, low-cut clothes, the works. I sidle up to him in the bar. He, predictably, offers to buy me a drink, and I agree. While he's not looking, I slip something into his glass.

When he wakes up, he's chained naked to a bed in a room he doesn't recognize. He struggles at first but soon realizes that it's useless. And at that moment, who enters from the other room? That's right, the rich bitch goddess, all decked out in black – thigh high boots, satin corset, sheer black panties. I amuse myself with him, tease him, drive him crazy, and finally tell him that I'm going to have his ass just as I promised. Then I pull out my big, nasty strap-on and fuck him.

Now I'd never done anything even remotely like this before. In fact, when I started reading the fantasy, I expected it to be a rich-bitch-gets-her-comeuppance story.

But what the heck, I thought, there's no time like the present, right? I knew that lots of men like to be dominated, and Dave had written such a detailed fantasy that it ought to be fairly easy.

I wrote him back telling him how much I enjoyed his letter and fantasy, and musing about how perhaps I'd tease and torture his nipples before I fucked him.

He wrote back: "Gently, Kristi dear, gently. I'm into sensual domination, not pain."

Hmmm. I wrote him back: "Aww, not even a few little bites?"

He answered: "Well, maybe just a few." And a grin. Good enough.

We chatted for a short while online, and he promised to call soon. He remained on my mind for the next few days. I wanted to do his fantasy right for him, but I also know (from personal experience) that it's very satisfying for the dominant to take the fantasy a step further. I wanted to add something new for him, something he'd never considered before.

It was tough, because most of my immediate ideas revolved around pain-play, and he didn't want that. I started thinking about the strap-on, and suddenly remembered a passage I'd read about dildos and harnesses, and the various places one could fasten the straps – around a big pillow, a chair, or a lover's thigh.

When I first read that, it didn't make sense to me at all. Why exactly would you want to strap a dildo onto your lover's thigh? It nagged at me enough that I tried to fantasize around it a bit, to see if I could figure it out. To my surprise, I was successful. I worked up a hot scenario where the dominant was lying on his back with the dildo strapped to his thigh, and the submissive straddled his thigh with the dildo inside her. Her hands were fastened behind her back, so she couldn't brace herself, and all the dominant needed to do was twitch his leg to move the dildo inside her and make her moan.

That image played around in my head for a while. I started picturing Dave's scene, and imagining the dildo strapped to the thigh of a submissive man. Yes. Deliciously, ultimately torturous for him. He's desperate for sexual relief, and the woman he wants ignores his needs

in favor of a dildo, one just inches away from his aching cock. He can feel her movements and her weight on him, but none of the pleasure or release. Yes, yes. Perfect.

This is about the time I started realizing that I might not be too awful at this domination business.

He called, and turned out to be a charming guy with a wonderful voice. I was surprised to discover that he wanted to role-play the entire fantasy from the beginning, including the whole stopped-for-speeding business. I obliged, but felt self-conscious and silly.

Once we got into the actual scene part, I felt much more comfortable. And I had him – he was all mine from the second he woke up in chains. My voice was soft and husky and (surprisingly) confident, as I walked him through his fantasy. He didn't say much, other than "Yes, ma'am" and "oh, god" but he moaned and groaned in earnest. He was deep, deep into the fantasy.

My embellishments seemed to work well, and I was somewhat startled to find myself drawn in to the scene, and very aroused. I do have some top tendencies – some sadistic ones, in fact – and I had to stop myself from cracking the riding crop across his ass a few times. I was very tempted!

By the end, I didn't have any idea whether or not I'd gotten him where he wanted to be. I knew he'd had an orgasm but that didn't mean the fantasy was right. But the first thing he said once he was recovered enough to speak was, "My god, you just... obliterated me."

I'm pretty sure that was a compliment.

Dave became one of my first regular callers, and as he began to trust me, he revealed more and more of his fantasies. I find his kink absolutely fascinating. It's not about submission, exactly. It's about being overwhelmed.

All his fantasies involve gorgeous women in tight clothes (think Emma Peel of *The Avengers*) overpowering unsuspecting good guys with sleeping potions, gas, blow-darts, or other technological gimmicks. These potions make the men obey in spite of themselves.

Essentially, he has a fetish for femmes fatales. He's always the strong man who would never submit. He never obeys willingly, but the technology or drug forces him to. Not only that, it forces him to *like* it.

It's a stunning piece of psychology. He can be dominated without being weak. He can submit to the evil villainess without having to reconcile it with his good guy conscience – it was all the drug's fault.

He likens his fantasies to the old Batman TV show. Batman is the good guy crime fighter who flirts with the lovely innocent woman at the party. She takes out a compact to powder her nose, and without warning, she blows some powder in his face. BAM! He's unconscious. He wakes up to discover that the girl from the party is actually the evil Catwoman, and he's helplessly under her spell. He's been drugged, and now he's her puppet – he'll do whatever she says and love her for it. Until the drug wears off, of course.

These scenarios are appealing to me on one level. I've never been altogether comfortable with the so-called "sissy boys." I know that a fair number of submissives like to be servile and groveling, but that's not my preference on either side of the whip. Dominating someone strong and challenging, though – that's attractive to me. Not a naughty little boy, but a tiger in chains. Definitely.

My second scene with Dave was about hypnosis. In this fantasy, Dave is an FBI agent. He and his partner are trying to crack a ring of smugglers, and they've traced the headquarters to a high-priced lingerie shop. They know the place but not which people are involved. Dave leaves his partner in the car and enters the store to investigate. Of course all the sales girls are wearing the merchandise, showing off their long gorgeous legs.

One of the things I like about Dave is that he knows his fantasies are a little juvenile and sexist – he acknowledges that – but he doesn't care. He has an unabashed joy in them. "Hey, it's my fantasy, I can make it as much like a bad late-60s science fiction TV show as I want!"

Anyway, he's in the lingerie shop, trying to figure out who the ringleader is, when a fantastically beautiful redhead (me) in a short dress and long black satin gloves approaches and offers to show him some lingerie.

As I'm showing him a beautiful silky corset, he notices a shiny ring on my finger. He becomes fascinated with watching the ring and listening to my voice. I start telling him to relax, and I hypnotize him right there. I implant the phrase "black velvet" into his subconscious –

whenever he hears it, he'll go right back into his trance. While he's under, he's in love with me. All he wants is to please me. Obeying me gives him great pleasure.

My other ladies take him into the back room, strip him, and chain his wrists to the ceiling. When he's secure, I clap my hands to bring him out the trance, and he struggles wildly. He's infuriated at having been tricked. He curses, he threatens to put me in jail, and he reminds me that his partner has probably gone for back-up by now.

I drop the bomb on him. I already have control of his partner. His partner was right there in those same chains a week ago. He knows he's in deep trouble. Just as he's bravely telling me I'll never get away with it, I whisper "black velvet" in his ear. He immediately falls back under my spell.

I actually enjoyed playing with him. I walked around behind him and ran my satin-covered hands all over his back and chest. I kissed him lightly, then let him pull one of my gloves off with his teeth. I unhooked the chain from the ceiling, yanked him forward by his still-bound wrists, and made him lick my nipples. Then I made him kneel on the floor and take off my panties with his teeth. Finally I had him bend over an ottoman. I buckled my strap-on to my hips and took complete advantage of my little captive.

The first time we played, we stopped the scene right after his orgasm, but this time I kept it going a little longer. As he was recovering, I whispered, "Now you're going to go back to your car, and file a report about how there's nothing unusual going on in this shop, aren't you?"

"Yes, ma'am," he answered, still trance-like.

"You were on the wrong track," I continued. "There is no crime ring. It's all random break-ins."

"Random break-ins," he said softly. "Yes, ma'am."

Afterwards he told me that the scene had been incredibly realistic to him. I was pleased and flattered.

He's called me many times, and I enjoy creating these scenarios for him. Once I was a jewel smuggler, and he dressed up as a bellhop to get into my room. He didn't know I was onto him, so he made the mistake of opening my suitcase. Oh no…what's that hissing sound?

What's that purple gas coming from inside the suitcase? Oh...I feel so woozy...

I was also an evil nurse who gave him an injection of a drug that rendered him entirely helpless to my will. (Actually, I turned out to be an alien who wanted to collect DNA samples from his helpless body. Guess which part of him I wanted the DNA from and how I collected it....) My favorite inspiration was the "knockout lipstick." One kiss and poof!

☎

The next step in my road to dominatrix-hood came a few weeks later. *Ring.* "Hello?"

"Kristi?" It was a female voice.

"Yes, this is Kristi."

"Hi Kristi, it's Marni." Marni is one of the other girls on the phone sex site, and according to her profile she is the "Mistress of the Night, Goddess of Your Soul."

In real life, though, she's a sweet, corn-fed Kansas girl with a husband and four kids. (Ever see the movie *Eating Raoul?* Remember Doris the Dominatrix, who walked around with a bullwhip by night and was a housewife by day? That's basically Marni.)

"Hey, Marni, what's up?"

"Are you available for a two-girl call? I have one of my regulars on the line."

"Sure! What's the scenario?"

"Oh, great! Well, he's my slave and you'd be my other slave," she explained. "But all you really have to do is giggle."

"Okay," I said. "I can handle giggling."

"Yeah," she said. "I told him I'm going to punish him, so I'll make him do embarrassing things in front of you and you laugh at him and stuff, okay? Don't worry, he's fun."

"Sounds easy enough," I answered. "Go for it."

She clicked over to conference the three of us.

"Mark?" she said. "You there?"

"Yes, Mistress Marni," a nice voice answered.

"Mark, we're in luck," she said. "Kristi was at home. Kristi, say hi to Mark."

"Hi, Mark!" I obliged in my chipper "bad girl" voice.

"Mark, why don't you tell Kristi about yourself, you bad boy," oozed Marni.

"Well, I'm 35, I'm married, and Marni is my slave," he answered, deadpan. He paused, then laughed.

She chuckled too. "Mark! You're impossible."

"I'm sorry, Mistress Marni," he said, unrepentant.

I giggled as directed, but then commented, "Mark, I hear you're in trouble."

"Well, er...."

"What did you do?" I asked.

"Yes, Mark, tell Kristi what you did," replied Marni.

"Well I... well... Mistress Marni wasn't available... and, er... I was really horny...."

"Uh oh," I said.

"Uh oh is right!" exclaimed Marni. "Go on, tell her what you did."

"Mistress," he pleaded, "I said I was sorry..."

"Oh, you'll be sorry all right," she warned. "Listen to this, Kristi. Not only did he masturbate without permission, but he actually called *someone else!*"

I drew in a dramatically loud breath and tsked.

Now despite the slave talk, this was a very lighthearted conversation. Mark obviously doesn't take himself or his scene very seriously, and all three of us were laughing the whole time.

"Oh, he *definitely* needs to be punished," I said.

"Kristi!" he pouted. "You're supposed to be on *my* side."

"I am?"

"No she isn't," answered Marni. "Kristi's *my* slave, and she's right. You're getting punished."

He grumbled.

"Now let's get your cock nice and hard first," purred Marni. "Stroke it for us, Mark. Kristi's going to watch."

Distracted by the prospect of a witness to his punishment, he made another mistake.

"Should I take my shorts off, Mistress Marni?"

"What? You're wearing *clothing?*" Marni was outraged.

"Oh, er, I... *shit!* No! I mean... well..." He was backpedaling fast, and I could almost hear the sheepish grin. I tsked again and Marni and I had a short discussion about the low quality of slaves these days.

"Well, what's Kristi wearing?" he demanded.

"Kristi? Tell Mark what you're wearing."

I glanced down at my sweats. "Why, nothing, of course."

He grunted. I think he was torn between being annoyed at Kristi-the-teacher's-pet and imagining Kristi naked.

"I would *never* talk to Mistress Marni unless I was naked," I answered loftily.

Marni made a pleased noise. "See? Kristi is such a good girl." I had the sudden image of her patting me on the head while he stuck his tongue out at me behind her back.

We ended up giggling for about 15 minutes, and she made him put on lipstick and perfume as punishment. He pleaded in earnest that his wife would be home in an hour and she'd notice it even if he showered, but Marni was adamant.

"If you'd have behaved yourself," she said, "I wouldn't have to do this, would I?"

"No, Mistress," he answered. "You're right, I'm sorry."

When we hung up, Marni asked if I was comfortable with that sort of call.

"Sure," I said. "Easy as pie."

"Oh, great!" she said, relieved. "Some people really get freaked out by guys like that."

"Really?"

"Yes, Gail refuses to do any kind of domination calls."

Interesting. I mean, the lipstick could have once been troublesome for me, but overall Mark was a nice, funny, intelligent, articulate guy. Far more so than some of the so-called normal creeps. I guess I forgot that some people find the entire BDSM realm weird.

"Oh no," I assured her. "Call me anytime."

A few days later Mark approached me online.

"Kristi, this is Mark, from the call with Marni. Do you remember me?"

Of course I did, and we chatted a bit. He looked at my website for the first time, and was practically drooling through the phone lines. He was tempted to call me, he said, but he was worried about how Marni would react.

"Oh, she won't mind if you call *me*," I assured him confidently.

It was true, actually. I knew she wouldn't mind. None of the girls in the company is competitive with the others, and we all recommend each other to the callers.

So he called and told me all about himself. His kink is a little like Dave's but not precisely. His biggest turn-on is something similar to blackmail. He loves the helplessness of feeling trapped. He's not necessarily submissive, but he likes to be forced to obey, particularly with threats to embarrass him.

I could certainly empathize, because I like threats too. And right then, I had one of my best phone sex inspirations ever.

"Hot fantasy," I said. "Isn't it interesting how easily it's become real?"

"What do you mean?" he asked.

"I'm definitely going to enjoy this call, because you're going to do exactly what I tell you to."

"Oh?" he asked smugly, "Why would I do that?"

"Because after I hang up with you, I'm going to write to Marni all about the call. And I can tell her anything I want, can't I?"

"What? Hey!" he objected.

I laughed, a nasty laugh.

"That's right," I teased him. "And just who do you think she's going to believe – you or me?"

He made a strangled sound. A strangled helpless hot sound. It was perfect. Fantasy became reality right there, especially because he had no real idea if I'd actually do it.

Later that evening I dropped a note to Marni to let her know I'd spoken to him, in case she wanted to use that information as ammunition. She answered the next day.

"Thanks for the note," she wrote. "I wrote to Mark and told him that I heard all about his outrageous behavior. I informed him that I already spanked Kristi soundly and that his punishment was going to be much worse." And she grinned.

I saw him online later that evening.

"Are you in trouble?" I sent.

"Begging right now," he sent back. "I'll explain later."

But he was having fun, I could tell.

☎

Soon after that, I realized that Kristi needed an alter ego. The process of learning about Dave's and Mark's femme fatale fantasies had introduced me to the world of sensuous dominance, and I know there's a large market for female tops, so I ordered a bunch of books and haunted female domination websites for a bit. Research, you know.

I was beginning to feel more confident. I had done well with Dave a few times and I'd even successfully managed a strap-on scene with a first-time caller. I was as ready as I'd ever be. It was time to advertise.

I created an auxiliary AOL screen name, in which I called myself Kristina, with a profile that offered, "sweet but demanding sensuous domination." I wanted to use the word "sweet" to distinguish myself from the bitchy "lick my feet" types. And so the dominatrix was born.

Of course the alter ego needed a website, and my first attempt was pretty weak. When I tried to write the description, I immediately hit a bizarre dilemma. How can you solicit customers *and* be dominant at the same time? I wanted to be warm, inviting, and helpful to customers who might be hesitant to call, because I was looking for new or shy submissive men (I didn't feel qualified to top very experienced people). On the other hand, "warm and helpful" isn't what they're looking for in a domme.

I solicited advice about my new site from some of my regular boys, including Officer Dave. All of them said the same thing – the pictures are great, but the copy is too wishy-washy. Be mean! Be strict! Put 'em on their knees!

Three pep talks later I had a new, more authoritative version. "Better," they said. "But you're still too nice! Don't be friendly and caring! Be a bitch!"

I whined at Dave. "But I'm not a bitch. I'm nice!"

He laughed at me. "*You* are nice. Your alter ego is a cool, calm, dominant bitch. Trust me, I know."

I grinned. Well, if anyone did....

"Take out the part about having a modest bustline," he instructed. "Take out all the parts that sound hesitant. You have the perfect ass. Stick it out and command them to kiss it. You don't have to cater to their fantasies. You *are* the fantasy. Just let them worship you."

Oh my.

But that, too, helped. Don't cater to their fantasy, because I am their fantasy already. It's not a concept that integrates easily with my self-image, but I could see his point.

Kristina started posting ads with subject lines like "Remove My Panties with Your Teeth." Business was definitely picking up. In fact, one of my first calls from the new ads was from a guy who was intrigued by the idea of spanking a dominant woman. He wanted nothing more than to take the strict bitch over his knee and turn her into whimpering slut. I certainly didn't complain.

☎

My first real domme call happened only a day or two later, and luckily it was a guy who wanted to be spanked.

"Hi Kristina, this is Jim. I saw your ad on the Internet."

"Hey, Jim, nice to meet you. I didn't know if anyone actually read those ads."

"Oh sure, lots of people do, I think."

We chatted for a minute or two. He's about 50, just going through a divorce. He likes to fantasize about being spanked, but he's never done it. He was already breathing hard just talking to me about it.

"So do you like erotic spanking, or, like, for discipline?" I asked.

"Erotic," he answered. "Definitely."

"Cool," I said. "So as foreplay or...?"

"Yeah," he said. "Like if I didn't do the dishes."

Ah. So our definitions of erotic differed slightly.

"Can you do that?" he asked. "Pretend I forgot to do the dishes and spank me?"

"Sure," I enthused falsely. Domestic discipline. Not my thing at all.

"James!" I said sharply. "James, come into the kitchen right now!"

"Okay," he answered.

I have to describe this "Okay." It was bland. Uninterested. A little shruggish. Picture a teenager when you ask what he did in school today and he answers, "Nothing." That kind of "Okay."

"Why are the dishes still in the sink?"

"I didn't do 'em."

"I see that, James."

Silence.

"Why didn't you?"

"I dunno."

"What did I say I'd do if that happened again??"

"You said you'd make me get the chair and put it in the middle of the kitchen."

Oh my. Four one-syllable responses and then he gets demanding.

"Well, do it then!" I snapped.

"Okay." Bored teenager.

"Wait a minute. First take your pants down around your ankles."

"Okay."

"And get the wooden spoon out of the drawer."

"Okay."

Geez, tough room.

I described sitting down in the chair and patting my thigh. I beckoned him to come closer.

"Okay."

I ordered him over my lap.

"Kristina, sweetheart, I'm done and I really have to go."

"What?" It took me a minute to realize that he wasn't in the roleplay.

"I'm done. And I'd love to talk more but I really have to go."

"Oh, uh, okay well..."

"This was fun, honey. I'll call you again."

And he was gone. I looked at the stopwatch. Five minutes and 13 seconds. Including the small talk. I suspected he started before he even called.

Not an auspicious beginning to my career as a dominatrix.

11. What to Expect When You're Expecting to Submit

Domination is one of the most popular requests any phone sex operator gets. It's a great way for you as a submissive (bottom, catcher, slavegirl, bad boy, choose your own label here) to dip your toe in the water, to learn, to satisfy those urges if you're alone or with an unwilling partner, or to just add spice to your sex life.

While domination is a fairly specialized field, the phone sex companies know that there is a high demand for it, so they generally urge their operators to add it to their list of specialties. This means that the majority of advertised Phone Mistresses have no training in the art at all.

So how can you find the right one? Well, if you're surfing the web, look at the written profiles. Is the description appealing to your particular desires or is there a lot of general fantasy material with a quick "I can also be the Mistress of your dreams" tacked on at the end? Forget the pictures of the riding-crop-brandishing goddesses in black leather – read the text.

If the service you call has a switchboard operator, she can probably connect you to the person who best fits your fantasies. If you're calling a potential phone sex operator directly, try asking her which role she prefers. Given a choice, I'd rather be submissive than dominant; not coincidentally, I'm a better bottom than I am a top. The women I know who are best at domination are generally those who enjoy it.

(This doesn't mean that some bottoms aren't also excellent tops, of course, but you have a better chance at a really satisfying call if you find someone who likes what she does.)

One definite don't: Don't try to make a dominatrix out of someone who isn't, unless you can be very specific about your fantasies. Almost any good phone sex operator can do a decent job if you give her a script, but if you don't want to plan out the entire scenario in advance, you're likely to be disappointed. If she says that domination isn't her thing, look for someone else.

Now, before you dial for the first time, sit down and think honestly about what you want. You won't have much luck if you just call and say that you want to be dominated. Being dominated means different things to different people, and no matter how much experience a phone sex operator has, she can't read your mind.

Negotiating a scene with a pro phone domme is not the same as negotiating with a lover. You may feel that all you want is to please her, but in the end this is a financial transaction for both of you. Calling a phone sex operator and saying that you just want to please her is like walking into a store and telling the salesperson that you want to buy whatever she likes best. She doesn't care what you buy – what's important to her is that you walk away a satisfied customer. She'll be happy if you're happy, and she needs to know whether you're looking for, say, a pair of shoes or a pink flamingo lawn ornament.

If you don't specify, you might end up in a fantasy call that involves:

• Worshipping your domina's body with your tongue, and having her sit on your face and smother you with her pussy; or

• Dressing up in women's lingerie, serving tea, and painting your Mistress's toenails; or

• Being dressed in diapers, getting a spanking from your Mommy, and being put to bed; or

• Clipping clothespins all over your body, masturbating with sandpaper, and eating your own semen; or

• Sucking another man's cock or having him fuck your ass, while your domme tells you how pathetic your tiny little penis is.

Does every single one of those choices interest you equally? If not, think about your submissive fantasies and you'll probably find that your favorites revolve around fairly specific scenarios, or at least definable areas.

Here are the most popular types of femdom fantasies that I've encountered in my career as a phone sex operator. There are hundreds of

thousands of combinations and variations, so see what appeals to you and explore.

The simplest form of phone domination is simply **sensuous teasing.** I'm not a hardcore dominatrix, but I love to tease. It's wonderfully sexy to see how long I can keep a caller right on the edge of orgasm – sometimes until he's groaning aloud and aching for release. Simple but oh, so thrilling!

Another popular game is **directed masturbation.** In its most basic form, this kind of play involves the phone sex operator telling you exactly how, where, and when to touch yourself. She might have you rub yourself against your sheets, stroke yourself with lotion or lubricant, and sit, stand, or kneel in various positions. She may instruct you to use a cock ring if you have one, or to improvise one out of a ribbon or shoelace.

If you're interested in anal play, she'll probably order you to play with your asshole with your fingers, a dildo or butt plug, or other item. If you have toys you like to use, let her know at the beginning of the call so she can incorporate them. Also, if you emphatically do *not* want the call to involve anal play, you might mention this at the beginning of the call as well to prevent awkward stops and starts later on.

Two safety notes here: First, don't stick anything up your butt that you can possibly lose your grip on. (All that lube gets slippery!) Play with toys specifically designed for anal use – they'll have wide bases or firmly attached leashes. Also, toys should *never* go from your ass straight into your mouth (or into your vagina, if you happen to have one) without first being disinfected. The easiest way to keep yourself safe is to use a condom for anal play, then simply remove and discard it.

If you like to play with stronger sensations like pain, your dominatrix might command you to spank yourself with your hand, hairbrush, wooden spoon, belt, or other implement. She might order you to use clips or clothespins on your nipples, cock, balls, or other places, or to intensify your sensations with ice or some heat-producing substance like Ben-Gay.

One of the rules will probably be that you have to warn her if you're about to come. Then she'll make you pull back, slow down, and start again. Depending on her skill and your stamina (and wallet), these games can go on for a *very* long time.

Not only will she tell you what to do, she might also forbid you to touch yourself or to climax. This kind of so-called **orgasm control** can

last only a short time (say, to the count of 20), for a slightly longer time (five to ten minutes or more), or for the insanity-inducing extended term ("Goodbye, slave, call me back tomorrow night and I'll consider letting you come then."). Obviously you don't have to obey her – after all, it's ultimately your money and your body – but games are more fun if you play by the rules.

If you like more dangerous diversions, some phone sex operators are expert in the practice of **financial domination.** "So, you perverted little puppy, you want to come today? Well, how much are you willing to pay for the privilege, hmmm?" Tip your Mistress $20 and maybe she'll change her mind about making you wait. Or maybe she'll demand that you pay five dollars per minute from now until you climax.

These kinds of games can make for some delicious dilemmas: "All right, you naughty boy, either you pay $100 for an orgasm tonight, or you're not allowed to touch yourself for a week. You have one minute to decide."

Just keep in mind that when your balls are aching, your brain might be on vacation, so don't offer a bigger tribute than you can afford. And if financial domination appeals to you, let your Mistress know your economic limits ahead of time (in other words, when your brain is firmly in control). That way you won't get deeper in debt than you can easily afford. Better yet, confirm those instructions via e-mail so that you have a written record of your request should you ever encounter trouble.

Some people like to involve bondage in a call. I once had a client who e-mailed me the combination to his padlock, then chained himself to his bed. He was completely at my mercy, because he literally couldn't free himself until I let him. (He claimed that he didn't remember the combination and couldn't get to it while chained.)

I have to admit, this was an exciting scene, but in retrospect it was dangerous and stupid. I no longer do anything involving self-bondage, despite the temptation, because it's just too risky. It's ridiculously easy to immobilize yourself accidentally – a key can fall behind a piece of furniture, a lock can jam, sweat can make knots tighten, or there could be an unexpected power failure. For your own safety, keep restrictive bondage to the realm of fantasy or save it for when you have a spotter.

Another common fantasy is **cross-dressing** (also known as feminization or forced fem). This can be anything from putting on a pair of

panties and masturbating, to a total transformation complete with high heels, stockings, and a wig. It might or might not include *verbal humiliation* – are you proud to be a pretty, sexy girl or mortified to be disgusting male chauvinist pig who needs a lesson in what it's like to be a woman?

Your phone domme can intensify feminization scenes by making you shave (your legs, your chest, your pubic hair), or forcing you to wear lipstick and polish your nails. If she's particularly evil, she might send you to a lingerie shop to (horror of horrors!) ask the salesperson for help in picking out an outfit for yourself.

Speaking of being out in public, here's another powerful fantasy: What would your neighbors or your wife or your coworkers think if they knew you were really a slaveboy slut under the total control of a beautiful Mistress? If this idea shames and delights you, you might have a taste for the almost unbearably exciting game of *public humiliation* (or, at least, potential public humiliation).

Your phone domina might require you to stand near a window with your hard cock in your hand and open the curtains just a bit. Maybe you'll call her from your car phone (pull over first, please!) and she'll make you fondle yourself right there in the front seat. Who knows who might pass by?

Maybe she'll force you to go to the store, buy some sexy thong underwear, and wear it under your clothes to work. Then you'll have to call her from your office and beg permission to go into the bathroom and jerk off. (Of course you might have to leave the office door open a crack when you call.) Even more dangerous, she might demand your cell phone or pager number and make you wait in delicious agony all day for her summons.

Secret adventures like these can be dizzyingly erotic, but you've got to be careful. Is the thrill worth your job or your family if you get caught? Don't give out your pager number if you're calling behind your wife's back. Don't give out your voicemail number if someone else occasionally picks up your messages. Just be sensible.

So how do you start?

If you feel nervous or shy the first time or two, you might try asking the phone sex operator to tell you a story so you can just listen. Again, you'll need to give her a general idea of what *kind* of story you

want to hear, but this is a good way to get to know a potential phone domme before you actually submit to her.

For example, start with something like, "Can you tell me about the last time you and your boyfriend dominated someone together?" If she says she doesn't have a story like that, ask her to suggest one of her favorite domination stories. If she says yes, you might take the opportunity to mention things you especially like or dislike. Statements like "I'd love to hear how you dressed him up in high heels and a wig," or "I don't like anything involving piercing or blood" give her a better idea of where to go with the story.

When you get braver and more comfortable, you can try a question like, "Have you ever used a strap-on?" When she answers yes (and she probably will), you can respond with something like, "I've always wanted to try that," or "I'm a little afraid to try that." She'll guide you from there.

Being a "submissive customer" may seem odd at first, but always keep firmly in mind that you're in charge of how much you want to submit. And if one phone domina doesn't rev your engine, try another. You're the client and you should get what you want. Even if what you want is to be debased and humiliated for your pleasure!

12. Sacrifice

Kristi, in her dominant guise of Kristina, was wandering halfheartedly around AOL. It was late on a Friday night, and I just couldn't get up the energy to be charming in a chatroom. A polite guy requested my link (he must have done a search in the member directory) and came back to chat a few moments later.

He was young, but he asked intelligent questions about phone calls, and then inquired if there was anything specific that I wouldn't do.

I gave him my standard answer: anything with a lot of blood or mutilation, and anything involving human waste products.

"What about choking?" he asked.

I hesitated. "Real choking or fantasy choking?"

"Maybe a little of both," he answered.

"No," I responded immediately. "No way. That's too dangerous. And you shouldn't do it either. That's how people kill themselves."

"Really?"

"Yes."

He was quiet for a few minutes. Then:

"You're a professional. Do you know a safe way to do it?"

"No," I said. "Because there isn't one."

I started to add "especially by yourself on the phone," but then didn't. I didn't want to imply that doing it with a partner was any safer.

"All right."

I was already feeling disturbed. I started to look up some "dangers of erotic asphyxia" sites in case he asked again.

He didn't. He said:

"Do you think I'm sick because I have that fantasy?"

That question always softens me. I have a special fondness for people who worry that their kinks are sick.

"No, I don't. I don't think any fantasy is sick."

Pause.

"And it's not an uncommon fantasy," I added. "It's just too dangerous to enact."

"You think it's okay to fantasize about it?"

"Sure. Fantasy is just fantasy. They're all okay."

"So if I called you," he asked, "would you do that fantasy with me?"

Damn.

I didn't want to. I should have just walked away from this guy right there. But I also felt a little bit obligated. I realize that believing that any fantasy is acceptable doesn't imply that I have to play with any fantasy, but I hated the idea that he'd lose that fragile "maybe I'm not sick" feeling.

And deep down, I was afraid – very afraid – that this kid was going to do something stupid. I don't know why I thought I could stop him, or why I should put myself into this situation at all. I don't know.

But I said, "I'll talk to you, if you want. You can tell me about it. We can see how it goes."

"Fair enough. What's the number?"

He seemed likable enough and he talked to Kristina like a person, not some dominatrix goddess. I appreciated that.

The first question he asked was, "So this is really dangerous, huh?"

I assured him that it was. I told him all I knew about accidental death and erotic asphyxia, including that you can do damage that you don't even feel until you just drop dead the next day. (I couldn't remember the details about that, but all I really wanted to do was scare the shit out of him. I wanted him to understand how serious this was.)

Finally I had to ask. "Is this something you're thinking about trying?"

"No," he answered. "Not really. I fantasize about it all the time, but I don't want to do it."

I was relieved.

"Except..."

"Except?"

"Well, a girlfriend kind of did it to me once, a while ago. I guess it was pretty stupid."

He started to tell me about the girlfriend. They played dominance and submission games. One night she wrapped a belt around his neck and attached it to a doorknob. She threatened to hang him, he said, and she very nearly did it. He found the experience to be incredibly erotic.

I was getting more and more uncomfortable. I found the whole conversation to be non-erotic and terrifying.

He laughed and shrugged off the memory.

"Have you ever heard anything so weird?"

"Don't worry," I tried to reassure him. "I've heard much weirder."

We talked a bit about fantasies and about dominance, and he started to tell me how exciting he found it to submit. He loved the idea of being the plaything of a strong woman, bound, blindfolded, helpless to her whims.

I felt on sturdier territory there. Just your average everyday submissive guy – strip, kneel, kiss my feet. No problem.

Then he started whispering about feeling my hands around his neck. I thought, I have to do this. This is his fantasy. It's just fantasy, and I believe fantasy is fine, whatever the subject matter. Put my money where my mouth is, so to speak.

One of the reasons I think I'm good at phone sex is that I seem to have the ability to find a way to make the fantasy work for both of us. I'm not always turned on by the same images as they are, but I can usually find an aspect of the fantasy that I like, and use that to get into it with them.

I've discovered that a number of men have fantasies based on fear. I don't mean sensual anticipation, or even anxiety, but genuine gut-wrenching cold-sweat terror. Kristina gets all sorts of requests like this one:

"If I send you a picture of me orally servicing another man, and a few e-mail addresses, would you use them to blackmail me for me to send you money every week so you won't send the picture?"

I thought it was just a game, but apparently it wasn't. Blackmail seems to be its own special kink, and at least half a dozen guys have approached me with variations on that same theme. They really like to

play with fire, because phone sex girls have their real names and addresses. Apparently fear is a genuine turn-on for them.

So I realized, almost belatedly, that fear must be at the root of the choking fantasy. He wanted to be pushed further and further, never knowing just how far his Mistress would go.

And that was my way in. I started to talk softly to him, to tell him about my hands caressing his neck, wrapping a scarf around him. I soon discovered that choking isn't what he wanted. He wanted me to threaten to hang him.

I pushed back the revulsion and tried.

"I'm tying your hands behind your back," I whispered. "You won't be able to stop yourself from falling, will you?"

"No," he moaned. "Oh god, no, I won't."

"I'm going to blindfold you too," I crooned. "You can't see a thing. You'll never know what's coming."

I was really getting to him. He was wildly aroused, groaning loudly.

"Is today the day?" I whispered. "Is today the day I'm really going to do it?"

I got ready for the pleas for mercy, wondering whether I could end the scene or whether it had to go further.

"Yes," he whispered fiercely, "yes, Mistress, please... I want you to."

"What?"

"Do it," he repeated. "Hang me!"

I was horrified. That's not at all what I expected. I thought that the fantasy was to push him closer and closer to the edge without going over.

I had misjudged it badly. He wasn't interested in fear. He wasn't afraid at all. He was anticipating it. He wanted it. He wanted the fantasy of being hung and choked to go all the way to the end.

I tried to ignore the realization, tried desperately to push him in another direction. He wouldn't go. He pleaded for me to "do it, do it now."

I was chanting to myself over and over: it's a fantasy, it's okay, his kink is okay, he's not really hurting himself, it's just a fantasy. I was trying to make myself believe it, trying to keep myself from hanging up on him, trying not to let him see my revulsion.

I have no idea what I actually said in those few minutes, but suddenly he started making horrible noises. Not gasping or moaning, but

real choking and gurgling sounds – noises that made me physically ill. Thinking about them still nauseates me. I can't get them out of my head.

I was frozen, terrified that despite everything I said, he was choking himself on the phone.

It felt like hours before I was able to stop it. I know it was only a minute or two, but it was far too long. I literally couldn't speak.

"Jason!" I said finally. I was scared silly.

To my vast relief, the noises stopped immediately. It took me another few deep breaths before I was able to say anything else.

"Jason, you're getting into an area here that makes me very uncomfortable."

He suddenly sounded perfectly normal and cheerful. "I'm fine," he said. "I'm okay. I'm not really doing it!"

I was so relieved that I was shaking. "Okay."

He laughed a little bit. "I really freaked you out, huh?"

"Yes."

"Don't worry, it's okay."

"Okay."

A minute or two on how tickled he was to freak out a phone sex girl. Then:

"That was turning me on so much. I really like the idea... the idea of sacrificing myself for my Mistress."

Oh god. How did I get myself into this?

"I'm almost ready to come," he said softly. "Please, finish the fantasy with me? Just help me come..."

All I wanted was to get this guy off the phone. I knew that the quickest, simplest way was to make him come. I didn't want to argue with him. I didn't want him to tell me why it was no big deal.

So I closed my eyes, gritted my teeth, and listened to exactly what he wanted me to say.

And then I said it. I told him how I was going to tie a rope around his neck, and how I was going to kick the stool out from under his feet. And I suppressed the violent nausea and told him how his neck was going to crack. That's what he really wanted to hear. That's what made him come.

I shuddered the whole time. Even now, writing about it, I feel cold. I can feel the gorge rising in my throat. I don't know how to shake it.

"You're open-minded," he said just before he hung up. "I like that. I'll call you again."

Never. Never again for any reason. Some things aren't worth the money.

13. The Dominatrix Blues

Trisha had been bugging me for some time to become an additional character. She was launching a new and slick website, and she wanted me to be one of the girls on that site, too. She herself plays about a dozen different girls – I have no idea how she keeps them straight.

I'd been extremely resistant to the idea, though I understood her logic. Kristi appeals to only a certain percentage of callers. Different characters with different profiles would be more lucrative.

Still, I didn't want to become another character. First of all, I wasn't convinced that I could pull off an accent or a very different personality. Also, I was concerned that someone who calls Kristi might also call the other girl. Trisha says that even regular callers never realize that they're talking to the same person, but I found that hard to believe.

Plus, I like Kristi. I feel comfortable with her. Her personality is basically just my personality. For the most part, the stories I tell about my experiences are true (well, embellished, but based on real experiences). So while I'm not a 22-year-old redhead with a gorgeous ass, the essence of Kristi is me, and I like that. It makes me feel real. I wasn't sure I wanted to be a completely fake persona.

I turned Trisha down several times. She was disappointed but understanding, and I thought she'd given up asking.

One evening, though, she sent me a link and asked my opinion. She does this now and then because she knows I do some web design and she likes my taste. The link took me to the new site, to a blonde bombshell in a black latex outfit: Mistress Nicole.

I found her appealing. She was prominent on the site, and the only hardcore dominatrix listed. I thought she'd do well and I told Trisha so.

"I need someone to play her," she said.

Oh.

I knew immediately that I was going to say yes. I don't know why. She just fit. I liked her look (I find many of the girls in the pictures to be very unattractive) and the idea of finally moving into a real hardcore domme was a temptation, too.

"Okay, okay, send me all the pictures," I sighed resignedly. "Let me get to know her a bit."

So I took a long, serious look through my card file of clients, and isolated the ones I thought might call Mistress Nicole. I came up with only about two dozen possibles – none of the rest was likely to be interested in a hard-nosed dominatrix.

Of those, about 20 of them had called me only once. That's when I realized that Trisha was right. Someone who talked to me for only ten minutes about four months ago was just not going to recognize my voice.

I decided that if any of my regulars found the new site and called Nicole, I'd simply ignore the phone. And if, against the odds, my caller ID didn't warn me, I'd just have to cope.

"Can I change the profile?" I asked Trisha. I didn't want to be stuck with someone else's writing.

"Change anything you want," she said. "Change the pictures too, if you like."

I called up the phone company and got a second toll-free number on my line. They offered to have it ring differently for a mere three dollars a month.

Enter Mistress Nicole.

Once I'd made up my mind, writing her profile was easy, even if I did giggle through most of it. This time I had no throng of boys to try it out on, because no one was supposed to know that Nicole and Kristi were the same person. I managed on my own.

Mistress Nicole's Profile

Hello, my little pets.

Your life is stressful, isn't it? You're constantly in charge. You make decisions all day long. Sometimes you dream about letting

go of your responsibilities and focusing on only one thing – pleasing a beautiful, sexy, strong woman.

Kneel before me and I'll take you away from your everyday life. I'll bring you into my world of pleasure and pain, of sensual submission, and willing humiliation. But remember – once you submit to me, there's no going back.

Shall I chain you up in my dungeon, my little one? I'll torture your nipples and your cock until you beg for relief. If you please me, I might be generous enough to bend you over my bed and fuck your waiting ass.

Or would you like to be my pretty little slut? I'd love to dress you in a pair of my panties and see you struggle for balance in a pair of high, spiked heels.

Maybe what you crave is to be the naughty student of a strict headmistress, or a bad boy being punished by his Mommy, or the helpless captive that I've kidnapped for my pleasure. The possibilities are endless.

Or perhaps I'll just order you to play with your toys for me. I'll stroke my wet cunt as I listen to you use your clothespins or paddle or dildo on your willing body. Will I let you cum, or will I make you suffer endless torment?

I wrote it…but could I come up with that dialogue on the spot? All I could do was wait and see.

When Mistress Nicole asked Frank about himself, he said, "I'm a fat boy." I didn't really know how to react to that; it's not normally the first thing someone says. So I just continued on, asking him how old he is and what he does.

When we got to what he likes to talk about, he answered, "I like to be humiliated."

Damn. There I went, from semi-confident to extremely worried in about half a second. I wasn't sure I could do it. I know there are people who enjoy being humiliated, but I still can't get my brain around *why* they enjoy it. I've accepted that it's a fetish, but I have trouble imagining myself doing it.

I know exactly why the fantasy doesn't appeal to me. I *hate* the thought of being humiliated. The unsexiest thing I can possibly imagine is for my partner to deliberately say that I'm unattractive, stupid, or

clumsy. None of those would be a turn-on for me. In fact, hearing any of them in an intimate moment might make me end the relationship.

Conversely, I have trouble saying those things to someone else. At least, I presume that's the dynamic. I just know that the thought of saying humiliating things to someone is uncomfortable at best. I don't like to think of myself as mean, even if that's what the customer wants.

I thought of just turning down the call, and I don't really know why I didn't. But I asked him what sorts of things he likes to hear – or maybe I asked what humiliates him.

"Well, my tits are big and floppy," he started out. "I really should wear a bra. Like I said, I'm fat."

Shit. Shit shit. The worst one. It hits my own insecurities dead-on. If anyone ever taunted me about being fat in a sexual situation, I just don't know what I'd do. It would truly be my worst sexual nightmare. How can I say that to someone else?

"And I have a small cock, really. And of course, the rest of my body just makes it look smaller."

I was only half-hearing him then. He stopped and waited expectantly.

"Well then," I said slowly, sliding into my low, sexy voice, "If I told you to stand in front of me, and take off all your clothes, would that humiliate you?"

Ease into it, see where it goes. Sound confident and sensuous, I thought. Just don't let him know you're scared to death.

"Yessss," he breathed. He said it softly, almost timidly, but I was clearly on the right track.

"And if I walked around you," I continued, "and told you to keep your hands at your sides while I looked at your body, would that humiliate you?"

"Ohhh yessss..." He was breathing heavily now.

"And if I dimmed the lights around you... and turned a bright spotlight down on you, so I could study every inch of your body..."

He groaned loudly and came. Oh.

I was vastly relieved and just a little bit disappointed. I hadn't said anything even remotely humiliating; he'd done it all in his own mind. I could have said almost the exact same words to a body builder.

Maybe that's the key. Maybe it doesn't have to be explicit, as long as it sparks their imagination.

Despite that minor success, I was still worried about the nastier femdom stuff, so I had a consultation with Mistress Marni. Remember Marni? Mistress of the Night, Goddess of Your Soul, Cooker of Husband's Dinner, and Changer of Dirty Diapers.

She was very supportive to me about becoming Nicole. (This is something else I never expected about phone sex: the camaraderie. Everyone is nice. We wish each other happy birthdays, we gossip about the guys, and we give each other advice.)

Anyway, I told Marni how nervous I was about the more intense humiliation-type scenes. They're just not in my nature.

"You can't be nice," she said. "They don't want nice."

"I know," I answered, "but I *am* nice."

We laughed.

"You know how you feel when you're way too busy, and you're just about to get your period, and everything in the universe irritates you, and you find yourself snapping at people you like?" she asked.

"Sure," I said. I'm intimately familiar with that feeling.

"Just talk to the guys the way you want to talk to people when you feel like that."

"Really?"

"Absolutely. When they say something annoying, say 'shut up and get on your knees!' They love it. Treat them the way you'd never dare to treat anyone."

Could it actually be that simple? And in some ways, to my surprise, it was. For next few calls, I simply didn't censor my irritation.

I found myself snapping, "Get those hands away from your cock *now!*" and "Not good enough! Do it again, harder!" and sarcastically asking, "What's the matter, my poooooor baby? You wanna come? Well that's just too bad!"

They lapped it up. Honestly, these have been some of my most successful calls. It made me feel like a bully but it's a great way to get your aggressions out.

By this time Kristi had enough regular callers that I'd mostly stopped hanging around America Online. Mistress Nicole, however,

was starting from scratch, so it was time to hit the chatrooms. It was Friday night and all the traditional phone sex rooms were full, so I settled down into my own little room (named, creatively enough, "Mistress Nicole") and waited.

I was overwhelmed within minutes. I had at least a dozen guys plus one woman all fighting for the chance to kneel at my cyber feet, and more were entering the room every second. I was busy enough just trying to send the link to my website out to people (the actual purpose of being in the chatroom) without having to play hostess at the same time.

I tried for a little while. There was no way I could deal with them all at once, so I told Elissa, the sub girl, to stand in the middle of the room. Then I commanded all the guys to kiss her feet and legs, and told her that she'd have to decide who did the best job. That gave me a moment's breathing room.

But even still, it was impossible. Every thirty seconds a new guy entered the room, each whinier than the next. The older ones – those who had been in the room ten minutes or more – began to remind me how patiently they had been kneeling and waiting for attention. I finally had to admit defeat.

I said a quick goodnight, and sent a private compliment to Elissa for handling herself so well when I put her on the spot. I expected her to laugh and make a snide remark about having dozens of men at her feet.

"Thank you, Mistress. I'm very glad to have been of service to you."

Some people just don't know how to relax.

The next night I decided to try a different strategy. I needed to talk to these guys only in private Instant Messages, so I could send them my link without having to entertain.

I opened a room called "Mstrss Nicole IMs only" and minimized the window. Every once in awhile I'd peek into the room and find the massive list of people who had come and gone, plus one or two poor souls kneeling and waiting in vain. I did not take pity on them. If they couldn't follow the simplest instructions, what good were they? (Hmm, maybe Mistress Nicole was rubbing off on me.)

Now, the convention on AOL is to read someone's profile before you send her a message, and Nicole's was very specific. It listed my

occupation as "Profe$$ional Phone and E-mail Dominatrix" with a note that I did not do real time sessions ever. It instructed potential chatters to send me a message for information and pictures. In large bold letters, it warned **"Serious inquiries from adults only. Do not send me a message just to chat."**

People began sending messages almost as soon as the room opened.

E1127:	Hello. Nice pic. It's hard to believe you are for real.
M50295921:	You are an amazing woman Mistress
No8:	how may i please you tonight?
CNee:	holy shit, you are hot as hell. wanna see whats in my hand?
Gummyboy:	Will you cyber me please? Please? Please please?
Pskates:	If that's really your pic you are hot!!!!!!
Marky:	Hi miss, very beautiful miss is, so does miss have room for another sub?
Iluvyurtoes:	can i lick ur feet?
Gummyboy:	Please, Mistress, please please, cyber me!
P19:	Hello mistress im paul 30 bi m may i have the pleasure of your wet little farts in my face and your hard leather fingers in my bottom
E1127:	Would you dominate me for real for a few thousand dollars? Not to flatter you but you have to be one of the hottest doms I have ever seen.
Gummyboy:	Mistress, your cyber slave is still waiting to serve you!

This went on and on for hours. Hours. And in the end, I only got one call.

I thought being dominant would get easier, but it never did. Every time I thought I was used to it, there was an unexpected curve.

Alan seemed pretty non-descript for the first minute or so, but halfway through the required credit card information, he broke in and said, "I have a very specific fetish."

"That's all right," I answered. "What kind of fetish?"

"I like to be humiliated."

I still had trouble with that particular phrase, but I was learning. I once asked Trisha how she reacted when guys started out with that,

and she didn't hesitate. She said, "Oh yeah? Well, with a cock that small it's a good thing you like to be humiliated. It must be a way of life for you."

I'd figured out by then that "I like to be humiliated" can mean many different things, and not all of them were activities I disliked. So while that statement might have scared me once, it no longer did.

"That's fine," I replied. "What's the expiration date on your card?"

I don't know if it's callous to do that, but I don't talk about fantasies until I verify the information. I've had literally dozens of guys try to get me to spend ten minutes talking to them without paying. I don't mind answering a few questions, but if they want to tell me a long, elaborate fantasy, they have to cough it up.

He gave me the expiration date, and then said, "It turns me on to know that a woman is taking my money. So the longer you try to keep me on the phone, the more I like it."

Wow, this could be a phone sex operator's dream client, I thought. It would be a turn on for him if I said, "Don't hang up until I let you."

I thought over strategies in my mind while I waited for the credit card to verify. He'd tell me he was going to hang up and I'd say, "Don't you dare!" or "You'll be one sorry bad boy if you do."

I settled down for a long call. After spending the usual two minutes getting him to tell me about himself, I started in. I made him stand in front of me and strip. He was definitely aroused. Then I told him I was going to take my tank top off, but that he wasn't allowed to touch me.

"Yes, ma'am," he answered breathlessly.

I didn't even get the shirt completely off before he gave a short, sharp groan and hung up. Four minutes. He didn't even give me a chance to keep him on the phone longer. I knew it sounded too good to be true.

☎

Once Mistress Nicole was really up and running, I had to stop posting dominant ads from Kristina. The dominatrix persona was taking over. The submissive male market is large and I was making more money than I ever had before, but I wasn't enjoying it. I didn't mind a few femdom scenes here and there, but when they began creeping up to almost three-quarters of my calls, I started to get depressed.

My submissive side started to fight back with a recurring fantasy I couldn't seem to shake off:

Mistress Nicole is entertaining a pair of submissive boys in her dungeon. She's decked out in her full black leather regalia, and the evening is just beginning. She's only just started to tease and torment the obedient slaves kneeling at her feet, when the door to her dungeon opens and an angry-looking guy bursts in.

This is Nicole's boyfriend, and it's not the first time she's stood him up without bothering to call. It's happened quite a few times since she started her new dominatrix business. He is Definitely Not Happy.

He's momentarily distracted by the sight of the lovely Nicole in all her leather glory, and she manages to reassure her clients that this is not an axe-murdering maniac who has broken in.

With a teasing wink at her kneeling slaves, she slips into her boyfriend's arms and kisses him passionately. At first she was angry that he interrupted her session, but now she's glad too.

He pulls her tightly to him, running his hands over her leather-clad body.

"I'm sorry," she whispers in his ear, running her hand through his hair. "I meant to call."

"You always say that," he growls.

"You're right," she admits, "I've been neglecting you shamelessly."

"Yes, you have," he answers, dropping one hand to squeeze a nipple.

"I'll make it up to you," she murmurs. "You can have your revenge on my poor, helpless body."

"Oh, I plan to do just that," he says quietly. "I plan to make you *very* sorry."

She shivers. "I just have about an hour with these guys, and then I'm all yours."

"No," he answers calmly, "you're all mine right now."

She tries to pull away a bit, but he holds her in place.

"I'm sorry," she says, "but I have to finish the session. I already charged them for it."

"Don't worry," he answers. "They'll get more than their money's worth."

Without warning, he drags her to a chair, and yanks her across his lap. Before she can even struggle he catches her wrists behind her back and holds her down.

With his right hand he lifts her leather mini-skirt and starts caressing her bottom, tracing the black leather g-string with his finger.

"Nice," he observes. "How come you never wore this for me?"

Whatever her answer is, it's muffled.

He looks over to her slaves, to see their reaction. They're right where they were a moment earlier, but they're confused and a little concerned. If this is one of Mistress Nicole's tests, they don't know the right answer.

He smiles at them.

"Guys, your mistress is about to get the spanking of a lifetime. Want to watch?"

She begins to struggle over his lap, and he brings his hand down hard, once on each bare cheek. She stops fighting immediately, and he admires the two red handprints for a long moment before he turns back to her slaves.

"Either watch and help, or leave right now," he says. "But you won't be doing her any favors if you leave. I'll just punish her that much worse for having such badly trained slaves."

He thought that would decide them and it does. They stay.

He points to one. "You, go find me whatever spanking toy she likes best," he said. "The one she uses on you when she punishes you."

The man hesitates for only a moment, and then disappears into another room.

"Now you," he orders the other one, "take her boots off. I don't need those high heels flying at my head."

He holds her down as her slave obediently strips the boots off.

"Don't kick," her boyfriend warns, "because it'll just be your pretty little slave you hurt, not me."

The first slave returns and wordlessly offers a large polished wooden hairbrush.

Her boyfriend commends the man's choice, and proceeds to rub the bristles lightly over Mistress Nicole's bare bottom, making her shiver and wince and start to plead. He ignores her, and addresses her slaves once again. "I don't think your mistress will want to be sitting anytime soon."

Without warning and without warm-up, he begins spanking her hard, quickly turning her bottom from pale white to pink to a dark, angry red. When her squirming becomes almost violent, he suggests

that her slaves hold her wrists and ankles in place. It takes him some time to get their attention because they're fixated on their Mistress, dazed and aroused by this sudden role reversal.

It isn't long before the once haughty and cruel mistress is sobbing uncontrollably over his lap.

There's a vague possibility that my subconscious was trying to tell me something.

☎

Over the next several months it only got worse. Mistress Nicole wasn't doing well, and it was getting to the point where I hated to hear her phone ring. She got almost no repeat calls, which I suppose confirms that I wasn't good at playing her.

I'm not sure why the Mistress calls were so difficult for me. I have much more kinky experience than most of the other girls, but the groveling guys always made me feel tongue-tied. I never knew what to say next. I could handle sensuous, teasing domination, and I could handle younger guys who always dreamed about being dominated, but I just couldn't cope with experienced submissive men.

I guess it's because Mistress Nicole was a construct, a fake, a stereotype of a dominatrix. There was very little of myself in her. She could have been the ultimate Mistress, but I clearly wasn't doing her justice.

Before giving up completely, I thought about asking one of the other girls if I could listen in on a few hardcore dominatrix calls, just to get some ideas. As it happens, fate intervened nicely in the form of a sub guy who called Nicole looking for a two-girl call with Trisha, the boss-lady.

The guy, Ken, was in a hotel room, so I took his number, promising to call Trisha and get right back to him. He just had one question before I hung up.

"Should I...have anything available for when you call?" he asked. "I don't have any toys with me."

"Like what?" I asked.

"I don't know," he answered. "I just thought... if I need to go to the drugstore or something, I'd do it now, before the call."

Drugstore. What would he need at a drugstore? A condom was the only thing that came to mind, but I had no idea why he'd need one. I racked my brain but it was blank.

"No, I don't need any props. Just your naked self," I assured him throatily.

That worked. He shivered and babbled and promised to wait by the phone.

Trisha was online, available, and as always, up for anything. (Me: "Do you want to do a two-girl call with Nicole?" Trisha: "Fuck, yeah!")

I explained the whole situation to her. This guy wanted us both to dominate him, or for her to dominate the two of us. I preferred the latter. She was agreeable – whatever I wanted, it was my call. I also mentioned his drugstore question.

"Did you tell him to get anything?" she asked.

"No, I had no idea what to say."

"Damn," she said. "That could have been fun."

Hmm.

We got the three-way call set up, and Trisha just took over.

"Hello, Ken," she purred. "I understand that you like to be dominated."

"Yes, Mistress," he answered, excited.

"Well good," she said. "I'm going to dominate both you and Nicole, is that right?"

"Yes, Mistress, I'd like that."

We joked for a minute or two about how she always was the dominant one, and then she got right down to business.

"Ken, what are your limits?"

I never thought to ask that question in such a direct way. It made perfect sense.

"Oh... well... " he hesitated only for a moment. "I'm not into golden showers or anything like that."(I wondered then if guys ever said, "I don't know," or "I have no limits." When I asked Trisha later, she explained in her own unique style: "Then I say, 'You have no limits? So it's okay with you if I shit down your throat?' They usually find some limits after that.")

"Oh, too bad," she said. "But you like to be controlled, right?"

"Ohhh, yes, Mistress."

"Good. Now Nicole tells me that you asked her if you needed anything for the call. Let's just see what you have available, alright?"

"Yes, Mistress."

"Good. Now, let's see... do you have some lotion?"

I was listening intently. She had an immediate list in her head and I wanted to learn it.

"Yes, Mistress, there's some here."

"Good. And do you have a hairbrush?"

"Yes, Mistress." That was quiet. He knew what the hairbrush was for, I guess. I thought I did too.

"And... hmm... a hotel room. Ah, do you have a shoelace?"

My, my, what an imagination.

"Yes, Mistress, I do."

"Excellent. And do you have some ice?"

"Um, no, Mistress, I don't have any ice."

I thought she was going to tell him to go to the ice machine and get some, but she didn't.

"You have toothpaste, though, don't you, Ken?"

"Yes, Mistress, I have that."

"Good. Now go gather those things," she instructed. "We'll wait."

"Yes, Mistress," he replied, and put down the phone.

We were quiet a moment.

"Toothpaste?" I murmured.

She chuckled evilly. "Listen and learn, child. Listen and learn."

I laughed. "I intend to!"

It took him a minute or two. I pictured him rushing frantically around the hotel room, naked, pulling a shoelace from his shoe.

He was out of breath when he came back. "I'm here, Mistress, and I have all the things."

"Gooooood, Kenny, good. Now, I need you to take that shoelace and make a slipknot in the end of it."

"Yes, Mistress."

"And put it around your balls and pull it nice and snug, alright?"

"Ohhhhh, yes, Mistress."

"And when you're done with that, I want you to take the long end of the lace and wrap it around each of your balls, separating them."

He groaned. "Yes, Mistress."

I'd been silent this whole time. There seemed to be nothing in particular for me to say.

He was still wrapping the shoelace when she began speaking again. "Now, we know you like to be dominated. Do you like pain? Spanking and things like that, Ken?"

"Ummm... well... yes, Mistress."

"Don't say you like it if you don't," she cautioned.

"No, no, I do like it, Mistress, very much."

"Good, good. Is the shoelace all wrapped nice and tight?"

"Yes, Mistress."

"Gooood. If I were there I'd tug on the end of it lightly every once in awhile, just to make sure you were paying attention."

A groan.

"And what about humiliation? Are you into that, honey?"

"Ummm... I... don't... don't really know... ummm... what you mean."

I was interested to hear the explanation myself.

"Well," she began, "some people who like to be dominated like to be embarrassed. They like to be seen, or be dominated in public..."

He was interrupting already, saying no.

"Or," she went on, "they like to hear me talk about their cock size, or call them names..."

He didn't say anything then, but she must have sensed his interest.

"Would you like that?"

"Yes, Mistress," he breathed.

"So you'd like it if I called you my little toy slut?" she inquired.

"Ohhhhh, yesssss, Mistress, yes."

"Well my little toy slut, let me hear you spank that ass five times on each cheek with that hairbrush."

It went on from there. She made him spank himself, then lube up the handle of the hairbrush with the lotion and fuck himself in the ass with it. Later she had him rub some toothpaste on the head of his cock ("NOT in the hole," she warned) and masturbate. He reported that the toothpaste made him feel very warm.

She did involve me in the call, by the way. She interwove her orders to him with a fantasy about all of us. She directed him to do things to me, while she did things to him. He licked and sucked and worshipped my body at her command, and eventually we ended up in a triple fuck – her behind him with a strap-on, and him behind me.

Trisha was generally mild-mannered throughout the call. Once, though, she asked if he was masturbating, and he said that he was. She immediately went into the angry domme routine, yelling at him for touching his "pathetic little cock" without permission, calling him things like a "dirty whore slut bitch pansy," and making him spank himself hard and beg for forgiveness. He ate it up.

It was a good scene, about 25 minutes, and clearly satisfying for the caller. Trisha said that by her standards he was easy to handle, and that she was very gentle with him.

I thought about this call for a long time afterwards. Now that I knew what to do, did I want to do it?

As luck would have it, Mistress Nicole's phone rang soon after, and I decided to try out my new knowledge. It was a little easier, I admit, but still uncomfortable. I tried the shoelace trick but must have missed some crucial point because the guy could only make it wrap around one testicle and he got confused. I, being inexperienced in Shoelace Nut Bondage, was unable to help.

So I finally admitted defeat and concluded that I was just not cut out to be Mistress Nicole. I disconnected her number and didn't miss her at all.

14. Conversation Interruptus: Short Stories of Short Calls

Andy interested me from the beginning, first because he said he was 6'4", and second because he said he was a redhead. Actually, those things interested Kristi – she's 5'8" and likes to wear heels, so she likes tall guys, and she'd never been with another redhead before.

He was very young, a 19- or 20-year-old college student, and very nervous when he approached me online. I didn't really expect him to be brave enough to call, but he was. I'm almost certain he'd never done anything as crazy as talking to a phone sex girl before.

He was most interested in hearing me describe myself, with particular emphasis on my stockings and heels, and all he wanted was plain old regular romantic sex. We built up slowly. We kissed and touched and I talked dirty until he was moaning. This kid was giving me such a wonderfully honest reaction that I began to think it was his first sexual experience of any kind. I worked even harder to make it good for him.

He started to breathe faster and faster, and he was just at that point of no return when I heard, "Oh shit, oh shit, oh god." This was not him climaxing – something was wrong.

"What?" I whispered.

"Shit, my roommate is home. I hear him in the hall." Oh, great.

"Close the door to your room," I urged.

"I can't, we share a room." He was still right on the edge of orgasm, torn between desire and fear.

"Go into the bathroom!"

"Goddammit!" he moaned, and hung up.

I felt very sorry for him. Roommates suck.

"Hi Kristi! Would you like to be my teenage next-door neighbor?"

"Sure, that sounds like fun."

"Great."

"Am I a nice girl? Or a slut?"

"A slut, definitely. I want to watch you undress."

"Through the window?"

"Yes, I'm watching through my window. You're out on the patio. Your parents are away."

"Ooh, I'm an exhibitionistic slut!"

"Yesssssss."

"Do I know you're watching?"

"Oh yes. You noticed me one time, and now you always undress for me."

I started off describing my outfit, how I'd worn it just for him. I told him how I waited for him to come home, and then when I knew he was watching through the window, I stepped out onto the patio.

I didn't really know where this fantasy was going. Was he going to come over and take my virginity right there on the patio? Spank me for being such a bad girl? Invite me over to play? I just went with it.

"I slowly lift my shirt over my head, and toss it onto the patio chair. I have a bikini top on underneath, and it's skimpy and tight."

He groaned.

"I pretend I don't know you're there, but I look right at you as I run my hands over my tits, my nipples already hard thinking about you watching me."

A bigger groan.

"Then I reach down and unfasten my top, shrugging it off my shoulders and lifting my arms to make sure you get a good view of my perfect little tits."

"Ohhhhhhhh god Kriiiiiiiiiiisti."

I paused.

"Oh, Kristi, that was great. Thanks!"

And he hung up.

I sighed. No spanking, I guess.

☎

New caller. Got all his information, no problem. Put him on hold. Dialed to get the authorization. Got that truly annoying "please hold for assistance" recording.

I hate that. First of all, it takes forever, and it usually means there's a problem with the card. I can't even click over to the customer to reassure him, because I'll lose my place in line.

Then they always ask for information that I don't have at hand, like the merchant number (which is programmed into the phone). And anyway, I feel funny – like the authorization guy just *knows* it's for phone sex.

"Amount?" he asked with an audible smirk.

"20 dollars."

"20 dollars even? Are you sure?" he leered.

Sigh. "Yes, I'm sure." I'll be damned if he'll intimidate me.

So I got the authorization from the sneering guy, no problem. He gave me the number, I thanked him, I clicked back and said, "Pete?"

Pause.

"You still there?"

"Yes," he answered, and I was relieved. The automated system only takes a minute or two, but a live agent takes much longer. With a new caller, that delay could cost me the call.

"I'm sorry," I explained. "They were having trouble with the automated system so I had to get the authorization manually."

"No problem," he assured me.

"Great!" I switched over into my sexy voice. "Sooooooo... tell me about yourself, sweetie."

"What?"

"Tell me a little about yourself, sweetie," I repeated.

"Um...ma'am, this is the authorization agent."

"What?"

"For the credit card company. This is the authorization agent...."

I turned purple, muttered an apology, and hung up. Luckily the real customer called back a few minutes later. (That agent could have had free phone sex. I never would have known the difference.)

☎

With all the crazy fantasy calls I get, sometimes it's the simplest ones that leave the biggest impressions.

Kyle is about 21 and lives at home with his mother and brother in some small *Bridges of Madison County* Midwestern town. He originally said he was interested in being dominated, but I think he was more shy and inexperienced than submissive. He just liked the idea of someone else taking the initiative.

We talked online, and he told me frankly that he was a virgin. He had a girlfriend but they both agreed to wait. I assured him that there's nothing wrong with that, and in fact, I think it's an intelligent choice in this day and age.

His first call was very sweet. He was a bellhop (his real profession) and I was a rich, sophisticated hotel guest. He carried my bags, showed me the room, offered to get me some ice, and asked if there was anything else he could do for me.

"Yes," I answered. "Call your boss and tell him that I need help unpacking and not to expect you back for an hour."

"But ma'am," he protested faintly, "it will only take five minutes to unpack your bags."

"Call him," I insisted, "and then take off your shirt."

Needless to say, he was easily convinced. It was a delightful, sensual call.

When I saw him online some weeks later, he was moody and frustrated. Trouble at home, he said. His brother was driving him crazy. I teasingly suggested that he should call me and I'd relax him, and to my surprise, he did.

"My brother's home," he said. "But I don't care. I have both phones in here with me, so he can't pick up."

We chatted a bit, and then I asked him if he had other fantasies he was interested in talking about. (The bellhop fantasy had been his idea.)

"Well," he said slowly, "there *is* one thing I've always wanted to try. But it's a little kinky and my girlfriend flat-out won't."

That sounded promising. Bondage? Exhibitionism? A threesome?

"What's that?" I asked encouragingly.

"I've always wanted to do 69. But she won't. I don't think she ever will."

Oh wow. Not at all what I expected. Such a simple thing for his girlfriend to be so against.

"Oh, I think I can help you out with that one," I grinned.

"Really?" he asked.

"Sure! Have you ever gotten a blowjob?" I asked.

"Yes," he said, unenthusiastically, "a couple of times my girlfriend did that, but she doesn't like to. She'll do it if I ask, but she'd rather not."

"Oh, man, that's awful!" I exclaimed. "I love doing that."

I was just sympathizing out loud, but I was immediately annoyed at myself for saying that. I make it a policy not to criticize their partners – it's none of my business. There's nothing at all wrong with disliking oral sex, and it's certainly not my place to judge her choices.

But he didn't seem to notice, and before I could apologize, he said, "You... like it?" He sounded stunned.

"Yes," I answered. "I do. I especially love the reaction I get."

He was silent, absorbing that. I'm not sure he ever imagined that a girl could actually *like* it.

I lowered my voice to a sensual whisper. "You know how I like to start?" I asked.

He could barely answer me. His breathing was raspy and quick. "How?"

"I'd start by unbuttoning your shirt slowly, kissing down your chest all the way."

The guy was practically hyperventilating. I didn't get far – nowhere near actual fellatio – before he hung up.

I was a bit surprised, because he'd lasted quite a long time on the first call. As it turns out, his brother had been banging on the door, so he had to hang up to beat him up.

Hey, everyone has his priorities.

Trisha went away on vacation and left us a list of her regulars. She left an outgoing message on her machine to try calling one of her girls, but this was the special "take extra-good care of them" list. One of the guys called me the next day.

Jack was cheerful, with a deep voice and an infectious laugh. I immediately felt comfortable with him, and he was just about the perfect phone sex caller. He was at ease with himself, had a vivid imagination,

and was very responsive. And he was a believer, totally taken in by the fantasy of the pictures and the profile. He was definitely talking to Kristi, the gorgeous redhead.

We talked about kissing – all the sensuous, exciting ways to kiss. We talked about what I was wearing and how exactly he would remove it. I could hear him getting more and more aroused with every word.

Unfortunately, halfway into what promised to be a truly memorable call, he cursed and asked me to hold on. After a few minutes he came back and apologized profusely, explaining that there was a workman at the door. Could he *please* call me back later?

"Of course," I assured him, but I couldn't help teasing just a bit. "Did the guy notice your raging hard-on?"

He groaned audibly and hung up.

About two hours later he found me online.

"The guy is *still here*," he complained.

I offered my sympathy and sent him a naked picture of Kristi and a few hot sentences. He then switched to complaining about how I'd managed to undo the careful calming down of the last several hours. I laughed at him and suggested that he throw the repair guy out.

He didn't get to call me back until the next day, but when he did, it was explosively hot. Afterwards he wanted to talk.

"Do you really like to get spanked?" he asked.

I told him a little bit about what I like. He'd never tried it, but he seemed fascinated. He's so incredibly fun to tease that I started describing what it would feel like to have a naked girl squirming over his lap. He surprised me by picking up the fantasy and having a second orgasm.

A few days later, Trisha sent a note with his name on it around to all the girls. It said, "No calls for this guy no matter what he says."

Odd, I thought. Even if his checks were bouncing, she'd usually say "no calls without a credit card." The only previous time I could remember a "no calls" message was about a kid who had been using his mother's credit card, and Jack clearly wasn't a kid.

I wrote Trisha and asked her what happened. (I was disappointed – I liked him!)

"He promised his wife he'd stop calling," she wrote back. "He asked me to write to you all so he wouldn't be tempted."

Awww. I thought that was sort of sweet.

"Hello, Kristi? This is John."

Oooh, yum. John had a lovely British accent. He'd seen my website and was intrigued by my statement that I like it rough.

"I like it rough, too," he informed me.

I was excited. I'm just a sucker for a British accent, and I had immediate visions of schoolgirl canings and scoldings. My knickers were ready and waiting.

"Not just spanking, though," he said. "I like sex rough, really rough."

Even better. Just show me where to sign.

"Well," he began, "why don't you imagine that you're in a nightclub. There are, oh, a dozen men crowded around the bar, and you're on top of it. You are, shall we say, the entertainment."

Not what I expected, but an image flashed in my head: Kristi doing a little tease number on the bar, being yanked down by a bunch of strong arms and, say, thrown over a barstool. The striptease was a little out of character, but hell, she's a very bad girl. She can learn to strip.

I closed my eyes and started to talk, picturing Kristi all glammed up and teasing a bar full of horny guys. First I told him about what I was wearing (skimpy clothes and high heels, of course) and then described the music and the movements. I'd never tried to describe dancing before, and it was more difficult than I expected.

I only fumbled for a few seconds, and then, inspired by some imaginary strip act (I think maybe it was Demi Moore in that terrible movie), I described turning my back, tossing my halter top away, and turning to face the crowd of guys. I whispered about crossing my arms over my breasts so the customers still couldn't see anything.

Now, time for the action.

"Oh, Kristi, that was terrific. Thanks, love." And he hung up.

"Hey!" I asked the dial tone indignantly, "What about my rough sex?"

And speaking of callers with accents…

I met Cliff online and we chatted briefly. He's your basic guy, with conventional fantasies, and anal sex as his kinkiest dream. He called and I was immediately distracted by his accent. He's from Minnesota, but he sounds like he's from Fargo. The movie *Fargo*.

He was perfectly average, but I had a *lot* of trouble with the call. Every time he said something, I wanted to burst out laughing. I kept seeing Frances McDormand with her huge pregnant belly, questioning the hookers in the restaurant:

"So, what'd he look like?"

"He was, yah know, funny lookin'."

"Funny lookin'?"

"Yah."

"So you were havin' sex with the funny lookin' one?"

"Ooh yah."

Cliff just wanted to talk about straight sex. Oral, anal, whatever. Completely ordinary and yet impossibly difficult. I would ask him some intimate question and he'd answer, "Ooh yah," and I'd be back thinking about McDormand talking to the other police officer:

"Didja have yer breakfast, Marge?"

"Ooh yah, Nerm made me s'me eggs."

"Yah?"

"Yah."

"Is yer cock hard for me, Cliff?"

"Ooh yah."

I barely got through the call. I was stern with myself. I could not laugh at this guy. There was nothing funny about the call, it was just the accent. *Stop laughing.*

I called Rachel afterward and we cracked up. For a little while it became my favorite phone sex story. Then he called back a few weeks later and I suddenly felt ashamed. This is a real guy, a person, not a caricature of a movie.

The accent still makes me laugh, though. Now I laugh and feel guilty about it. I'm not sure that's an improvement.

But I confess, I live in fear of men with accents now. I'm terrified both that I won't know what they're saying and that I won't be able to prevent myself from laughing.

I had one aborted call from a guy with a southern accent so thick I could barely understand him.

"Sheeeeeeeee-it! Yer a hottie!"

I admit, I was relieved when his credit card was declined.

Then Henry called – a young guy from New York with a pronounced Asian accent. It was thick but he was still perfectly comprehensible, and we had a pleasant time chatting.

This is good, I thought. The accent doesn't matter. He seems interesting and intelligent. We'll just have a lovely chat.

"You haven't commented on my accent," he said a few moments later. "You must have noticed it."

Great, just great. Damned if I do, damned if I don't.

"Oh yes," I said brightly, braving my way through, "where are you from originally?"

"Guess."

Just fucking great. Thanks a lot. I'll guess Korea, and he'll be Japanese and offended.

I went with the safe, vague answer.

"Oh, somewhere in Asia I bet."

How's that for a cop-out? But it worked.

"Chinese," he said. "But I was raised in Hong Kong."

Oh good. Fine. We talked about Hong Kong for a bit, and then moved on. I figured we were safely out of ethnic territory. I was so so wrong.

"Let me see your tits," he said. "I love white girl tits."

Sigh. I can deal with this. I did a little white girl strip tease.

"You want to suck my Chinese cock?" he inquired.

"Um, yeah, yeah, I can't wait to have you in my mouth..."

"Tell me," he insisted. "Tell me how much you want my Chinese cock."

And here we are again trying not to laugh hysterically.

"Ohh, I really want your Chinese cock." *Cough sputter.*

"Yeah, you white girls love Chinese cock."

That's all he wanted over and over. I had to tell him how much I wanted to suck his Chinese cock, how badly I wanted his Chinese cock inside my white pussy, how I wanted him to fuck me with that big hard Chinese cock.

How I did that without offending him or laughing at him, I will never know.

On the other hand, an accent can also be very sexy. I got the chance to do a soft southern accent with Paul, my rich boy, when we played one of his fantasies in a bar. He was the bartender, and I was a customer (a customer in battered denim shorts over a bikini, but hey, it's his fantasy).

I'd forgotten my wallet and tried to sneak out without paying.

"Ma'am." A big bartender blocked my way.

Paul paints vivid images, and I can still see the dark bar, the colored lighting, the sawdust on the floor... jukebox... warm air...

"Ma'am, ah do believe that you haven't settled your bill just yet."

Paul has a charming but mild southern accent, and I somehow found myself answering in kind.

"Oh now, you didn't think ah was tryin' to slip out, sweetie..."

"No ma'am. Ahm sure you weren't."

"Ah just left mah wallet in mah car. Ah'll be raht back."

"Ahm afraid ah cain't let you do that, ma'am."

It was a lovely scene. I pled guilty and my charming bartender agreed to waive my bar bill in exchange for doing a pair of "body shots." (I'd never heard this term before, but he explained that it meant you pour the shot onto the other person and drink it from their body.)

He had me sit back against the bar and he poured the shot into the hollow of my neck. Oops! It dribbled all over my breasts and stomach and even down into my shorts. Well what's a poor southern gentleman to do but find and lick up every drop? And to keep my word, of course, I was honor-bound to do the same.

In any case, playing with the accent, even so lightly, really made the scene.

But most of them terrify me. The most recent was the worst. He had a long, unpronounceable (to me, anyway) Eastern name – he was from Pakistan – and his name sounded something like Natjilethalnfgpammsdlkghrah.

"And what do people call you?" I asked, trying to sound casual.

"They call me Natjilethalnfgpammsdlkghrah."

Oh please oh please, some deity, please help me out here. Then came the very longest pause of my entire life while I tried to muster myself to say it.

He must have sensed my desperation.

"Well, some people call me Nat."

Thankyouthankyouthankyou.

"Well, great, Nat. Tell me a little bit about yourself."

I'm not sure I can convey the accent accurately, but it was your stereotypical Pakistani/Indian type accent. It was strong, but his English was excellent and I understood him perfectly.

I asked him what he was wearing.

"You really want to knoh bwhat I am really weh-ring?"

"Yes, I do."

"Well, my gell-friend left behind sohme tings end I em weh-ring her bra end penties."

He had domination fantasies. He wanted to be "spenked," tied up, bent over, and fucked with a strap-on "deeldoh." I obliged, but I did a really lousy job of it. He didn't react much and nothing I did seemed to interest him. Not that I blamed him, mind. I think it was my worst call yet. I just couldn't get past the accent.

I consoled myself with the thought that I'd obviously done such a terrible call for him that he'd never phone me again.

Of course I was wrong. He called a few days later and I froze. I desperately did not want to do the call. Luckily (for me), he asked if he could just call me back from the other room, and then I didn't answer the phone when it rang again. I felt badly about it, but I just couldn't do it.

15. Size Matters

Instant Message from ShortStuff

ShortStuff: Hi, Kristi, do you do role-play?
Kristi: Sure!
ShortStuff: Well, mine's a specific fantasy.
Kristi: Oh? Tell me.
ShortStuff: I dream about a giantess.
Kristi: A giantess?
ShortStuff: Yes. A woman who can shrink me down to fit in the palm of her hand.

I didn't get it at all. It made absolutely no sense to me. After a few minutes of floundering, I asked him to write me an e-mail describing his fantasy, but he never did. I wasn't disappointed.

I mentioned the giantess thing to Rachel the next day. "He wanted to be small enough to fit in my palm," I said.

"Or other places," she observed.

Oh. Of *course*. How the hell did I miss that one?

"Maybe I'll send him to you," I teased her. "You seem to understand him."

"Sure," she answered. "I can think of stuff to do for him. Let him hang from my giant nipples."

We laughed. Having a friend in the business really helps sometimes.

☎

This guy's profile said, "Just call me Big Todd." We had a nice online chat, and he admitted that he occasionally called phone girls.

"What do you like to talk about?" I asked.

"Well I have two fantasies," he began. "One is mostly vanilla, and the other one is pretty out there."

"Tell me the out there one!" I said enthusiastically. "I like out there." I figured it for something BDSM-related, since he'd used the word vanilla.

"I like to imagine shrinking a woman down until she's really small."

Great. Too bad this was a guy or I'd send him to the giantess fantasy boy.

"How small?" I asked.

"It depends," he answered. "Doll-size, or sometimes much smaller. Different women like different sizes."

How many different women like this at all?

"How small do you think you would like to be?" he inquired.

Think fast.

"I'm not sure," I answered. "I never really thought about it." I remembered the image that the giantess guy had given me. "Maybe small enough to fit in the palm of your hand."

"Or maybe even smaller," he said with a grin.

"What do you do with the women you shrink?" I asked.

"Well if they want to be doll-sized, I usually give oral. But I have... other things I like for the really tiny ones."

All sorts of wild and semi-unpleasant thoughts flitted through my head.

"Like what?"

"Nah," he teased. "It has to be a surprise."

He promised to call me soon.

Oddly enough, as I was poking around online that very night, I came across an article about giantess fetishes. I read it, fascinated. It was about men who fantasize giant women – huge, stomping creatures who can squash them with a single toe. It even gave these men a name: macrophiles. And it provided a list of links to macrophile sites.

Curious, I popped over to Yahoo and entered the world "microphile." Maybe the reverse also exists. A bunch of sites came up, and they were all named some variation on "The Incredible Shrinking Woman." Wow.

I clicked onto the first site, and sure enough there was a picture of a scantily dressed woman sitting in the palm of an enormous masculine hand. I'll be damned.

☎

When Todd called, he didn't want to tell me about his fantasy in advance, he just wanted to role-play.

"It's your first visit to the bar," he began. "You came here because you heard it was wild, that all kinds of amazing things go on."

"Mmmmm, I like it already."

"All around are people in leather, spikes, all sorts of wild clothing. It's loud. You make your way to the bar, order a drink, and turn to have a look around."

I could see it. The crowds, the lights, me glancing lazily around the room.

"I catch your eye – you notice me right away."

"Oh?" I inquired, teasingly. "Because you're gorgeous, right?"

"Exactly!" he replied. I could almost hear his eyes twinkling.

"Mmmmm," I replied. "And what are you wearing?"

"A business suit, very sharp," he answered. "But it's not the clothes that attract you. It's the come hither look."

I approached his table and smiled.

"You look new here," he said.

"I am. It's my first time."

He smiled at me. "I love redheads."

"What a coincidence. Mind if I join you?"

"Please do."

We sipped our drinks, smiling at each other, making small talk for a few minutes. Then:

"You're very beautiful, you know. Are you interested in an unusual experience?"

"I like unusual experiences. What kind?"

"Let's just say it's the ultimate in submission."

I was silent for a moment. "The ultimate?"

"Yes," he replied. "Are you up to such a challenge?"

An odd moment. I actually considered saying no.

"Well," I drawled, "I always did love a challenge."

He looked into my eyes, stood, and held out his hand. "Come with me."

He led me back into the hallway. There were many doors on either side, and he escorted me through one and locked it behind us.

"Why are you locking the door?" I asked.

"So no one disturbs us."

"I see. Should I be scared?"

"No," he said, then added, "Not yet."

"So what happens now?" I asked. The scene felt very real. I could feel my own tension in the small, locked room.

"Make yourself comfortable on the bed there. How about if I pour you a drink?"

"All right," I answered. I kicked off my shoes and stretched out on the bed, back against the wall. "What are you having?"

"Well, I'm just having some bottled water. But please, have a drink. What would you like?"

Another odd, disjointed moment. I don't drink. But I suppose Kristi does. What would I like to drink? My mind refused to work. What do people drink normally? I have literally no idea at all. Oh wait...

"I'll have a glass of white wine."

"Excellent. I have a lovely white here. A toast."

I took the glass. "What should we drink to?"

"To adventure."

"To adventure," I agreed. I already knew the wine was drugged. And so did Kristi. But the fantasy girl didn't. How many personas did I have going at once?

We drank and he watched me closely. He put on some soft music.

"Would you care to dance?" he inquired.

"All right," I agreed. "I'd better put my shoes back on."

"Yes," he said. "As you step into your shoes, you notice that they feel a bit looser than they used to."

I didn't react.

I stepped closer to him, and he put his arm around my waist, drawing me against him. I slid my arm around his neck, swaying with the music.

"And you notice that your shoes are feeling even looser."

"Something... strange is going on here."

"Just relax, there's nothing to worry about."

"Okay," I whispered.

"Your clothes are starting to feel loose too. You feel them hanging on your frame, but you don't get worried until suddenly you feel your panties slip down your legs."

"What's happening?" I sounded scared.

"It's okay," he soothed.

"No," I insisted. "Something's going on. I feel... funny."

"There's nothing to worry about."

"Did you... did you put something in my drink?"

"Yes, I did," he answered, matter-of-factly.

I stepped back and pushed him away.

"What was it?" I demanded.

"It was a shrinking agent."

"A what?"

"Surely you realize that you're getting smaller."

"What are you doing to me? How small will I get?"

"Don't worry. You'll become about 12 inches high."

"12 inches!"

"You did say you wanted an adventure, my dear. The ultimate submission, remember?"

"Yes..." I paused. "Is it... temporary?"

"I have the antidote, it's all right."

I tried to relax.

"How big am I now?"

"Oh, about... about three feet tall. Your clothes are quite large on you now. They look very uncomfortable tenting around you."

"They feel heavy."

"Here, let me help you out of them. There, doesn't that feel better? Let me help you up onto the bed. Now just relax as I get out of my own clothes."

"Oh, everything looks so strange... so big."

"I'm naked now, and I join you on the bed. You look so small and sexy lying there against the pillows."

"I... feel a little sexy. So tiny... so small and helpless..."

"Mmmmm, good girl. Now spread your legs for me... that's right... I'm going to put my cock inside you so gently..."

I gasped. "Ohhh... it's so big...."

"That's right," he said softly. "It's very big inside you... and you're so small and tight..."

"Ohhh.... yessss...."

"And you're still getting smaller...so it feels like my cock is expanding inside you."

Wow. Now that *was* sexy.

"Every time I thrust into you, it's bigger and bigger... you're getting smaller and smaller... so tight that it almost doesn't fit..."

I gasped and moaned and almost cried a little...then after a moment I sensed that he was waiting for something, so I tried, "Oh pleeeease... it's too big... take it out...."

"Ahhhhh, I slip out of you... you're getting so tiny... I lean down and put my head between your little legs and press my tongue against your tiny little pussy..."

"Ohhhh... ohh yesss...."

"My tongue is enormous against you... it covers your entire pussy with every movement... I can lift you with my tongue..."

"Ohhhh god.... ohh yesss yesss...."

"Now come for me, my tiny little Kristi... dance on my tongue for me..."

What a wild image.

"And as you're coming you're getting smaller still... until you're only about 12 inches high. Oh, good girl, Kristi, you look so beautiful like that... I pick you up in my hand and let you sit in my palm."

I enjoyed that. It seemed like a fun place to be.

"Oh, this is so amazing," I said. "Your fingers look so big! I put my arms around one of your fingers and squeeze, just to see how it feels."

He sounded amused, chuckling almost indulgently.

"Now, would you like to try being even smaller?" he inquired.

"Oh... umm..."

I was a little disappointed. I wanted to play more. I wanted him to put me on his cock and let me straddle it, and then climb up his chest hair.

"I'd like to make you very, very small..."

Damn. Got to be a phone sex operator. "How small?"

"A quarter of an inch. Maybe smaller."

"Oh, that's tiny!"

"Yes, it is. Here, be a good girl and open your mouth."

I obliged.

"I take a drop of your wine on my finger and let it roll into your mouth. Just a drop is all you'll need."

"Oh, it's happening so much faster this time... I can see everything changing around me..."

Let me just stop the description right here. Up until now, the scenario had been a little silly and a little sexy. But then the next question he asked me was whether I liked "facials." Bleh. I have to say, I don't even like the "come all over my face" thing when I'm five feet tall. Bathing in semen does not sound like my idea of a good time.

But I had to be a professional, so I obediently oohed and ahhed over the idea, and let him put me, er, on the inside of him.

As you may have guessed, my imagination sometimes tends to run on its own, so I immediately started feeling like I was in a dark cave with a long passageway. I suppressed a giggle and resisted the impulse to jump up and down and bang on the walls.

He started talking about jerking off with me on the inside.

"Oooh... I can feel your cock moving..."

I'm Princess Leia from *Star Wars*! (Remember when the ship started shaking and they realized the cave wasn't a cave?) I pictured holding my itty-bitty arms out for balance. My god, it's an *earthquake!* Hang on!

But wait! What's that big rumbling sound? I'm Indiana Jones. "I've got a baaaaad feeling about this..." Oh no... what's that rushing towards me? Ruuuuuuuuuuuuuuuuun!

Okay, okay, I'll stop making fun of it. After all, that must be what it feels like to get shot out of a cannon. Um, a really wet cannon.

But instead of flying across the room to land in the middle of a pile of cotton candy near the lion cages, I apparently landed on his stomach. Ah well.

"And now you start to feel the drug wearing off," he said. "You're growing, expanding, bigger and bigger, and you're lying on top of me, naked. And just as you're back to your regular size, I wrap my arms around you and kiss you."

That was even sort of romantic.

When I wrote him his note the next morning, I included a picture of Kristi. A very, very tiny one.

Todd has become one of my most faithful callers. When he got a raise and a promotion, he called to celebrate, and I actually felt funny about it, like it was too close to real.

That evening he shrunk me down so that I could fit in his shirt pocket and he took me to his new office. I could just imagine Kristi

149

sitting in his pocket, arms folded, peering out over the edge of the fabric.

He sat down in his chair and put me on his desk. I felt like I was in a big playground. I tiptoed on a pencil like a balance beam, I climbed around on his phone, and I bounced up and down on his stapler. He laughed tolerantly, exactly as you'd laugh at a little kid in a toy store. Then he started to tell me about his old boss, whom he described as a real bitch. He wanted to celebrate his promotion away from her department by playing a fantasy about her with me.

He began the scene with her coming in to berate him about something. I hid behind the pencil cup and watched. He let her rant for a few moments, and then pressed a hidden switch on his desk. He explained how she was beginning to shrink. With great satisfaction he described the outrage and fear she felt as she shrunk right out of her clothes and down to doll-size. With one hand he picked her up – naked and shrieking and kicking – and plopped her down on the desk.

"Well, Kristi," he said, "She doesn't seem so powerful now, does she?"

I laughed. "What should we do with her?"

"Anything you want," he answered. "I want to watch."

"Ooooooh," I exclaimed. "Fun!"

I considered, casting around for ideas on the desk. What would make a good toy? Then I had an inspiration.

"Make her sit on the tape dispenser!" I said. "With her legs hanging over on those pointy edges!"

He laughed loud. It was that "Man, Kristi, you sure are outrageous" laugh that I get occasionally. The last time was when I told a caller that I had new nipple clamps that I bought off eBay.

"You're really mean," grinned Todd, but he dutifully scotch-taped his miniature captive down, wriggling, to the tape dispenser.

I taunted her for a few minutes, and was just about to start bending paper clips into mini-handcuffs when he got impatient and took over. He shrunk her to half my size and made her pleasure me in a variety of ways while he watched. Finally he kicked her out of the office. He seemed immensely pleased with the image of the tiny little bitch sobbing and scurrying away.

He turned his attention back to me and told me how sexy it was to watch us together – little and littler.

I suggested that he pick me up and put me on his shoulder. I'd just watched *Hook* on TV and wanted to try out some good ideas that I'd gotten from seeing Julia Roberts as Tinkerbell. I stood on his shoulder and whispered nasty stuff in his ear. He seemed to like that, so I kissed my way down his neck, with hot, teeny tiny kisses that made him shiver. I enjoyed myself, describing how I would unbutton his shirt (the buttons seeming very big in my hands) and nibble my way down his body.

He had to help get his pants off, since they were completely out of Kristi's scope at the moment. He didn't seem to mind. I stood on his thigh and stripped off my doll-sized clothes, twirling around to show off my petite little naked body.

Now, ever since the first time this guy had called, I'd had this fantasy about him. I wanted to sit on his cock, straddling it, and then lean down and wrap my arms around it. I don't really know why, but that image followed me around for months.

So I did it. I wasn't sure if he would like it, but he did. I just wrapped my whole body around the length of his cock, hugged it, and gave him, well, not a hand-job, but a full "body-job." It really was erotic. For me, it was all about imagining and describing the sensation. Where would my breasts be? If I wrapped my legs around his cock, which parts of me would rub where?

From the sound of it, he enjoyed himself too.

His most recent call was different. After a minute or so of chatting, he asked, "Heads or tails?"

"Tails!"

He chuckled. "Well look at that. It's tails!"

"Ooh, what does that mean?"

"It mean," he said, "that you get the shrink ray today."

"I get to shrink you?"

"Uh huh."

"Oh my..."

I had teased him about shrinking him down to size, but I never expected him to want to do it.

"Todd, how tall are you?" I asked.

"About 6'2"," he replied.

"Mmmm," I whispered. "I'm 5'8", you know. And first I'm going to press this little button and shrink you down just a little bit, just so you're the same height as me."

"Oh?" he asked, sounding aroused and a little surprised.

"Mmmm hmmm," I answered. "Just for now. I love the feeling of being mouth to mouth... chest to chest... hip to hip..."

I've learned a great deal about sex doing calls, and I'm really stunned to find myself so aroused by some of these unusual kinks. I mean, the first time the guy called with a giantess fantasy, I laughed for a week. The idea seemed ludicrous to me. I'm beginning to form a theory, though. I think that people with fetishes see all the subtle variations of their fetish activities in a way that people who don't share their kink don't. Or maybe it's that conveying the subtleties are the key to making vanilla partners understand. Most any unfamiliar kink seems weird and even laughable. We just see the gross outline, which doesn't make any sense.

This shrinking business is the same. It isn't just, "*Bam!* You're two inches high, so crawl inside me." I find nothing arousing about that. In fact, it seems ridiculously unsexy. But shrinking him little by little, seeing where his hands and mouth ended up at every stage, noticing how small his hands were in relation to my various body parts... it was a whole different story.

So we spent a bit of time kissing, lips at the same height, and then I shrunk him a bit more so that his mouth ended up conveniently placed at my breasts. Coincidentally, his arms wrapped perfectly around my ass in that position.

I was impatient then, and suggested that he remove the shirt that had become so baggy. He resisted and said that if I wanted him out of his clothes I'd have to shrink him out of them. I was agreeable. I sat down and leaned back in a chair, pressed the imaginary button at my side, and watched him reduce down to about three feet tall.

This was quite a good height indeed.

He disentangled himself from his pile of clothes, approached the chair, and proceeded to demonstrate exactly what activity this height was conducive to. He used his mouth first, then slipped his entire hand inside me. (I've never liked the idea of fisting, but this was a very small hand!) I squirmed and moaned obligingly, but in truth, I was enjoying the fantasy.

For the next logical step, I shrunk him down to, as he puts it, doll-size. This was small enough for him to fit in the palm of my hand, so I

leaned down and he climbed on. He moaned audibly when I described picking him up. I lifted him first to my breast, where he held my nipple between his two hands, kneading it and kissing it. I imagined the tiny hard fingers pressing into my soft breast and the pair of small lips opening wide to encircle my hard nipple. Lovely.

Finally I lifted him off and placed him on the chair between my thighs. He had mostly let me do the talking to this point, but he'd clearly imagined this particular scenario before, because he became very descriptive. He told me how he'd run his whole body up and down my pussy lips before parting them with his hands. He described my clit overflowing both his palms, and trying to take it all in his mouth.

I have to admit, at this point I was losing interest. I've just never been one for detailed gynecological descriptions, and when he stuffed his whole body inside me (feet first, which somehow surprised me), I'd had enough. By the time he described emerging covered in slick bodily fluids, I'd really had enough.

But I obediently allowed him to believe that I had an orgasm with his whole body inside me, and then took a cue from my first call with him. I enlarged him until he was a reasonable size, then pulled him against me and whispered for him to put his cock inside me.

He did, and I set the enlarge button on "slow automatic." I described his cock getting larger and larger inside me while his arms wrapped farther and farther around me. I didn't press the "stop" button until he was just a little larger than he normally is.

He grinned at me, and said he'd keep the extra inch or so for a while.

16. Yours, Mine and Ours: Three Stories of Masturbation

Yours

I only recently realized how much I hate the places and times when I have to keep large parts of myself concealed, and how much more relaxed I feel around people who know about both my phone sex work and my kink.

With some people it's just not practical or desirable to tell all. People often ask if my parents know I do phone sex, and indeed they do. When I first started, I didn't intend to tell any of my family about it, but I made a dumb mistake almost at once. I get a good long-distance rate on the phone sex line, so I called my mother from it one night. I forgot that she has caller ID, and I hadn't blocked it, so she immediately said, "What number are you calling from?"

I told her I got a new phone line for my computer, but please not to call it. (I couldn't come up with any reason why she shouldn't call it, though. It was not me at my quickest.)

Over the next few days I grew more and more uncomfortable, saying that nothing was new and that life was as boring as ever, until I finally decided to tell her. My parents have always been open-minded, and she took it well. Her biggest concern was safety. Even though I assured her that the phone number is unlisted and I'm using a fictional name, details, and pictures, I think she's nonetheless worried about stalkers and such.

"But you're not going to meet any of these guys, are you?"

"Mom, they think I'm 22 and gorgeous."

"But still..."

"Mom, I promise, I have no plans to meet any of them ever."

At the core she's fine with it. The next time she called me, she asked for "Bubbles."

I waited a bit longer to tell my dad. The only reason I decided to tell him at all was because I'd been wailing to him about my financial woes for months, and suddenly I was doing fine.

He came to visit me, and I decided to break the news in person. He was surprisingly enthusiastic about the idea, and thought it was a terrific way to make some extra money on the side. I think he just pushed away the thoughts about the actual calls and concentrated on the business end.

I had to laugh, because while my mom didn't want to know any details, I spent two hours discussing it over dinner with my dad. He was interested in all the business arrangements, how I advertised, and exactly what Trisha does for her percentage. He pulled out a pen and started calculating my quarterly tax liability on a napkin right there in the restaurant, based on average call times. It was pretty cute.

He also came up with the brilliant idea that my experiences would make a great book. I guess it's true what they say – the apple doesn't fall far from the tree.

So my parents know about my phone sex work, but not about my kink. I don't have any reason to believe they'd object, but I haven't had the urge to tell them. Most of my close friends know both things – at least, the friends that I spend any significant amount of time with. I can't imagine trying to cover it up. It would make me feel profoundly uncomfortable, as if I had to watch what I said all the time.

I once spent a weekend at the beach with some friends, including Rachel. Rachel doesn't tell everyone about her phone sex work, and out of respect for her I don't discuss it when certain others are around. While I know that I'm allowed to tell people about my own life, I'm always afraid that if I even mention it, I'll slip up somehow and "out" her.

It was a weekend full of good-natured double and triple entendres, and there were many opportunities for phone sex jokes. I mean, when you're skinny-dipping with another phone sex babe in broad daylight, how can you help imagining how the story would sound to a caller? But I suppressed the comments, and contented myself whispering the occasional remark to Rachel on the side.

It bothered me more than I expected. It's not that I want to talk about phone sex all the time, but I actually consider it the most interesting thing I do right now. It's a big part of my life, and it falls naturally into my conversation as often as my regular job does. I don't like having to hide it.

On Sunday afternoon some of the others went home, leaving only people in the know. Jake, our friend Brad's new boyfriend, learned about our phone sex work for the first time that weekend, and he seemed to find the idea exciting.

I found it particularly interesting to talk about straight phone sex with gay men. Most people I've spoken with before have been interested in the women or the fantasies – the callers are incidental. These guys wanted to know about the men, a fact I suppose shouldn't have surprised me.

Who are they? What do they do while they're on the phone? How do they react when they come? Those were the kinds of questions Jake asked. The difference was subtle, but distinct. For example, when I mentioned that the most frequently requested act was anal sex, I had to clarify that it was me on the receiving end.

The conversation got even more absorbing when Rachel and I started to gripe about how difficult it is to handle the "tell me what to do" callers. These are the guys who don't want fantasy or role-play; they simply want to be told how to masturbate in excruciating detail.

"What do you say?" asked Jake.

"I tell them to touch themselves," I explained. "And how to do it."

"You mean like 'now feel the vein,'" he asked, "or 'play with the slit' or 'rub your finger around right under the ridge?'"

"Right," I said, admiring his ease with the subject. "But now imagine keeping that going for 20 minutes."

His eyes met Brad's, and they both shrugged. "Well it's probably much more difficult for them than it would be for us," said Brad.

True enough. I'm sure a man could more easily instruct another man about how to touch himself. More familiarity with the equipment.

"You just said a whole bunch of things I never thought of," I said to Jake. "I wish I wrote them down."

Brad laughed knowingly and remarked, "You should send these guys to me. I'll tell them what to do." And he'd probably enjoy it more than I would, I thought enviously.

I went on to tell them about Zach, my most frequent "tell me what to do" caller. Zach is probably my only regular caller that I'd define as submissive. He doesn't want humiliation or any of the other aspects of domination that I find difficult, so I generally enjoy our calls.

Some guys claim to be submissive, but they only want you to order them to do exactly what they want to do anyway. I'll say, "Now pick up those clamps and attach them to your nipples," and they say, "Oh, please, Mistress, may I put them on my balls instead?"

The first time I said no, thinking that the begging was part of the game. The guy immediately dropped his role and explained that he didn't like clamps on his nipples and I shouldn't make him do that.

"Alright, slave, now grab your balls hard and squeeze them in your hand!"

"Please, Mistress, may I stroke my cock instead?"

Fine, fine, whatever. It's their money, obviously. But they sure aren't submissive.

Zach, though, really does want to be told what to do, and his first few calls were easy. He told me what he likes, gave me his boundaries (no pain), described the dildo he uses, and I took it from there.

The problem was that I exhausted my imagination pretty quickly because he wanted something new every time. We did ice. We did toothpaste. I had him masturbate through his clothes, and facedown against the sheets.

One inspired night when Zach forgot to have his dildo ready, I told him that as a punishment, he wasn't allowed to touch his cock with his hands. He was sitting on the floor at the time, so I made him rub himself against the carpet until he came. It was pretty intense because the carpet was just uncomfortable enough to make it difficult for him, and he felt very dominated.

But eventually I just got stuck. I tried to get him to tell me his other fantasies, or talk to me in a different way, but he wouldn't. Once I really pushed and he remarked, "You're different today. Not your usual dominating self."

"Is that a hint?" I teased.

"Well," he said. "Actually yes."

I sighed and racked my brain for something new.

Finally, in desperation, I wrote to Trisha for help. I simply could not think of anything else to do with him. As I hoped, she was full of suggestions.

Have him stroke into a condom or use rubber gloves, she recommended. Have him buy your panties, or fuck his pillow. Tell him to put his cock between the mattress and the box spring, or send him naked out into his yard.

Her last suggestion was a complicated scenario involving lotion, Saran Wrap, a washcloth, toothpaste, and a basin of hot water.

I avoided him for a while, but he kept calling. I decided to try just the Saran Wrap and the lotion without any of the other complicated stuff. He was clearly startled when I inquired if he had any Saran Wrap, so I asked if he'd tried it before.

"No," he answered. "I never thought of that. It's just funny because I bought some at the market just an hour ago."

"It's fate!" I declared. "Go get it, and some lotion too."

It only took a moment. "Okay, I've got it!" he giggled, excited. A kid with a new toy.

"Great! Now, wrap up your cock!"

I suddenly couldn't remember whether the lotion was supposed to go on first. I started to worry. Could he actually do any damage to himself if I ordered him to do the wrong thing? I had a vision of his cock turning blue from suffocation. I could just imagine the headlines.

I told him to leave the head uncovered.

He was already getting hot. I could hear his moans, and in the background, the absurd tearing and crinkling sounds of plastic. I tried hard not to laugh and utterly failed. I had to bite my lip and cover my mouth with my hand.

"Should I wrap my balls up too?" he asked. I wasn't sure, so I said no. Better safe than sorry.

It seemed to take a long time to encase his cock. The crinkling noise continued until I finally asked if he was done. He sounded a little sheepish as he explained that his first try had looked all wrinkly, so he had unwrapped it and started again.

He lubed up his hands with lotion and went to work on the Saran Wrap. He liked it a lot – said it felt wonderful and smooth. After awhile I had him tear a small piece of plastic from the roll, put lotion on it, and

rub it loosely over the head of his cock. He went into raptures then, and came hard.

"Oh Kristi," he breathed. "You always have the best ideas."

Great, I thought, just great. Now I need something new for next time.

I told the guys about the Saran Wrap Incident. I thought they would be scornful, but they actually seemed somewhat interested, and I wondered idly if Saran Wrap would be making its way into their bed sometime soon. I told them about the next call too, when I made him fuck his bed as per Trisha's other suggestion. Again I expected disbelief and disdain, but they both nodded as if approving of the concept.

"But now I'm so incredibly out of ideas again," I complained.

Brad smirked and nodded, pointing at himself. Yes, I know. Send them to him.

"I've done toothpaste," remarked Jake. "Toothpaste can be fun."

"But you have to be careful with toothpaste," I said.

"Oh yeah," agreed Jake emphatically.

"Where do you put the toothpaste?" murmured Brad curiously, aside to Jake.

"On your dick," answered Jake quietly, amused.

"Yeah," I went on. "Toothpaste was before Altoids."

"*Altoids?*" asked Brad incredulously.

"The curiously strong sensation..." I teased, and Jake grinned toothily. Brad made a face that clearly said, "Forget it!"

I still want to tap into that wellspring of male masturbatory reference material. I think Brad is too self-conscious to actually talk to me about it in detail, but I might just have to take Jake to lunch one day.

Hell, it would even be deductible as a business expense.

Mine

Of course the biggest question on everyone's mind, whether they ask it or not, is this: Do you really do it? Do you ever get turned on? Do you masturbate while you're on the phone? And... do you ever *(gasp)* have an orgasm, too?

Well, here it is, the inside scoop.

Yes.

Shall I elaborate? Well, okay, here goes.

Do I ever get turned on? Yes, often. Not always, but often. I mean, it's phone sex – it's sexy. I can't imagine *not* getting turned on.

Do I masturbate while I'm on the phone? Yes, often. I don't always do what I say I'm doing (in other words, I'm not shoving a 13-inch dildo inside me), but for many calls I do just let my hands wander lazily. It's almost impossible not to – I'm lying in bed talking dirty with a guy – my hands just naturally do what they do.

Do I ever have an orgasm? Yes. But almost never. First of all, lots of the calls aren't long enough. But mostly because the phone takes so much of my attention and effort that even if I'm very aroused, I can't concentrate enough on myself to get over the edge.

My most memorable masturbation call was with Drew – you know, Drew of the short spankings and the long gangbangs. He sent me a message online, asking me if I'd done anything lately that I needed to be spanked for. I gotta say, I just wasn't in the mood for an orgy. I was interested in talking to him, but those group scream-and-moan fests are exhausting.

I wondered if I could get him interested in a call without all the complicated role-play. I messaged him back that he ought to call me just "because." I told him that when he came out of the shower I'd be waiting for him, naked, facedown on the bed, with my legs spread. I didn't know if he'd go for it, but he did. In a big, big way.

"I wonder...."

"Yes?" I encouraged him.

"I wonder how you'd feel if you rubbed yourself all over with ice."

Oh my.

"Probably ice would be really cold on your nipples, too."

I whimpered at him online, but he was having none of that. The dominant had appeared.

He was calling in five minutes, he said. Before he called, he wanted me to strip down to just a pair of panties and set out some assorted toys, including a dildo and a glass of ice.

"Get into bed," he said, "and take an ice cube and run it all over your panties, so that they're nice and cold and wet by the time I call."

There was absolutely no chitchat – we were both way too hot for that. He first wanted to hear the ice clinking in the glass. Then he made

me rub the ice over various parts of myself (er, externally and internally, cold cold *cold*) and touch myself all over.

This went on for several long minutes; we were both breathing heavily. During our previous calls he'd always made the sound effects, and he was really finding the genuine noises erotic.

A few minutes into the scene he asked if I had the dildo handy. Yes, I did.

"Put it in the glass of ice. Let's get it nice and cold for later."

Oh. My. God. Even with all my perverted fantasies and readings, this never occurred to me. I couldn't even imagine what that would feel like. I whined, but he insisted.

I slid the dildo into the glass of ice. I shivered just watching it. We had a few more minutes of fingers and ice and a vibrator and hot talk and then...

"How's that dildo doing?"

I touched it with dread. "Um, cold. Very, very cold."

"You know what I want you to do now."

Pause.

"Yes."

"Do it."

Ladies, if you've never felt an ice-cold silicon dildo inside you, let me just warn you that this is *quite* an experience. Especially if you have to hold an ice cube next to your bare nipples at the same time. And especially if you then have to leave the dildo inside while you use your vibrator.

I actually had an orgasm talking to him. First time. Not a little wispy one, either – a great, big mind-blowing one. I never expected that to happen. It was pretty amazing.

The funniest thing was that he had to ask me if I'd come or not. None of the guys have ever had to ask before. I guess my fake orgasms sound realer than my real ones.

Ours

A Saturday night. A call from a lively spanking person, with the classic "my wife doesn't understand" dilemma.

We chatted for a while; he seemed in no hurry. Once I started to relax and ask questions like, "How's the weather in Hawaii" instead of

"So what would you like to talk about?" I've found that most callers seem happy to just chitchat for at least a few minutes.

This guy was friendly, and I enjoyed talking with him. He's a switch, he said. I told him real life scene stories, and he reciprocated. We commiserated about the trouble with non-kinky partners.

He told me about his wife, whom he said was very open-minded and had willingly tried spanking. She'd gone along with it for a while, he said, but in the end she got bored with it. He got bored too, he said. It just wasn't that much fun to spank someone who didn't really want to play.

His wife knew his interest remained, but not that he pursued it in any way. But she was out of town for the weekend, and was I game for a spanking? I was enthusiastic; I'm always game for a spanking, I told him.

He asked me to put on a pair of high heels – a *very* common request – so I went rummaging through the closet offering him choices. (You want suede? I have shiny black patent leather with zippers. Verrrrrrry kinky!) We laughed a whole lot, and every once in awhile remembered that we were supposed to be working up to a serious spanking fantasy. We tried unsuccessfully to stop giggling.

Once the shoes were straightened out, he asked me if I had ever been spanked with a rubber spatula. I hadn't, but I knew it was supposed to hurt quite a bit. Did I have one, he asked? I replied that I did, but that it lived in the kitchen, not the toybag.

"Go get it," he said.

"Now?" I asked.

"Yes, now," he replied. "You're getting a spanking, remember? Rubber spatulas make a great sound."

Ah. He didn't want a fantasy. He wanted to hear me smack myself. I was actually a little nervous. I shyly admitted to him that I'd never done it before.

The prospect excited both of us, and I enthusiastically pulled out the toybag and described the contents. He chose a belt, along with the rubber spatula from the kitchen. He declined the ping-pong paddle on the grounds that it wouldn't hurt enough – damn, I thought, this guy knows what he's doing – and suggested that I have the paddle with the holes handy "just in case." I never should have mentioned it.

"Do you have the shoes on?" he asked. I did. I suppose I could have just pretended to put them on, but I was enjoying myself.

"Pull down your panties," he said. "And spread your legs."

Ohhh, I like it already.

"Take the belt," he went on, "and give yourself five strokes on your right cheek, down low."

"Okay," I whispered, starting to sink into subspace a bit.

"Wait," he said. "Keep the phone near your mouth so I can hear you. And remember, if I can't hear the stroke, it's not hard enough and it doesn't count."

That's when I realized that I couldn't fake it. I couldn't think of any way to make the right sound at the right distance from the phone other than actually spanking myself. I didn't want to fake it, but I realized at that moment that if it got intense, I was going to have to do it or tell him I couldn't. He'd know if I pretended. Suddenly the situation seemed ten times as erotic to me.

I reached back and whacked myself with the belt five times.

"Oh, definitely not hard enough," he scolded. "I could barely hear them."

I whined. "But you did hear them, so they count!"

"Five more. *Right now!*" he snapped, but I could hear him smiling.

I obliged, as hard as I could, and only managed a few wimpy swats. Then I started to laugh, realizing what was wrong. I was stretched out on the bed. On my right side with the phone in my right hand.

"What?" he demanded.

"I guess it would help if I used my right hand."

"Are you right-handed?"

"Ummmmm, yes."

He tried to sound stern, but he couldn't. He just laughed.

"Okay, okay," he said. "Serious now."

"Okay," I said.

"Five strokes. With your *right hand*."

I whacked myself with the belt five times, hard, and gasped into the phone. I could feel the sting.

"Oh, now, that's much better," he said. "Yes, that was very good. Five on the other side now."

The spanking went on for at least ten minutes, with the belt and then the spatula. He made me smack myself not only on my bottom,

but also on the backs, fronts, and insides of my thighs. He was clearly an experienced top, and always knew when it wasn't hard enough. He didn't let me get away with anything, and a few times he made me go harder or faster than I really wanted to. I felt pretty well spanked.

I did have one amusing moment that I didn't share with him. Somewhere in the middle of the scene, he told me to bend over farther, as far as I could without losing my balance. He assumed that I'd been standing up the whole time, and since he told me in detail how much he was enjoying imagining me in that position, I decided not to disillusion him.

Just as I was feeling pretty hot and tingling, he told me to pick up the paddle with the holes. I hesitated for real. That thing is harsh, and hitting myself hard enough with it for him to hear would be painful. It never even occurred to me to use, say, the ping-pong paddle instead.

As if reading my mind, he said, "It'll hurt, I know. But I really want you to do it. And you want to do it, don't you?"

He was right, I did want to. And I did. Those few smacks definitely were the most pain I've ever caused myself intentionally. The paddle makes a dull thud, and I had to use it *hard* – harder than I'd let someone else use it on me. It was worth it, though. My reactions were loud and genuine, and aroused him enormously.

I didn't know if he'd come (I didn't think so), but the spanking was clearly finished. I was just breathing deeply, getting my head back together and talking casually with him and laughing. I was sorry the call was over.

"Did you enjoy that?" he asked.

"Very much," I answered honestly. "Although you were pretty mean to make me use that spatula on my thighs," I complained. "That still hurts!"

"Would you like revenge?" he inquired.

"Revenge?" I asked, not understanding.

"Well, I did mention that I'm a switch," he answered.

I was wrong. The call wasn't over, not by a long shot.

"Wow," I said, "I've never done that on the phone before."

He was incredulous. "How is that possible?" he asked.

"I don't know," I replied. "No one ever mentioned it before. But it sounds like fun!" I hastened to add. And it did.

I got right into it, and laughed the evil top laugh. "What kind of toys do you have?" I asked.

He listed them for me, but I don't remember any of them now.

"A belt, I think," I chose, "since that's what you had me use. And by the way, I didn't hear that rubber spatula in your list. Do you have one?"

He grimaced aloud. "Yes, I have one."

"Good," I said, in full top mode. "Get that out too."

He made complaining noises.

"Spanking me first was a *big* mistake," I informed him, grinning.

"Yeah," he said, "I'm beginning to get that idea."

I directed him for a while – left, right, belt, spatula, bottom, thighs. He was very responsive, and made noises I recognized perfectly – ouches and giggles and moans of arousal. I let my sadistic side come out and play, making him spank himself twice on each inner thigh with the spatula. I really enjoyed his yelps.

"Call me again soon!" I said as we hung up.

"Probably not soon," he said a bit wistfully, "but sometime again definitely."

17. Hey, Kids, Try This At Home!

You don't have to call a professional (or be one) to enjoy phone sex. If you and your sweetie are apart, it's a great way to stay close. It's also a good way to play with someone you don't know as well, or are hoping to meet, be but warned – phone sex *is* sex. It can be shockingly intimate, so if you're not emotionally ready to go to bed with a new friend, you might not be ready for a phone encounter either.

On the other hand, phone sex is the ultimate safe sex – no exchange of fluids, and no risk of pregnancy or disease (although my friends teased me mercilessly the time I got an ear infection).

Take reasonable precautions if you're talking to someone you don't know, of course, but otherwise, relax and enjoy the ride.

Your Phone. If you're going to be doing any serious phone sex, you'll need to think about (what else?) your phone. You can use a plain phone attached to the wall, but I prefer a cordless for the freedom it gives me to move around. If you're going to go cordless, don't skimp – the 900 MHz phones are considerably better than the older style 49 MHz. They give you greater range with less interference; believe me, a few bouts of trying to hear your lover through horrible static will make you wish you had spent the extra 20 bucks.

There are, incidentally, new 2.4 GHz phones, which supposedly give you much better reception up to about half a mile. In case you feel the urge to have phone sex from out in a field or a neighbor's house. I can't personally vouch for these – my 900 MHz has always been plenty.

A good feature to look for in a cordless phone is volume control. Lots of phone sex involves whispers and murmurs, and sometimes it's

sexier to just crank the volume a bit instead of asking your partner to moan louder.

If you're planning an extended session, you might want to make sure you have a regular corded phone easily accessible. More than once I've had static overwhelm me in the middle of a call, or heard that horrible beeping sound that means the battery on my cordless is about to die. Picture me frantically running around untangling another phone to plug in before I lost the customer. Not a pretty sight.

If you're very concerned about your privacy, keep in mind that it *is* possible to intercept the signal from a cordless or cell phone. I don't know how likely it is, but if it worries you, stick with a land line.

Hands Free? If you want both your hands to be free for purposes besides holding the phone, you might try a speakerphone. I don't personally like them, because I feel like they take something away the intimacy of the call. But some people do enjoy them, and they're especially useful for domination calls where the top wants to order the bottom into complicated positions.

Another hands-free choice is a headset. I always imagined phone sex operators using them, but I don't, and neither do most of the other workers I've polled. I did test-drive a few different kinds, but I ran into an unexpected snag. Apparently headsets are designed for use while sitting up in a chair, not lounging back on a bed. Every headset I ever tried had one of two insurmountable problems – either it constantly slipped off the back of my head, or the microphone fell into my mouth.

So I use a plain cordless phone, and it isn't as difficult or constricting as it might seem. It's pretty comfortable for me to hold the phone between my ear and my shoulder, though I get cramps if I do it for hours at a time. Often the easiest way for me to work is to lie on my side, holding the phone to my ear against the pillow with my head. Both hands are then free to wander.

So try a headset if you like, but take my advice – make sure it's returnable.

Noise. Noise can be incredibly distracting during phone sex, even more than during in-person sex, because all your concentration is focused on listening. During in-person encounters, you're both accustomed to the same background noises. The city traffic, the ambu-

lance sirens, the next-door neighbor's dog barking, the thunderstorm outside – all of these become white noise that just fades into the background. But when you're having phone sex, sounds you don't even hear can be incredibly intrusive to your partner. I'll never forget the time a caller asked me in amazement, "Are those crickets I hear?" And they were, incredibly loud crickets. I was just so accustomed to them that I didn't even notice them anymore. But he did. I closed the windows.

A word about music: While music is sexy in the background of in-person encounters, I personally find it to be little but a distraction during phone sex. If you do want some background music, pick either you or your partner to use the stereo. The first time you try to listen to two pieces of music at once, you'll know exactly what I mean.

Preparation – The Mundane. Preparing in advance can help make for a much better scene with fewer interruptions from your real life. So disable your call waiting (dialing *70 works in some areas), and turn off your cell phone and your pager if you can. (And really, can't you? Can't work wait for half an hour? If you wouldn't answer it during in-person sex, don't answer it during phone sex, either.) Don't forget to turn down the ringer on your other phone line if you have one. I've forgotten this myself, and have on occasion tried to ignore it, while the annoyed caller asked, "Do you have to get that?"

Do whatever seems best with your pets (mine are quiet if I let them in the room, but yowl continually if I lock them out), and turn off the washer, dryer, dishwasher, and television. Unfortunately the kids don't have an off-switch, so figure them into your calculations the same way you would for a live encounter.

Especially if you're planning a hot phone session in bed late at night, do all your pre-bedtime chores before you settle down for the call. Lock the doors, feed the pets, put away the dinner dishes, and turn the downstairs lights off. That way you'll be able to hang up the phone and drift off to sleep afterwards. Nothing spoils a great afterglow like having to get up and close the bathroom window.

Other mundane preparations: I like to have a glass of water, cough drops, and some tissues near the phone, just in case I start to sneeze or cough – screaming and moaning continuously can be difficult on the throat! Just make sure your glass of water won't be knocked over by an

over-enthusiastic foot or elbow. A splash of cold water on your hot body is one hell of a mood spoiler. (Ask me how I know this.)

Also, if you're messy like me and have clutter everywhere, clear off the bed first. More than once I've been thrashing around only to knock several piles of clean laundry onto the floor. It's distracting.

Preparation – The Sensual. Find a place where you can get comfortable. I find it impossible to have phone sex sitting up at my desk; with very few exceptions, I do all my calls from my bed or occasionally my sofa. My callers usually say they're in bed, too, though occasionally they say they're sitting at their desk looking at Kristi's pictures on their computer.

Set the mood just as you would for a face-to-face encounter – dim the lights, close the drapes, and maybe light a candle or two. (Be careful not to leave a candle where you could knock it over in the heat of passion. The fire department won't appreciate it, and neither will your lover.)

Dress for pleasure, the same way you'd dress for an in-person date. Shower, do your hair, shave (your face, your legs, your crotch…), put on your favorite cologne. Sure it's just you there, but you don't just pamper yourself before an erotic encounter just for your partner's sake, do you? It feels good to indulge yourself, and the better you feel about yourself, the sexier you'll be.

Pick out clothing that makes you feel sexy, too. It can be fun to tell your partner that you're hot and naked for them under the covers, but starting off stripped-down jumps over some of the best parts. It's no coincidence that the stereotypical first phone sex question is, "What are you wearing?"

By the way, phone sex is a stellar opportunity to wear the clothing you dream about but wouldn't be caught dead in. So get that fabulous teddy or that leather jockstrap or that rubber bra you've been ogling. Your partner will adore knowing you're dressing sexy for your phone date, you can describe your clothes in detail, and you don't have to worry about how you think your ass looks fat, or your stomach hangs over, or your knees are knobby. No one will see you except you. Maybe you'll get comfortable wearing it for your partner someday and maybe not – but why deprive yourself of the pleasure of wearing it for them over the phone?

Read Me a Story. Let's say you're shy or inhibited, and you can't imagine talking sexy to your lover on the phone. Don't worry, you're not alone. I had amateur phone sex long before I had professional phone sex, and believe it or not, I could barely open my mouth. The first few times I didn't say a thing. I tried, but all I could do was breathe hard and listen. Occasionally in response to a direct question I managed to croak out a simple yes or no, but that was the extent of my phone sex ability. Trust me, it gets easier.

A good way to ease into phone sex is to read aloud to each other. Reading takes the pressure off your imagination – you don't have to figure out what to say. You can even practice beforehand if you think you'll stumble over those naughty and nasty words.

If you have Internet access, you can find stories about anything and everything fairly easily. Enter the phrase "erotic stories" into a search engine, sit back, and read until your eyes pop. Some are more graphic than others, so you should be able to find one at your comfort level without too much trouble. If computers aren't your thing, there are tons of other sources. Just browse the sexuality / erotica section of your local bookstore and see what looks interesting.

You're too shy and inhibited to buy such obvious sexual material, you say? Well, have no fear. The best kept secret in erotic fiction is the plain old romance novel. Just bring home a couple of paperbacks with drawings of Fabio on the cover, and you'll easily find enough hot stuff for a phone call or ten.

If you're brave enough, write your own stories to read aloud. You don't have to be a literary genius – just write what turns you on. You may find that just the act of writing your fantasies down arouses you more than you expected. Your partner will probably love that you spent all that time writing a sexy story just for them, and it's a terrific way to test the waters on new fantasies. If your partner gets turned on, great! If not, well, it was just a story.

Mutual Masturbation. Some of the most basic (and most exciting) phone sex is simply telling your partner in detail what you're doing to your body and how it feels. Be as descriptive as you can. "I'm tracing my finger around my nipple in little circles... it feels wonderful... I can

feel the nipple getting harder... now I'm flicking it with my fingernail... oh, I just felt a jolt of pleasure right down to my toes…"

You don't even have to talk about your genitals. Tell your partner how you're caressing your stomach or your thighs. Describe the way your long hair feels against your neck and shoulders. Turn over and describe the sensations of the sheet against your legs and back. Everything you do will sound sexy.

If you feel a little shy or silly, try masturbating a bit before the call starts. This will help in two ways; first, you'll be able to tell your partner what you've been doing for the last few minutes (they'll *love* the thought of you touching yourself while thinking of them). Second, the more stimulated you are, the less self-conscious you'll be. You may not be able to imagine saying, "My finger is sliding into my hot cunt," right now, but you might be surprised at how much easier it is in the heat of the moment.

Involve each other in your descriptions. "I'm imagining your fingers rubbing my nipple as you're looking into my eyes..." or "I wish I could be there to watch you play with your pussy lips... put your finger in your mouth and get nice and wet, then put it back down between your legs..." or "I'm rubbing my beard over my hand... it feels all short and prickly… I wonder how you'd react if I rubbed it against your inner thigh…"

If you've been together before, remind your partner about something one of you did in your last encounter. "I'll never forget those blue panties you wore…I could see your soaking slit right through them," or "Remember when you pushed me down against the bed and held my hands above my head last month? I've come a dozen times since then thinking about that."

And keep in mind that you don't have to talk all the time. Once you get going, the sounds of your body and your breathing are pretty erotic just by themselves. There are no words sexier than your gasps and moans.

Role-play. The phone is the perfect environment to share fantasies that would be physically impossible or undesirable in person. You might not really want to fellate an entire football team, or be fucked by a 12-inch spiked dildo, or strip naked in the subway, but in phone fantasy, all things are possible.

One of my favorite callers likes to fantasize that he has magical powers. The calls always start the same – we're hugging goodnight after a pleasant but bland date, when suddenly his arms tighten around me and I feel myself transforming into something or someone else. He's turned me into Pamela Anderson, a tavern wench, a 14-year-old prostitute, a female chimpanzee, a cavewoman, a wet nurse, a big black voodoo goddess, and countless others. I never know what's going to happen next time.

Role-play usually means one of two things, and the difference is the same as between telling a story and acting in a play. You can alternate descriptions:

"And then I hold the glass to your mouth, tipping it forward just slightly…"

"Oh yes, I can feel the wine in my mouth, so sweet and cool…"

"I let some dribble down over your chest, so I can lean down and lick it up…"

Or you can put yourself into the role of the characters:

"Here, darling, open your mouth so you can taste this wine…"

"Mmm, that's delicious! Oh, but you've spilled some…"

"That's all right, let me lean down and lick it up for you…"

Sometimes the difference is more pronounced. If you're doing a rape fantasy, for example, there's a vast difference between "now I'm crying and begging for you to stop…" and "please, please, oh god, please stop, I'll do anything you say…" You'll have to decide together which way feels more natural.

Let your imagination run wild. Have you ever dreamed of being able to fly? Having sex with a movie star? Screwing in outer space? Being Superman or Wonder Woman? Well, go for it! You're limited only by your powers of description.

Enhancements. Are you visual? Send your lover a sexy photo of yourself in the mail or via e-mail. The advent of digital cameras means you don't even need to have photos developed, so no one will ever have to see the picture except the two of you.

You can also find pictures on the web and send them. I have one client who regularly e-mails me pictures of nurses in thigh highs, innocent brides, Catholic schoolgirls – whoever he wants me to be for the

next call. If you'd rather not send pictures of other people, the accessories will do as well. Send your lover a photo of the spike-heeled boots you imagine her wearing, or the police uniform, or the leather harness.

Of course, if you like, you can actually send your phone sweetheart the clothing to wear. It can be very sexy to know that your partner has seen and touched the clothes you're wearing. The clothing might still smell like you or your cologne, and smell evokes very powerful emotions. It's not for nothing that many phone sex operators run a lucrative side business selling their panties, stockings, lingerie, and other personal items.

Send your lover a t-shirt or pair of pajamas (or pair of panties, if you like) that you've worn. If your lover can fit into your clothing, they'll love feeling like your arms are around them. Even just wrapping what you send around their pillow will let your lover breathe in your scent, and make you feel closer together.

Don't forget the most obvious thing to send in the mail – sex toys! Send a dildo, a cock ring, a feather, or a riding crop and listen to your partner use it at a distance. Vibrators are especially good for this purpose, because you can hear the buzz through the phone line.

Tricks of the Trade

So after listening to well over a thousand orgasms on the phone, do I have any phone sex girl sure-fire secrets to share? Why, certainly!

Talk but also listen. I have some callers with whom I can barely get a word in edgewise – they like to do the talking. If your lover is one of those, relax, enjoy, and don't feel like you have to participate verbally – your groans and sighs are the equivalent of applause. If you both like to talk, it can be awkward when you both try to say something at the same time, so leave room for the silences. If you feel like you're stepping over each others' tongues, stay deliberately quiet for a minute or two. Then jump in for a few sentences, but pause naturally to let your partner talk. It won't take you long to develop a rhythm.

Find your partner's hot buttons. Almost everyone has a phrase or two that sends them right to the moon. Some people like to be called by sweet endearments, others by blatantly sexual or demeaning names. Often you'll find a clue in the fetish or role-play. If I'm playing a young

girl, I'll talk about my little hand, or my tiny tits, or my smooth baby pussy. If it's a force fantasy, my partner might like to hear how scared I am. You can usually tell you've hit the mark when you hear a sharp intake of breath on the other end of the phone. Remember what you just said, and say it again.

Delay the main event as long as you can. Believe it or not, phone sex can actually get boring. The stuff that feels the best in person doesn't always make for the best talk, because it's often repetitive. You might want intercourse to go on and on, but there's only so long you can describe the pumping over the phone before you start wondering what's on television. Why do you think actors in porn movies change positions so often? They have to keep your interest somehow other than thrusting over and over and over.

Occasionally I misjudge a caller, thinking he'll be a ten-minute man when he really intends to talk for half an hour or more. I hate when I do that, because if I get to the fucking too fast, I can end up moaning and groaning until I just about hyperventilate. It's exhausting!

So delay, delay, delay. Set the scenario. Seduce your partner, and describe your foreplay in loving detail. Tell them what you're going to do to them. Get each other so hot that by the time the intercourse (or spanking, or fisting, or whatever your main event is) starts, you're both ready to explode.

18. Multiple Personality Disorder

Callers ask all sorts of questions. One of the most common is, "Do you do real life sessions?" They often seem surprised when I say no. Apparently most phone sex girls claim to also have other sex-related jobs: stripper, x-rated model, exotic dancer, escort, hooker.

I suppose this makes sense. It goes along with the "I'm a nymphomaniac" persona that is so apparently appealing to callers. The profiles of lots of these girls say things like, "I just can't get enough" or "*Everything* turns me on, baby!" or "I have 15 orgasms a day and my fantasy is to fuck a different guy every hour on the hour."

It all sounds so fake. Does that sound strange? Obviously it *is* all fake, but I always thought the idea was to make it *seem* real. How else do you sustain the fantasy?

Well, no, of course fantasy doesn't have to seem real, and I suppose that the guys are entitled to their daydream "38DDD, 105 lb. shaved" nymphettes. But guys who want a cookie-cutter fantasy chick don't like Kristi. Kristi's just a regular person, with a real job and real ups and downs. When they ask if her father ever fucked her, she says no. When they ask when she last had a real cock in her mouth, she giggles and tells them it's been a long time. Some of them get confused (Hey, where's my nymphomaniac?) but lots of them laugh and start treating me like a person instead of a fantasy.

Kristi's a bit shy. She did the one photo shoot for the website, but it was difficult for her. She doesn't take her clothes off for strangers, she doesn't do live web shows, she doesn't do lap dances, and she doesn't turn tricks.

I'm astounded by the number of men who ask things like, "Well, wouldn't you make more money stripping than you do working in an office?"

When I tell them I probably would make more, but I still would never do it, they're baffled. Why wouldn't I? I'm a phone sex slut, so why wouldn't I want to be a stripper? Or a porn star?

Sometimes I just change the subject, but sometimes I explain. Kristi enjoys her phone sex job, but she's not going to do it for a living. She's saving up money to go back to school. I go on to explain that I work from my own apartment, alone. No one is touching me. I don't work in a smoke-filled bar, breaking my back and taking off my clothes every night for a bunch of drunk, sweaty guys who are hooting and grabbing at me. I'm home. I'm safe. I'm comfortable. And the worst thing that will happen if someone bothers me is that I hang up the phone and don't pick it up again.

This is a revelation to them sometimes. To a lot of these callers phone sex equals stripping equals lap dancing equals prostitution. It's all the same.

By the way, I have nothing against lap dancers or prostitutes, nor do I think that any of those professions is equivalent to the other. And I don't think it's a continuum either. I can easily see how someone could be comfortable being an escort and uncomfortable dancing on stage. All the jobs are different.

But it amazes me how these callers cannot understand why I'm comfortable talking to strangers on the phone but uncomfortable having strangers touch me. To me, there's a universe of difference. Though I guess these are the same guys who believe that the pictures are real, and that they've made me so hot that I had two orgasms in the first three minutes of the call.

In any case, after I killed off Mistress Nicole, I decided to create a different new character, one that I'd enjoy more. And I thought I'd give the whole phone-nympho thing a try. Why not? Apparently it works for lots of the other operators.

In thinking about what kind of new girl I wanted, I tried to figure out what made Kristi successful. What came immediately to mind was that she's different from the other girls on the site. She's got that great red hair, and there are no other redheads. I knew I wanted to try a brunette (Mistress Nicole had been blonde) and I started thinking about what was missing from the lineup.

I realized it pretty quickly – there were no ethnic-looking girls. They all looked white bread. No Hispanics, no Asians, and only one African-American. I thought it seemed likely that a more ethnic girl would attract a different crowd than Kristi would. Trisha was agreeable. She thought an Asian character would be most successful, though she did caution me about the difficulty of maintaining an accent.

I'd already considered that, and knew there was no way I could pull off an accent. My girl would have to have been born in the U.S., I decided, and grown up in New York. (New York or San Francisco seemed logical as the biggest Asian population centers, and keeping her in Eastern Time Zone would make things less complicated for me.)

Trisha didn't have any pictures of Asian girls. If I found them she promised to pay for them, so I began searching the web. This was an experience in and of itself, by the way. The sheer number of sites offering legal adult webmaster content for sale is amazing.

"We have everything!" they hawk. "Softcore, hardcore, teens, streaming video, Asian, pregnant...!"

And they do. Everything. I was looking for photosets – groups of pictures of the same girl – and there are literally thousands of them for sale. Despite the selection, finding one I liked was difficult. I wanted an Asian girl with a pretty face, who could pass for at least mid-20s (late-20s or early-30s would have been better – I was getting sick of playing ten years younger than myself), and who had a selection of primarily softcore photos. I preferred at least medium-sized breasts, since Kristi is small-breasted and I was looking for contrast.

Most importantly, I wanted to find someone who just felt right. I knew her as soon as I saw her. The site listed her name as Kim, but I wanted to give her a name I liked. I prowled Japanese baby name websites and came up with "Jini," to be pronounced "Ginny."

Jini's Profile
Hi, I'm Jini. I'm 27, 5'4", with long dark hair, a tight, round ass, and 36C tits just perfect for you to suck on. I keep my pussy bare, so it's soft and smooth and always ready.

My parents were very strict with me when I was growing up. I went to private school and wasn't allowed to go out with friends - forget dating! I guess when I moved away from home I went a little crazy trying to do everything I missed.

As soon as I turned 18, I got an apartment with a girl a few years older than me. She just couldn't believe how innocent I was, and she made it her mission to corrupt me. The first night I moved in she took me out to this bar she knew, and I had my first drink and my first cock that same night! The feel of that hard dick sliding in and out of my cunt just about drove me insane, and I knew I could never go back to being a good girl again.

She taught me everything about sex – how to dress hot, how to suck a guy to heaven, and even the pleasures of a little girl-girl action. Our second week together she slipped naked into my bed, kissing me deeply, then burying her face in my throbbing pussy.

We spent three years raising hell and trying every kind of kinky sex imaginable. We got jobs in a strip club to make some extra cash, and at least once a month we'd take a couple of customers home after hours and make them very happy.

I think I got addicted to sex, and now that I live alone I can't get enough of talking to you while stroking my slick, hot pussy. I like to imagine all kinds of dangerous games. I'd love sucking your prick in the back row of a movie theatre, or a hard, fast fuck in the bathroom at a party where your wife is in the next room, or sex with a nameless stranger whose eyes meet mine across a smoky bar...

I can be your naughty little girl or the teenage bimbo taking on the whole fraternity house. Or anything else you can possibly imagine. Oral, anal, threesomes, gangbangs... the kinkier it is, the better I like it!

I don't know how it happened, but Jini turned out to be a valley girl. I didn't plan it. This high-pitched giggly voice just came out of my mouth the first time I got a call.

She sounds like a complete ditz. She's cute, she's breathy, she giggles, and she says things like, "No *way!*" and "I'm, like, soooooooo totally wet!"

I'd been a little nervous about the whole Asian character, and of course, the very first call came from a guy who had spent six years in Japan. He immediately started chattering at me.

"I'm from New *York*," I whined. "I don't, like, speak any Japaneeeeese!"

He laughed.

Somehow this ridiculous, almost dumb persona is sort of freeing. I can say anything, no matter how outrageous, and the guys think it's adorable.

This must be what it feels like to be a trophy wife. The callers are so entranced with my open sluttiness, willingness and good cheer that it just doesn't occur to them to demand intelligence too.

Sometimes even *I* don't believe the things that come out of my mouth. I behave like a nymphomaniacal piece of fluff. A Barbie doll with hormones. But they lap it right up.

"Oh, Jini, you're so hot..."

"Oooh, thanks!" I giggle. "You're fun! Want me to take my top off?"

The breathing deepens. "Um, yes, I'd like that."

"Cool but, like, you have to take yours off tooooooooo!"

An indulgent masculine chuckle. "I think I can arrange that."

"Ooh, you have lots of hair on your chest. I looooove that. I loooove to run my fingers through it! What do you think of my tits? Ya like 'em?"

Strangled sound. "Oh yes, Jini, very much."

"Me too!" I declare. "I like to rub them like this, y'know? And watch the nipples get, like, all hard 'n stuff... and y'know what I *reeeeally* like?"

"What?"

"I reeeeeally like to have them sucked on. You wanna suck on them?"

"Ohhhh <*gasp*> yes, I do."

"Mmmm that feels sooooooo good! I'm, like, soooooooo totally wet right now! Y'know what I wanna do?"

"What?"

"I want you to put your cock inside my pussy, y'know? And get it all good and wet and stuff... and then pull it out right away and then I wanna lick my juices off it 'til you cum in my mouth, 'k?"

Like, wow. Tubular.

I no longer worry about Kristi callers recognizing Jini, because they sound nothing alike. The biggest danger is that I find myself occasionally slipping into the Jini ditz-giggle during Kristi calls, and I really don't want that.

A number of Jini's calls have been specifically Asian-related: a guy who once dated a Korean girl, a guy who fantasizes about his Japanese sister-in-law, and a guy who claimed that only Asian women really know

how to be submissive. I've also had a few overlap callers, mostly men who called Kristi one time several months ago. Some of these also called Nicole, so I think they just call every new girl for the novelty.

I have to be careful with these, because I know more than I'm supposed to. I have to ask for all the information again, even though I have it right there on my index card. And I have to be certain to avoid referring to information they gave me the first time they called. The last thing I need is, "Hey, I never told you my wife's name. How did you know that?"

I had a real challenge a few weeks after starting as Jini. I came home from the supermarket Sunday afternoon and saw a familiar-looking name on the caller ID. I looked it up, and cursed to see that it was Jeremy, Kristi's hot prison guard guy. Well damn, I thought, I missed him.

But only a few minutes later the phone rang again. It was him! But it was Jini's phone, not Kristi's.

For a moment I was actually insulted. How dare he call someone else? What was wrong with Kristi? Why didn't he ever call her back?

Ordinarily I don't pick up Jini's phone if it's a Kristi caller who might recognize the voice, but I had the overwhelming urge to see if I could pull it off. And if not? Well, too bad on that two-timer!

"Hello!"

"Hello, is this Jini?" The same voice.

"Yup, that's me! Who's this?"

Same name, same address, same credit card. Definitely the same guy. He seemed as entranced with Jini's mindlessness as all the rest of the guys, and he definitely didn't realize he was talking to Kristi.

I was dying to find out what other kinky stuff he had on his mind, but I held back. I asked all the polite questions about what he looked like and how old he was, checking them off the list of the information I already had.

"And so, like, what do you do for a living, hmm?" I tried to think of a question to ask about being a prison guard that was different from Kristi's questions.

"I sell real estate."

Huh?

I stopped myself from saying, "What? I thought you were a prison guard!" and stammered out, "Real estate? Reeeeeeally?"

"Yeah," he said. "It's kind of boring, but it's a living."

Before I could formulate a coherent next question, he continued.

"So, Jini, I have this fantasy I like. See, I'll be the prison guard, and you're a new prisoner..."

Damn. So the phone girls aren't the only ones who lie.

Jini's phone is the same as Kristi's phone, but it has a different toll-free number. It also has a distinctive sound – two short rings instead of one long one.

This guy called and asked for Jini. We chatted for a few minutes.

"So, Jeff, do you want to do a call, or do you have a question?"

"I think I'd like to do a call."

"Great! Now let me get some information."

He gave me his name, address, and phone number. He made jokes. Halfway through the credit card stuff, he said, "So are those pictures really you, or are we just pretending that they're you?"

"Nope, they're really me!" I assured him enthusiastically.

"Wow, really?" he asked.

I gave him one of my two standard lines. "Yup! As long as you're looking at the redhead!" (The other is, "If I was going to pretend to be someone else, I'd pick someone with bigger tits.")

Just a half second too late I realized my horrible mistake. That's *Kristi* with the red hair. He's talking to Jini. Dammit.

"Redhead?" he repeated, puzzled. "I'm looking at pictures of a brunette. Isn't this Jini?"

Shit. Shit shit shit.

"Yes..." I answered slowly, trying to think how on earth to get myself out of this.

"Aren't you Japanese?" he asked.

I couldn't say, "Oh yeah, I know I said I was a redhead, but I'm actually Japanese. I just forgot."

So I said, "Nope, I'm a redhead."

"Oh," he answered, confused.

I was quiet for a moment, and then I feebly ventured, "Maybe you meant to call the other Jini."

"Other Jini?" he asked.

"Ummm..." (I was hoping he wouldn't ask why my number was on the imaginary Jini's website.)

"I guess I might have gotten you mixed-up," he said. "Do you have a picture of yourself?"

All I wanted was to get this guy off the phone and this was the perfect opportunity.

"Sure! Give me your e-mail address, and I'll send it to you, and then you can call me back after you get it!" I babbled.

He did, and I hung up fast. I thought about sending him Kristi's picture but decided it was too risky. What if he'd seen Kristi's site too?

Instead I turned off the phone so I wouldn't hear it when he called back wondering what happened to me. I felt badly but I couldn't think of anything else to do.

Jini gets many more calls from guys who want to hear her masturbate than Kristi does – I guess the profile encourages that. Some guys are so unpleasant and have such unrealistic expectations, though, that I wouldn't dream of really getting into it with them.

Chris called Jini a few weeks ago. He was very interested in toys, and he wanted to hear me use clamps, clothespins, and vibrators on myself. He took control of the call right away, and while I didn't actually do much of what he wanted, he thought I did and it was entertaining.

He called again the following week, and if he'd been mildly dominant the last time, he was downright nasty this time. There was lots of "do it now, bitch" language. It wasn't to my taste. It might have been hot with a different person, but with him it just felt misogynistic and mean. All in all, a big turn-off for me.

But hey, he's the customer, and his kink is okay. What I found amusing was how unrealistic his expectations were. He gave me a list of toys to gather, and waited while I did so. He told me to strip and get into bed. So far, so good.

"What's the biggest vibrator you have?" he asked.

I cheerfully described it to him, and after a few seconds he interrupted and ordered, "Shove it up your ass right now. But don't turn it on yet."

I refrained from primly explaining that this was not an anal toy, being much too large and also not equipped with a flared base. I'm sure he wouldn't have been interested.

Now there are some things I'll actually do on the phone, but anal masturbation is not one of them. I was happy to pretend, however, and I made the appropriate rattling and moaning noises.

Less than 30 seconds after his instruction, he was demanding to know if it was in yet. I suppressed a burst of laughter. This was obviously someone who didn't understand what he was asking. Even if I was a circus contortionist who had anal sex multiple times daily and had all my toys lined up and pre-lubricated at my fingertips, it wouldn't have been anywhere near in yet.

"Not yet," I answered.

"Well hurry up, bitch," he snarled. "What's taking you so long?"

And that was the end of my interest in the call. That was the end of any pretense of realism on my part. Immediately I relaxed back on the bed, dropped into "compliant slut" mode, and said, "Ohhhh, there, I'm sliding it in."

"Put clothespins on your nipples," he snapped. "Three on each. Then stand up. But don't you let that vibrator slip out of your ass."

I wished for nothing more at that moment than someone to roll my eyes at.

The call progressed, with me moaning prettily in response to every ridiculous instruction. Either he was really dumb or he just didn't care if I was actually doing it or not.

I ended up (theoretically) standing next to my bed, naked except for my high heels. I had a seven-inch vibrator in my ass, a vibrating egg in my pussy, three clothespins on each nipple, and a pair of weight-bearing nipple clamps attached to my pussy lips. Oh, and I was holding the phone.

When I was "ready," he commanded me to spank myself with one hand and hold another vibrator to my clit with the other.

Come to think of it, that would have been quite a sight. If I'm that amazingly talented, maybe I *should* be doing live web shows.

Jini's callers do seem a little different from Kristi's callers – more intense and pushy somehow. I suspect that Kristi's intelligence intimidates some men, whereas Jini's obvious ditziness encourages them.

Harry is about 60, well spoken with a deep, gravelly smoker's voice. He's married, but his wife was out of town for a week. Harry is an odd

juxtaposition. One minute he's sounding sweet, telling me about his job, and the next minute he's snarling, "On your knees, bitch!"

He also makes goofy phone sound effects. In this scene he stripped me, tied my hands in front of me, and pressed a button that raised them over my head (VROOOOOM VROOOOOM). The machine elevated them higher and higher until I was lifted off the floor by my hands.

I made suitable crying and pleading noises, and avoided pointing out that my arms were being torn out of their sockets.

"You know what's going to happen now, bitch?" he growled.

I whimpered.

"That's right, little bitch," he barked, "you're getting a taste of my whip."

"Oh, no, please, Master, please no!" I begged.

I couldn't get into it at all. The "little bitch" language didn't bother me, but it didn't turn me on either. And the scenario was so unrealistic that I couldn't even enjoy the fantasy. I mean, one good stroke in that position would send me swinging across the room like a trapeze artist.

"Oh yes, little slut!" he shouted. "CRACK! CRACK! CRRRRRRRRAAAAACK!"

He actually said the word "crack." Also "smack" and "whoosh." I very responsibly didn't giggle. (Well, not out loud.)

I didn't think it was such a great call, but I guess he had a good time because he called again a few days later. That call started out more promisingly. He stripped me naked and dressed me from the skin out – stockings, high heels, a short slutty black dress, and a leather collar and leash. He didn't allow me panties or a bra, which made me beg for him not to take me out in public.

"Oh, you're going, bitch. You'll go wherever I tell you to go, won't you, little whore?"

He blindfolded and dragged me into a car by the leash. He refused to tell me where we were going, and seemed happiest when I was making little non-descript sobbing noises.

"That's right, whimper, you little fuck toy. Just you wait until you see where we're going."

Fuck toy. Charming. That's what I get for pretending to be a nymphomaniac, I guess.

When we got to our destination, he dragged me from the car and hooked chains to my wrists and ankles. He then described raising me

off the floor and ripping my dress off. I got confused. First I thought I was hanging upside down, but then I wasn't sure. I had a lot of trouble responding, because I'd lost the mental picture. I really couldn't interrupt and say, "Um, excuse me, but where exactly are my ankles right now?" So like a good little fuck toy, I just whimpered.

He whipped me thoroughly (CRRRRRACK! WHAP WHAP WHAP! CRRRRRRRRACK!) and made me promise to behave. Then he lowered me down and dragged me stumbling into another room, forcing me to kneel, still blindfolded.

"Now, bitch, do you want me to tell you where you are?"

"Oh, yes Master, please!"

"You're at the Ten-Six club. Ever heard of it?"

"No, Master. What is it?"

"Oh, it's a very special club. In order to be a member, you have to have at least a ten-inch cock."

I repressed a giggle and a "yeah, right" reaction.

"And it has to be at least six inches around."

Wow, what a vivid and detailed imagination he had. I was picturing the application process: a desk, a tape measure, maybe a clipboard...

"And you have to be black."

Ah. Harry isn't black. So he wasn't a member of the club.

"And I pull off your blindfold, and you're kneeling on a turntable, surrounded by huge black men, with their huge black dicks right at the height of your mouth."

I made a whimpering, frightened noise.

"That's right, bitch, you're going to suck every one of them off while I watch. Every last one!"

Well, you can imagine the rest. I ended up being violated every which way possible by the Ten-Sixers while my "Master" watched, and finally took his turn at the very end.

Apparently this "white woman raped by a bunch of big black men" is a very stereotypical fantasy. Apparently the only unusual thing about it is that I haven't gotten a call like that sooner.

See what you learn when you become a nymphomaniac?

19. Dirty Words

Fairly soon after I started taking calls I realized that I needed some creative help with my dialogue. I was beginning to run out of jargon after only a week or two, and I was having trouble thinking up variations. And so, I turned to my old standby, the method by which I've taught myself almost everything I know. Books.

I found an article online about talking dirty, pulled up the bibliography and started ordering. I giggled to myself as I realized that I was buying sex books and they were legitimately tax-deductible.

All of them were aimed towards lovers, naturally, and most of them targeted learning to talk during sex. One or two had chapters about phone sex, for when you and your honey are traveling. The books were helpful in a limited way. They contained lots of exercises for you and your shy partner to practice with, and most of them didn't apply to me.

But one book helped me realize something I had sensed but never articulated. Four letter words aren't the only key. The real power is in detailed descriptions. In other words, why say, "I'm going to suck your cock" when you could say, "I'm going to wrap my wet lips around your rock-hard cock?" Even better, "I'm going to lean forward, letting you feel my long, soft hair tickle your naked belly ever so lightly...I'll slide my tight little tits over your thighs as I brush my full, wet, red lips over the tip of your hard, aching cock..."

Details. And not just about the sex parts. That helped.

But how to spin particulars was only half the battle. I needed to expand my erotic vocabulary. There are only so many times you can use the word cock in a 15-minute period without starting to feel stupid.

Many of the guys have fixations on specific phrases. Triggers. They want to hear how smooth my pussy is, and every time I use those precise words it sends them higher. And they usually don't mind telling you exactly what they want to hear. One of my regulars insists on continual repetitions of the following exchange:

"Why are you being punished?"

"Because I'm a bad girl."

"And where do bad girls get punished?"

"On their assholes."

He doesn't want variety, he wants to hear that 15 or 20 times in every call.

Many customers don't specify what they want, though, and I knew that my success as a phone operator was going to depend on my getting comfortable with explicit dirty talk.

Donna once told me that "cock" and "pussy" are the industry standard words to describe genitals. (Who knew this industry even *had* a standard?) But she's right, they are by far the most popular nouns used, and luckily I became reasonably comfortable with both of them after a couple of calls.

But since the men who call can't seem to hear enough about their organs – how hard they are, how big they look, how gorgeous, tempting, deliciously sexy they feel – I figured that cock alone wouldn't do the job. (Of course, that only applies to some men – other men prefer to hear about their tiny shriveled pathetic stumpy little weeny excuse for a cock that couldn't satisfy a woman if it had a steel rod reinforcing it.)

Anyway, the other penis-word most often used by callers is "dick." "Suck my dick, bitch," or "I'm sitting here with my dick in my hand." I don't like dick. I don't know why, it's a perfectly good word, but it doesn't appeal to me. I use it occasionally, but it's not my first choice.

On the other hand, I've always had affection for the word "prick." I love the implied action about it, and how it seems to give me this wonderful sense of something warm and alive and ready to burst out. I've noticed that men almost never use it, though. Maybe it's because of the way some people use it as an insult, as in "Can you believe what a prick he is?" (No one ever says, "Can you believe what a cock he is?")

I've tried incorporating more pricks into my conversations, but they just don't seem to flow smoothly over my lips, so to speak. I think

it's the double consonant. The word slows me down and somehow throws me off rhythm when I try to use it in fast-paced chat. So I save it for the long, slow blowjobs, savoring the sound and the feel of it in the air.

Cock, dick, prick. Not a big arsenal, those three words. I needed more.

Here the books were a godsend. Several of them had long lists of different names to call things, and I sat down with a pencil to pick a few.

I crossed out some right away. They were just too silly – pecker, wang, willy, dong, wiener, dork, worm. I couldn't use any of these in conversation without starting to giggle. Then there were the more elaborate phrases like "love muscle" or "skin flute" or "man fruit" or "trouser snake." (Ohhh, yeah, yeah, stuff that trouser snake into my sugar basin, yeah, baby...) "John Thomas?" Only if I had a British accent, I think. None of these seemed usable.

I did re-discover "rod," "shaft," "tool" and even (for when I'm feeling poetic) "lance." I use them all, but my staple is still "cock." I often forgo an actual noun in favor of the generic "it," and that seems to work too. (Oh, put it in me, it's soooo hard, yes, yes, I love it...)

Testicles are a popular area to talk about, especially when the call involves oral sex. Apparently few women in the world are willing to get their mouths around a pair of testes, and it's a big source of frustration to men. I'm perfectly happy to oblige on the phone. Here I pretty much restrict myself to "balls." That's it; I can't deal with anything else. No "jewels" or "bobblers," "swingers" or "pounders" for me, thank you very much. I used to like the word "nuts," but then Rachel told me the story about a guy who sang her his "I'm Milkin' My Nuts" country-western song that he sings when he masturbates. Now the word nuts just makes me giggle.

Now as for the female anatomy, we have your basic "breasts" (used mostly by men trying to be polite when they ask how big they are), the ever-popular "tits," and the less trendy but still-employed "boobs." Variations I loathe include "titties" and "boobies," both of which have stalwart devotees. Those words (along with "nipples") are generally sufficient for Kristi, who is small-breasted.

(I did find the word "cherries" in one of the books, and that seems like it would be a fun and descriptive word for Kristi's anatomy, but I haven't yet found an opportunity to work it naturally into a conversation.)

Jini and Mistress Nicole, who are decidedly more full-breasted, sometimes get "melons" or "hooters." I had to learn more breast words for Jini in particular, since a number of men have wanted to fuck them – you know, "slide their hard-ons" between her "jugs," her "knockers," even her "puppies."

Then of course, we get to the ultimate draw, the supreme attraction: the mysterious female genitalia. I really didn't find any words in my books that I like better than "pussy," though more exist than I would have imagined – "box," "muff," "pond," "jelly roll," "chalice," "twat," "quim," "mystic grotto," and my all-time favorite, "love pavilion" (Ohhhhhh yeah, c'mon into my loooooooooooove pavilion.)

None of the many euphemisms appeal to me, and I find I generally stay with "pussy" and "clit," and use lots of adjectives – hot, slick, wet, sweet, dripping, throbbing, smooth, pink, warm – you get the idea.

Only one guy wanted me to call it my "vagina." He really had a fixation about the word, and loved to say it, all drawn out. Vagiiiiiiiiiiiiiiiiiina. He didn't want all the conversation to be clinical, he just liked that particular word, so the call ended up sounding something like, "Oh that's right baby, fuck me so hard, stuff that big hard cock into my smooth, wet, er, vagina."

Pussy works most of the time, but I also had to learn to say "cunt," and that was definitely more difficult. Cunt is a word that I'd always been taught was bad and rude – a degrading way to refer to a woman. I'd never actually said it aloud, except as a whispered piece of essential information, and only if I absolutely had to. I'd barely even written it, even in my most erotic and explicit of stories.

I knew I had to learn to use it without flinching, and I practiced. The first few times I said it fast, like pulling off a band-aid. Now it's become so easy that my chief worry is that I'll slip and use it in inappropriate company.

It's funny, but now that it no longer bothers me, I really notice how difficult it is for some people to say it. I was talking recently to a vanilla friend, who was telling about a gesture she saw. I heard in her voice what used to be in my voice – the hesitation, the almost-whisper, and more than anything else the sense of *shame* about the word.

"I think... maybe it meant... he was calling her... a... a... you know... a..."

I did know, and I had the insane urge to say it loudly. "A *cunt*? You think he was calling her a *cunt*?" (Don't worry, I didn't.)

I'd read some articles about reclaiming the word cunt, and even some fiction that used shocking physical descriptions like "pretty cunt" or "lovely cunt." I was always incredulous. Why would anyone want to reclaim it? I found it to be an ugly word, an expression of negativity. A pretty cunt was an oxymoron.

But I've discovered that it's also an incredibly powerful word when I use it in a positive way. For a lot of guys, it's a word they've never been able to say either, and it holds some secret fascination for them.

I've deliberately experimented with it, and found that if I use it first, I always get a positive reaction. Always. It's true that there are plenty of guys who like to use it as an epithet ("Get on your knees and suck my dick, cunt!"), but that's no different from slut or bitch. Those guys don't react. But if I'm talking to a "nice guy" and I suddenly whisper, "Yes, yes, slide your fingers deep inside my cunt" I always hear a loud moan or a sharp intake of breath. It's as if they're both shocked and violently aroused at the same time.

I must say I've grown rather fond of it.

20. Listening, Watching, Imagining

Listening

Richard called on a Sunday afternoon. He had a slight Hispanic accent, just thick enough for me to have to ask him to repeat himself a few times. We chatted for a few minutes and he told me about himself – his appearance, his age, and his job in retail. Then out of the blue he said:

"My girlfriend is here sucking my cock."

"Right now?" I asked. Ooh.

"Yes," he said. "Is that okay?"

"Sure! That sounds hot."

It did, too. I wondered if it was true.

A husband and wife once approached me online, and they got me interested in trying a couple call. She was bi-curious, and they wanted to see how they would react to a phone call before they tried a live threesome. I was willing. Unfortunately I never spoke to them because they have little kids, and they could never seem to get Grandma to take the monsters away for the evening.

Anyway, I was definitely up for playing with a couple.

"Can she hear me?" I asked, hoping for speakerphone.

"No, we just have one phone," he said.

"Oh," I said. "Well, can I say hello to her?"

I didn't want to be rude, and greeting the other half of the pair seemed like only basic courtesy. He hesitated and then said that she wasn't really comfortable talking to me. I was disappointed and decided that there was probably no actual girlfriend with him.

But as he went on describing what she was doing to him and what he was doing to her, I started to hear little feminine moans in the background. He would say, "And now I'm pinching her nipple," and there would be a corresponding cry. She was really there.

I listened to them make love and wondered if I would agree to such a call if I were the woman involved. I could imagine enjoying myself if the phone sex operator was on the speakerphone, but what would be the kick about giving a blowjob to a man who was talking on the phone to another woman? Nothing that I could think of.

I asked him some questions at first, but he seemed to find them distracting. He didn't want me to tell them what to do, and he didn't want to fantasize a threesome. Basically he just wanted me to listen to them.

After the first exciting moment of knowing there were real live people fucking on the other end of the line, the call was actually fairly boring. But they must have liked it because they called me twice more to have sex in my ear.

Oh well, they're easy, if not interesting.

Watching

Sex technology, like every other kind, is becoming more sophisticated. About a year after I started doing phone sex, we got a new online system for running credit card charges. Instead of typing the credit card number into the phone, we began entering it into a website that verifies the address and gives us an approval number. It even builds a database, so if any of the other girls have talked to the client before, the address information is already there.

Nick, a regular caller of mine, is always at the cutting edge of sex technology. Nick could easily be an entire chapter of this book, not to mention a case study for a psychologist.

He says he manages a nightclub, but he spends so much money on phone sex that there must be more to his income. He talks for at least an hour at a time, and he calls several of the girls regularly. Mostly he tells me stories about his alleged sexual experiences. He doesn't even want my input, though I breathe heavily and moan for him a bit. Sometimes his stories are quite sexy, and they're always totally outrageous.

Nick's fetish is about paying for sex. Occasionally he talks about other phone girls or prostitutes, but most often his stories revolve around paying non-professionals for sex acts. Sometimes the story involves a straight cash transaction – he approaches a beautiful young woman in a mall and offers her five hundred dollars to give him a blowjob. Sometimes it's more subtle – an adorable but lazy cocktail waitress makes a deal to fuck him instead of getting fired.

More often than not, though, it's a complicated arrangement. For example: a broke but cute girl needs a place to stay, so Nick offers her a room in his house until she saves some money. In exchange they decide on a complex and specific pattern of gratuities. She agrees to, say, perform oral sex on him every morning, plus have sex with him in the missionary position on Tuesdays and Thursdays, and doggie style on Sundays. The poor girl always ends up needing extra money for something (usually a boob job), which Nick agrees to supply in exchange for progressively kinkier additional services.

Anyhow, as a prelude to one of his stories, Nick started telling me about the exciting new world of video sex. Like phone sex, you pay by the minute with a credit card, but unlike phone sex, you can watch the girl of your choice on your computer screen while you talk to her. If you like, you can hook up a camera so she can see you too, or you can remain faceless.

Now, video sex is not something I'm ever going to do. First and most obviously, I don't actually look like Kristi. But even apart from that, it wouldn't be the same. I'd always have to look presentable. I'd have to wear what I said I was wearing and do what I said I was doing. It would be a whole different world.

My first real awareness of video sex was during a two-girl call with Trisha and one of her regulars. They have a unique relationship, he explained. She is his phone mistress, and he obeys her commands. On video. She doesn't have a camera but he does, and she has special software that allows her to see him over the Internet. He turns the camera on himself and follows her commands.

Suddenly I was intrigued. I hadn't imagined that a situation in which the caller has a camera but the phone sex girl doesn't would make sense, but this one did. The guy said it was the ultimate in domination – to submit to the faceless voice of a woman watching your every move.

I promised to look into getting the special video program, the name of which I immediately forgot. I really wasn't interested in investing money in a piece of software for this one guy who would probably never call me.

Soon after that, though, Richard called. I thought I was in for another evening of listening to him and Linda having sex, but he was alone. We chatted casually for a bit, and then he asked me how old my computer is.

"It's brand new," I answered, wondering why he was asking. "I just got it about two months ago."

"Does it have NetMeeting on it?" he wanted to know. "Most of the new ones have it pre-installed."

"I don't know. What is it?"

"It's a videoconferencing program," he replied. "I have a camera, and if you have it, you'd be able to see me."

"Cool!" I exclaimed. "Should I go look?"

"Yeah, go look!"

We laughed, and I went to sit at the computer. It took a few minutes of searching, but I discovered that I did indeed have NetMeeting. I typed in the string of numbers he gave me and less than 30 seconds later I was looking at him on my computer screen.

Wild.

The picture was a small square, just like any video clip you'd download. But it was live. It refreshed about every second, so it wasn't as clear as streaming video, but it was close.

"This is amazing," I said.

"You can see me?" he asked, waving.

"Yes! I see you sitting at your desk waving to me," I exclaimed, like a kid with a new toy.

Then I had a brief moment of irrational paranoia.

"You can't see *me*, can you?"

I don't know why I even asked. I knew he couldn't. I don't have a camera. I knew it was a dumb thing to say even as I said it, but I needed the confirmation.

He laughed. "No."

I don't know what I thought he was going to look like, but he was perfectly average: around 30, glasses, a little nerdy, somewhat heavy.

Not the hardbody type that one might expect to be such an exhibitionist, I mused. (Then I chided myself. I know that exhibitionism has nothing to do with having a conventionally attractive body. Sometimes those damned stereotypes sneak up on me and piss me off.)

We talked for a few silly minutes. "Put your hands over your head!" I ordered, just to see him do it. He did, and we giggled.

"Oh, I wish Linda was awake," he sighed. "You could watch us."

"Ooh," I said. "I'd really like that."

"Really?" he asked.

"Definitely!"

I meant it. How often do you get a chance to watch real people doing it right there on your computer *and* get paid for it?

He got suddenly shy. "Would you... maybe... um..."

"Yes?"

"Can I take my clothes off?" he asked.

Hey buddy, it's your $1.99 a minute, you can do whatever you want. "Sure!"

So he did. He lifted his shirt off, and then shrugged out of his pants and underwear. It was awkward and slow, a real person getting undressed in front of a stranger. He was nervous. (Well, nervous but excited. That much was, ah, quite clear.)

He focused the camera right at his penis, showing me how hard it was, and stroking it for me. I think this has got to be a gender difference. Maybe it's just me, but I cannot imagine a woman deciding to focus the camera directly at her genitals in the first three minutes of the call. But I digress.

So I spoke to his penis for a few minutes, then he said goodnight. He was excited, but he wanted to save it for when Linda was awake.

"Can we do that?" he asked. "Call you together to watch us?"

"Absolutely!" I enthused. "I'm looking forward to it."

And they did, just a few days later.

We got all hooked up and there he was again, but this time he wasn't alone. Linda was with him, looking shy but eager. She looks – well actually, she looks quite a lot like me – the real me, which I found kind of amusing.

The camera didn't show a big enough area for me to really see both of them at the same time, so Richard sat down in a chair at the

edge of the frame and pulled Linda in front of the camera. I could see him holding the phone with one hand and touching her with the other. It was very sexy. He ran his hands over her body, talking to me the whole time. She couldn't hear me, so I told him how pretty I thought she was. (I hoped that he'd convey that to her, but he didn't. Men.)

He lifted her shirt off over her head to reveal a nice shiny satiny bra holding up big breasts.

"Isn't this exciting?" he asked me.

I agreed that it was. Linda squirmed, clearly turned on.

He continued to caress her, but seemed at a loss for what to do next. I decided get aggressive.

"Linda looks like she has such pretty tits," I observed. "Can I see them?"

He didn't answer, just said, "Take your bra off," to her. She moaned, and did so. He grasped her nipple and pinched it.

"Ooh," I breathed, "she *does* have nice tits. I love big tits."

He was breathing harder. "I'd love to see you suck them," he said.

"Ohhh, I'd love that too," I answered. "I wish I were there. But why don't you suck on them?"

He leaned forward and took one nipple in his mouth. She groaned loudly. I saw almost nothing but the back of his head.

"How was that?" he asked.

"Ohhh, great," I lied. "Hey, I bet she has a great ass, too."

"Oh, she does. Want to see it?"

"Yes!"

Within moments Linda was completely naked and facing away from me, Richard's hand running up and down her cheeks.

"Ohhh, nice," I breathed into the phone. "Tell her to bend forward over the chair there."

He guided her so that she was leaning forward, her butt sticking out. Very nice. Like having my own personal video toys. I wondered if I could maneuver them into a doggie-style fuck. But no, he was already bored.

"Want to see her suck my cock?"

Oh well, can't have everything. "Sure."

This took time, since he had to get his clothes off, sit down, and reposition the camera. It took several tries, during which I wondered

again what the kick was for Linda in these calls. Richard didn't tell her anything I said – overall, she had no real contact with me. I still don't get it, if truth be told. It seems to me that it would be like, well, like having sex with someone who was on the phone.

I was snapped back to reality by the sound of him moaning. She was indeed sucking him, quite enthusiastically in fact. But again, I could mostly see her head bobbing up and down. It was sexy, yes, but less so than you might think. At least in the porn movies they get the camera angles right.

That lasted a few minutes. Then they showed me Linda's pussy, which I agreed was very lovely and wet. I also agreed that yes, definitely, they should fuck now.

I was interested, actually. It seemed like it would be an exciting event, watching two people have sex live – a show just for me. But sadly, once they got into position, his thigh blocked the entire camera, so all I saw for three or four minutes was a beige blur moving back and forth.

Then their cat walked in front of the camera. Maybe the technology still needs work.

☎

Imagining

Despite Nick's claim that it's the wave of the future, I don't think video sex will ever replace phone sex, any more than movies will ever replace books. In a way, it's too real.

Some guys, like the ones who are mainly interested in listening to me touch myself, would certainly enjoy the enhancement of video sex. But if a caller wants a role-play fantasy – a Daddy's little girl, or a violent rape, or a gangbang – video sex just wouldn't work. On the phone, I'm just a voice. I can be as young as he wants me to be, dress him in a thousand-dollar ball gown by Bob Mackie, or insert a 14-inch dildo in my ass while tap dancing. Video would spoil that.

Sometimes just listening is sexier, because the imagination works all on its own. For instance, I always look forward to calls with a man I've nicknamed "The Whisperer." He calls me with his cell phone, usually from his car which is sitting in a parking garage, but that's the only thing I know about his real life.

His calls always feel intimate to me, and I think it's because he whispers. I don't ever recall hearing him speak at full volume, though I suppose he must have the first time when he gave me his credit card information. Far from being the annoying type of whisper that I can't hear, his low voice is perfectly comprehensible. It's an undertone that invites intimacy, and I can't help reciprocating with my own murmurings.

I love to whisper on the phone. It just feels right to me most of the time, and unfortunately sometimes callers have to ask me to speak up. I would have thought that talking softly was common, but apparently it isn't. Whenever I've listened in on other calls, the girls have spoken in everyday, normal tones of voice. Trisha especially almost sounds like she's shouting.

In any case, this particular caller whispers, and I whisper back to him. He's never once asked me to speak up, and I know somehow that it would break the spell if I did. After his last call I found that I had burrowed under the blankets to talk to him, and I realized that I always do that when he calls. It reminds me of having slumber parties as a kid, making fortresses out of the blankets so we could hide underneath them and tell secrets.

That's just what these calls are like – listening to sweet, sexy secrets, the kind you can only tell in the dark. I don't know if the stories he tells are real or fantasy, but it doesn't really matter. He presents himself as a heterosexual man, and at the very beginning he talked about wanting to be with a dominant woman. Very quickly, though, it became apparent that the women in his stories are incidental, just tools to get him into situations where he sexually services other men.

He talks conversationally – well, as conversationally as he can, in a whisper – and likes it when I ask questions and tell him related things about myself. He seems especially pleased that I can identify with his submissive impulses.

I've wondered whether he is ashamed of fantasizing about men, and I don't know the answer. On one hand, he tells his tales eagerly and in detail. On the other hand, I get the impression that the whispering is a necessity, that he couldn't voice his desires aloud even if he wanted to.

The first story he ever told me was about him serving a dominant woman, who took him out in her car to a highway rest stop, found two

truckers taking a break, and offered them the use of his body. He had never been with another man, he said, but the woman didn't ask his permission and he didn't protest.

"Did they take her up on her offer?" I murmured.

"What do you think?" he whispered.

"I think they did."

He was silent. And then softly, very very softly. "Yesssss... they did."

I moaned quietly, encouragingly.

When he didn't continue, I coaxed him with questions, "Did you want them to?"

He answered again, exactly as he had before. "What do you think?"

I knew it was not a rhetorical question. "I think you did. You wanted them to," I whispered.

"Yesssss..." he hissed. "Yes, you're right, I did."

He went on to tell me how the woman bent him over a corner of the hood of her car, so that one trucker could use his mouth and the other his ass. It was obviously an intense, emotional story, but I couldn't tell if he was aroused or not.

Towards the end of the description, after the truckers had switched places and finished with him, I asked a little teasingly how his cock had felt being pressed against the warm metal of the car hood. Out of nowhere he moaned loudly – incredibly loudly for a conversation that had been entirely in soft voices – and the noise of his moans continued for a long time.

"Thank you, Kristi," he whispered.

"Thank *you*," I whispered back. "That was a hot story. I'd like to hear more." It was the truth. I was aroused by his account, and sorry it was over.

"Okay," he sighed happily. "I'll call you again."

And he hung up. Now he calls every few weeks to share his secrets with me under the blankets, and I always hang up the phone grinning and tingly. Video sex won't ever match that.

21. Tales from the Dark Side

After we had decided to be phone sex operators but before our phones were working, Rachel and I got together with Donna and rented *Girl 6*, Spike Lee's film homage to phone sex.

At first the movie made us giggle, and we were disappointed at how unlike our company the fictional one seemed to be. After all, the movie showed operators working in cubicles, having official training sessions, and calling each other "Girl 3" and "Girl 7," even over coffee. Later in the story the heroine began working from home (working for Madonna, no less), and then we got more interested.

All the situations that seemed so silly to me at the time – the customer calling from his cell phone in the car, the guy asking over and over to meet her, the businessman staying late at work to call her – all of these have now happened to me. I once had to insist that a customer pull off the road; he wanted me to keep talking to him and make him come while he drove. I actually fought with him about it, explaining that I really didn't want to be responsible for a car accident.

And while I don't call any of my colleagues "Girl 42," I do use their character names. We all do, it's just easier. Some of them know my real name, but most of them call me Kristi, even the ones who know me fairly well. It might be different if we were physically working in the same place, but it might not. Besides, all the names are common, and we have characters named Jennifer and girls named Jennifer. Even the boss refers to us by our character names.

The movie got a little uncomfortable when Girl 6 started getting regular business from a man who called himself "Mr. Snuff." She didn't

know his real name, and he didn't have her direct number, because in the fictional service, the customer called a main phone number and an attendant put him through to the phone sex girl.

The Mr. Snuff calls were upsetting. He wanted her to tell him that she was a worthless whore. She had to say things like, "I'm unhappy because I'm a fuck-slut." She did it, though she was clearly uncomfortable with that dialogue. He would then explain to her how he was going to end her suffering by tying a plastic bag over her head and fucking her while she died.

We were all uneasy, but hey, it was just a movie. Donna assured us that she had never had a caller like that.

Mr. Snuff started to get more aggressive. "Let's do it for real," he said. "How about I come over there and we'll do this for real?"

The girl in the movie obviously didn't know what to say. She hung up and told the service not to put him through anymore. "Send me someone sweet," she begged.

Her phone rang again and she raced to pick it up, but instead of her "someone sweet," it was Mr. Snuff. He knew her home phone number and had called her directly.

All our hearts raced. He was on his way over, he told her. Finally she said, "But you don't know where I live." And he recited an address. Visibly terrified, she slammed the phone down and ran out of the apartment. It was definitely frightening, and in a realistic way.

Now as it happens, the man did not show up at her apartment, and she did not die in the movie. And it *was* just a movie, so it needed plot points. But still, it made me wonder about fantasy and reality and how often people actually do cross the line.

For the record, the vast majority of men who call me are perfectly pleasant and charming. Some, though, are a little creepy.

"I like to hear you beg," said one caller. "I want to do a rape fantasy, but you need to talk, beg, plead."

I was agreeable. I enjoy most rape fantasies. He sounded intense, but that was fine. It went well enough, with him breaking into my house, slapping my face a bit, pinning me down underneath him, and forcing me to do all kinds of unspeakable things. Nasty but good.

"Don't hurt me," I begged him. "Please, I'll do anything you say."

"Yes, you will," he hissed. "You're going to do everything I say, but I'm still going to hurt you."

"Nooooo, please, please..."

"Yes. And I'm going to turn you over and fuck your pretty ass."

"Oh god, please don't. Please, just let me go."

"Not a chance, you little slut."

"Please, if you let me go, I won't tell anyone, I won't call the police or anything."

"Yeah?" he said. "Well you won't call the police if I kill you, either."

Just what I wanted to hear.

On the other hand, there are guys with horribly vicious fantasies who are themselves funny and warm. There's just no predicting it. Like Timothy, who is into nipple torture. Not just pain, but actual torture. I like him, though. He's a just an average, run-of-the-mill accountant with nasty, cruel fantasies.

The first time he called he told me he wanted to hold a cigarette lighter to my nipples. He seemed very happy that I didn't freak out. His calls are always short, often less than five minutes long, and always outrageous. I just play along, pleading and making pain noises.

"You're naked," he whispered once, "and you're lying sideways across the bed. Your head is hanging backwards over the edge of the bed and your arms are tied over your head."

"Ohhhh," I answered truthfully, "I like this. I'm all exposed."

"Yes," he hissed.

"I can't move away from anything you want to do."

"Yes, exactly," he murmured. "I'm stroking your breasts, and suddenly you feel me near your head. My cock is right at your mouth."

"Ohhh, I want to lick it..."

"No," he said firmly, continuing to play with my nipples. "Not yet."

I whimpered.

"That's good, bitch, you just do what I tell you," he said softly. "Now I'm going to light this cigar. See, the tip is glowing red."

"I'm watching the cigar," I said softly. "I can't take my eyes off it, and I'm so scared... please don't hurt me..."

"Suddenly I shove my cock in your mouth," he said. "That's it, take it all."

I obligingly began to simulate blowjob sounds.

"Now don't you dare stop sucking," he warned menacingly, "and don't even think about biting down."

I intensified my whimpers and scared noises, letting a few muffled "please"s and "no"s slip through.

"Oh yes," he answered. "Now I'm lowering the cigar to your nipple..."

I shrieked into a pillow and didn't hear whatever he said next. It didn't matter anyway, he was done.

Timothy calls me about twice a month (and I see his name on my caller ID much more often). He always talks about torturing my nipples, generally clamping them and burning them with a lighter or even an acetylene torch. Lately he's been into needles and piano wire.

I jokingly refer to him as "the guy who wants to set my nipples on fire," but weird as it is, I like him as a caller. He's easy, first of all. I know exactly what he likes.

And I *do* find it erotic. I don't really want to try having a lit cigar taken to my breasts, but the scenarios he builds are sexy, and I can identify with erotic nipple pain. I think my mind just blanks out on the amount of agony he would actually cause me, and replaces it with something more tolerable.

No, the really scary calls are the guys who, like Mr. Snuff, make me worry that they might actually be serious. Probably the most genuinely frightening person ever to call me sounded perfectly average at first. We chatted a little, then got into your basic sex scene. All was well until we got near the actual intercourse part, and he said, "You want me to fuck you?"

"Oh yes," I replied. "Please fuck me."

"Okay," he said. "I'm gonna fuck you."

Sounds simple enough, but he didn't stop talking.

"I'm gonna fuck you, fuck you, fuck you, fuck, fuck, fuck, Fuck you, Fuck You, FUCK you, FUCK you, FUCK you, FUCK YOU, FUCK YOU, FUCKYOU..."

He started off softly but got progressively louder, and his voice was almost sing-song. The emphasis was on the work "fuck," and it had a "tic toc" rhythm. It got more and more intense.

I thought: I am now talking to an actual serial killer.

I broke in. Maybe I could distract him. "Oh yeah, baby, I can't wait to feel you inside me."

He seemed to recover. "Oh yes, I'm stroking my cock for you now...I'm gonna put it in you, put it in your wet pussy..."

"Oh yesss, yesss, do it now, honey. I want you so bad."

"Yeah, yeah, I'm putting it in, I'm gonna fuck you good, gonna fuck you soooo good, gonna fuck you, fuck you, fuck you, fuck you, fuck you, fuck you fuck fuck fuck you, Fuck You, Fuck You, FUCK you, FUCK you, FUCK you, FUCK YOU, FUCK YOU, FUCK YOU..."

Uh huh.

When I was about 20, I worked with emotionally disturbed kids, one of who had a disorder called "echolalia fixation." It means that he never spoke except to repeat what someone else said, and then when he did finally say something, he fixated on it.

Conversations with him sounded like this:

"Want a cookie?"

"Cookie... cooooooookie.... cookiecookie.... cooooooooooooookie... cookie... cookie... COOKie...cookiecookiecookie...COOKieCOOKie... cookiecookiecookiecookiecookie... COOKieCOOKie... COOKIECOOKIE COOOKIECOOKIECOOKIECOOKIE...."

He could literally go for hours. Sometimes it would be possible to distract him, but usually we just had to cope. I had the uncomfortable feeling that I was talking to this same kid, all grown up. It was genuinely disturbing.

The one I've found most difficult to handle to-date has been Jordan. On his second call, I had to look him up in my card file to see if we had spoken before. We had, but neither of us remembered it. I guess he calls a lot of girls.

"What did we talk about last time?" he asked.

"Oh, you think I keep notes about all the guys I talk to and what we talked about?" I teased.

He laughed. "Yes, I think you do."

I laughed too. "You're right, I do." I flipped the card over and looked. "We played that I was your 14-year-old niece that you kidnapped and raped..."

"Oh, yeah," he interrupted. "The snuff thing, huh?"

I didn't answer right away. I looked at the card again. There was no "bad" notation, and I certainly would have remembered a snuff call.

"No," I said carefully. "I don't think so. I think it was just rape."

"Oh yeah," he said. "Okay, sure. You up for doing that fantasy again?"

I hesitated, wondering whether I should mention that I don't like blood. But no, he seemed to be looking to repeat his last call, and that one had obviously been fine.

"Sure," I said.

He started telling me the scenario, and as he did I remembered the previous call. I was a scantily dressed young girl, and he lured me into his car. As soon as he gave me an order I didn't like – maybe it was "unbutton your top" – I complained and he snarled, "You see this knife?"

"Yes," I whispered, frozen.

"You do exactly what I say and you won't get hurt, got it?"

I whimpered and started to plead.

"Shut up," he snapped. "Just shut up and do what I say."

"Shut up" is a strange thing to say to a phone sex girl. My voice is my only connection with him. So I took "shut up" to mean that he didn't want me to talk, but I continued to make noise – to cry, whimper, and moan.

He pulled the car off the road and into the woods. He held me at knifepoint, grabbed a bag from the car, tied my hands, and marched me deep into the forest. In a hidden clearing he pulled my clothes off, threw a rope over a high branch, and hoisted me off the ground by my wrists. He reached in his bag and pulled out a whip (he didn't describe it so I don't really know what he was imagining) and started using it on me savagely.

I screamed and cried and begged, but there was nothing upsetting about the call yet. It was perhaps a little more violent than average, especially when he started talking about the whip drawing blood, but it was just a fantasy like any other. I recalled that in the earlier call he had cut me down, bent me over a fallen log, and raped my ass. We seemed headed in that direction this time as well.

Bent over the log, I was sobbing and pleading, when he again said, "Be quiet! You're too noisy, bitch. Cut out the crying, I'm sick of hearing it."

I paused, again not sure what that meant. Was it just dialogue? If he didn't want me to talk, and he didn't want me to cry and moan, what exactly was I supposed to do?

I made a quick decision, and stuck my head in the pillow, continuing to make noise but pretending I was trying not to. I figured that was what the real person in that situation would do.

Preoccupied with the crying issue, I barely noticed that he had begun to ask me questions as he raped me. The questions were quiet and loving, as if he were soothing a scared child. "What's the matter, baby?" he asked. "Is something wrong, sweetheart?"

He became audibly more excited every time I told him I was scared, or hurt, or especially if I said something about bleeding. I was talking quietly, and getting softer with each answer. I don't quite know why, but I was pretty well into the fantasy by then, and I felt... weak. I felt like my will was draining away, leaving me barely enough energy to answer him.

Later on, I thought a lot about why I reacted this way. I've (thankfully) never been trapped in a situation where I was experiencing that sort of relentless pain, but it seems to me that there might be an upper limit on screaming and begging. Eventually exhaustion and hopelessness would have to set in, and that's where my head was. My crying was tired and bleak.

Just as it felt like I was just completely out of strength, and he was at the peak of his excitement, he did something unexpected. He pulled the knife out and plunged it into my stomach, stabbing me three or four times in a row. I didn't scream; I was too tired to scream. I just moaned and sobbed, feeling my life's energy ebb away, and wondering in a separate portion of my brain if that's how it really feels to be beaten down and finally killed.

"What's the matter, darling?" he asked soothingly.

"Bleeding," I whispered.

"Yes, you're bleeding," he answered, quiet but aroused.

"Hurts," I whispered.

He whispered something unintelligible. I had to ask him to say it again.

"Have... you... had... enough?" he asked softly, dreamily.

"Yesssss," I answered, not knowing whether I was answering the fantasy rapist or the caller.

"Good," he murmured, and hung up the phone.

I stared down at the receiver in my hand, and tried to pull myself together. Please, I thought to the universe, please send me someone sweet.

22. Is My Fantasy Too Weird?

Dear Kristi,

I saw your profile and I'm very interested in calling you. I wanted to e-mail you first because I have a very "different" kind of fetish. I know this will probably sound strange, but the sound of a woman sneezing really turns me on.

I have tried to talk to a lot of phone sex women, but not many can really sneeze for me. So before you answer, please try to make yourself sneeze with some pepper or something, and see if you can do it.

I don't want to talk about sex, just sneezing. If you have allergies, that's a big plus too – I'd love to hear you talk about them. I am looking for the right person, and will be a loyal caller to the woman with the right sneeze.

Thanks!

Most phone sex operators, once they have been doing it for a while, are pretty much unshockable. If you think your fantasy is too strange, believe me, it isn't. I don't even have to know what your particular fantasy is to say that with confidence. If the operator hasn't heard your specific fetish before, she's heard much weirder.

I had a man call wanting to hear about my underarm stains. Another wanted me to feed him to a bloodthirsty plant. Still another wanted me to tell him all about how I'd leave him for another man with huge biceps. One even wanted me to kneel down in my prom dress and suck his cock in front of my parents while he (I swear) ate a bologna sandwich with mustard.

Still think yours is too strange? This chapter is for you.

Breathing Lessons

Dear Kristi:

I like your pictures and your description. I have a specific fetish and would like to know if you would be up to chatting with me about it.

My first erotic encounters were in my swimming pool. Ever since then I have loved watching and listening to girls hold their breath as long as they can. I also love having contests with them to see who can hold their breath the longest.

You have probably seen kids playing in a pool, or even girls at a slumber party, decide to have a contest to see who can hold their breath the longest. That's what I enjoy (but in sexy women, not kids!). If they are strong-willed and competitive they might really push themselves to win, but there's no force or anything dangerous involved.

For most of my life, I thought I was the only person in the world with this desire, but since the Internet, I have discovered that there are hundreds of people out there like me.

If you think you'd like to chat with me about this, please let me know, and I will call soon.

Thanks!

Russ

He called the next day. It turns out that the underwater business is incidental, and it's really the "breath-holding" that's the fetish. I didn't find it distasteful, I just didn't see the sexual appeal of holding your breath.

He told me his own history with his kink. I didn't find it especially sexy. I actually found it awkward, and I didn't think the conversation was turning him on. The most interesting thing he said is that lots of people hold their breath when they come, and that he never understood how you could *not* associate breath-holding with orgasm.

Finally in a desperate attempt to make conversation, I asked him how long he could actually hold his breath. I could tell right away that this was the right question.

"Guess," he said.

I thought for a moment. "A minute and a half."

"Do you want me to try?"

"Sure," I said. Finally something was working. "Should I time you?"

He made a small turned-on noise. "Yes! Do you have a watch?"

I glanced at the stopwatch, ticking away his $1.99 minutes. "Yes, I do."

"Okay, tell me when to start."

"Wait," I said. "Do you want me to talk while you're doing it or be quiet?"

"Oh yes," he said. "Definitely talk."

"Ummmmm... what do you want me to say? Do you want me to tell you a sexy story or..."

"No," he answered. "Why don't you, hmmmm, cheer me on. Encourage me to keep holding my breath. And also, tell me if you think you could hold yours as long."

"Okay," I answered slowly. An unworthy thought: why do I keep getting the freaks?

"Tell me when to start."

"Okay... go!"

He took a huge, loud breath, much louder than I expected, and then there was dead silence on the other end of the line.

And then I had to talk. He wanted me to talk.

"Well okay...that's ten seconds...um, that's good, yes I know I could hold my breath this long...and, ummmmmm, yes, 20 seconds, almost half a minute, yes, great, half a minute, pretty good but I could still do this ... *[silence silence]* okay, coming up on a whole minute, see, I think maybe a minute is as long as I could go, but you can probably do it longer than me, because you've been practicing, and wow, a minute and 15 seconds, great, good going, yes, and wow, a minute and a half, I'd definitely be breathing by now... *[silence silence]* and you really are good at this, almost two minutes, I'm really impressed..."

He held his breath for two and a half minutes, me blathering awkwardly the whole time, and then he panted and gasped and finally breathed. The last 30 seconds or so I could hear him struggling.

By this time I was feeling very uncomfortable, because I really didn't know what to say.

"Were you surprised at how long I could hold my breath?" he asked.

"Yes," I answered honestly. "Surprised and impressed."

"How long do you think you could hold yours?" he asked.

"I don't know..." I thought. "A minute, maybe?"

"You think you could hold it that long?"

"Yes, I do," I said.

A pause. I could almost hear him thinking in the silence, so I said what I knew he wanted me to say.

"Do you... want me to try it?"

"Yes," he said immediately. "I'd like that very much."

"All right," I agreed. I'll be happy to hold my breath for you for $1.99 a minute. "What do I do?"

He was interested and excited now. "Just start taking long, deep breaths. Start concentrating on your breathing. I'll tell you when."

I did, and began to breathe deeply into the phone. I actually caught a little of his excitement, and started enjoying the anticipation.

"We'll start in 20 seconds...just keep breathing deeply...starting in ten seconds ... 5... 4... 3... 2... 1... go!"

I took a deep, audible breath and held it.

"Oh, god," he said intensely, "You have no idea how much this turns me on."

I realized for the first time that I couldn't answer him. Holding my breath meant that I couldn't talk. I know that sounds obvious, but I hadn't really been thinking about it, and suddenly it felt like... like bondage. I was surprised to discover that little bit of my own kink in his.

When he started talking to me, I finally understood what he had meant by encouragement. It sounded just like what you expect from phone sex.

"Oh yeah... that's right... hold your breath... hold it... hold it... oh yeah... that's good, real good, Kristi... oh yeah, come on ... 30 seconds... just a little longer... that's it... hold your breath..."

It was very, very odd, and strangely arousing. Just a little bit. It clanged on my submissive buttons – "don't breathe until I let you." I held my breath for one minute and five seconds.

We talked some more, and then he asked me to try again, and to really try hard to hold my breath a little longer. The struggle seemed to be a big part of it for him.

I admit that the second time I faked it. I didn't intend to, but I started out wrong and had to breathe after about 25 seconds. I didn't want to disappoint the guy, so I covered the phone and inhaled. I supposedly lasted a minute and 15 seconds that time, gasping convincingly at the end, and he seemed very happy.

He told me again how much listening arouses him, and it finally occurred to me to ask if he liked to have sex or to masturbate while holding his breath.

"Oh yes," he said, "That's the whole point."

Ah ha. I don't know why I didn't catch on to that quicker. "So do you do it before or after or during...?"

"Any or all of the above."

I asked him to tell me about it, but he said that he needed to go. It had been about 20 minutes.

After we hung up, I stayed where I was. I thought about sex, and tried to imagine sexual situations involving holding my breath. Holding my breath while someone played with and pinched my nipples. Holding my breath while someone performed oral sex on me, me wriggling around trying desperately not to breathe. Going down on a guy while he was holding his breath, doing my best to make him lose his self-control. Something clicked in my head, and I kind of, sort of, almost understood it.

> Hi Russ -
>
> I just wanted to drop you a note to say that I really enjoyed talking to you. I hope you enjoyed it too - as you know, I was on unfamiliar turf there.
>
> I really did find it sexy - holding my breath, which meant I couldn't talk, trying hard not to let go. I've been wondering what it would be like to touch myself while I was holding my breath, maybe listening to you talk to me while I was doing it. Or vice versa.
>
> Hope to talk to you again.
> Kristi

He went nuts. He wrote back, telling me how delicious my e-mail was. It made him hot. We starting chatting online for a few minutes every day; I would tell him how I began to notice things I'd never seen before – girls holding their breath at a pool party, for instance – and he

started asking me questions about spanking. He'd never even considered my kind of kinky play, but he agreed that making someone hold his or her breath could be considered a dominant act. He liked that idea, and I did too. He especially liked the idea that it turned me on.

One day he mentioned holding his breath for three minutes, and I said, "If you hold your breath for three minutes, I'll try to hold mine for a minute and a half."

This challenge was apparently the most exciting thing I'd ever said to him, and sent him halfway to orgasm. I saw him online the next day, and he confided that he'd been hard ever since our last conversation.

"I wonder what would happen," I typed, "if I had your cock in my mouth while you were holding your breath."

He typed out a groan and said he'd like that.

"But I would only do it while you were holding it. I'd stop every time you had to breathe."

I had him then. Somehow I'd gotten into his head. He called the next day and we were much more comfortable. He held his breath for three minutes, while I teased him. Then I kept my promise and tried to hold it for a minute and a half while he talked to me. I could hear him breathing hard, definitely turned on more and more each second.

Finally I started describing taking him in my mouth, licking and sucking on his cock. I told him to hold his breath, and kept talking to him about sex and breath-holding, and he came like lightning. I was pretty turned on too.

> Kristi:
> It was wonderful. You were wonderful. I will never forget that incredible feeling of hearing your teasing, coaxing, encouraging voice in my ear as I held my breath, and held it... and held it... pushing myself past all desperate warning signals from my body...
> Thank you.
> Russ

We're still chatting when we see each other online. He's threatened that the next time he calls me he wants me to hold my breath for two minutes. He'll learn to use a cane, he says, and he'll cane me once for every second under two minutes I last.

Not That Kind of Kinky

A shy boy IM'd me, asking if my hair was natural or permed. He seemed disappointed when I said it was natural. But he went on talking about how gorgeous it was, and how he'd love to do my hair. Also, he said, he really liked spanking.

"Oh," I asked, "so you might like to hold me by the hair and spank me?" That sounded pretty good to me.

"No, no," he replied, "I like to *be* spanked."

"Oh," I said, suppressing my disappointment, "So you might like me to spank you while draping my hair all over your bare skin?"

He groaned. "Oh yes," he said. "And with my hair in curlers."

Great. That's just great. I sighed. I tried to get into this. I like long hair on guys...

"So do you have long hair?"

"No."

Count to ten. Don't snap at the customers. 1... 2... 3... 4...

"Well is it long enough for curlers?"

"Oh, wait," he said, "I don't mean that kind of curlers."

Ah ha! Maybe I misunderstood.

"Oh? What kind do you mean?"

"Like little ones," he clarified. "Perm rods."

"You mean the little plastic curlers with the piece of elastic and the little hanging cap?"

"OHHHHH YEAAAAAAAAH!"

Sigh.

Down for the Count

Kristi:

Just found your hot website. I have a unique boxing fantasy where a sexy athletic woman knocks me out and then revives me sexually. Do you think you could make me see stars?

Let's box until I drop!

I suppressed my giggles and wrote him back something enthusiastic, but I didn't hear from him so I figured he'd gone elsewhere. It's common for a guy to send the same fantasy around to a bunch of different phone sex girls to see which response he likes best. Rachel and I often start to describe the same amusing letter to each other, and I've even gotten the same exact piece of e-mail to more than one of my characters. It makes sense – why waste your time and money calling if the operator can't handle what you want?

One night I was chatting away with a new caller, and after a few minutes he hesitantly mentioned that he had written to me a long time ago.

"You might remember," he said haltingly. "It was about a boxing fantasy."

Of course I remembered, which seemed to impress him. "That's one advantage to that sort of fantasy," he joked. "At least it's memorable."

He also recalled my reply to him in detail, and asked in a kind of inside joke way if I was getting any better at my side-kicks. At first I didn't know what he meant, but then I realized guiltily that he must have written to me during my extremely brief flirtation with Tae-Bo. Oops. That lasted all of a week.

Well, I'd just have to fake it. Quickly changing the subject from my own inadequate martial arts experience, I asked him if he'd ever tried boxing with a woman in real life. To my surprise, he actually had.

Apparently there are websites catering to this fetish (there are websites about everything these days) and there are a few female athletes who specialize in playing out these kinds of fantasies. I got the impression that these women are like professional dommes – they're not prostitutes, but they provide sexually oriented fetish services.

A woman from one of these websites was going to be traveling in his area. She was primarily a wrestler, but when he wrote and asked her, she said she did some boxing as well. So he made an appointment with her.

It sounded to me like they basically horsed around for an hour in her hotel room. This sounded more appealing to me than what I had imagined, traditional boxing match in a gym. Despite myself, I got interested.

"What were you wearing?" I asked. "What was she wearing? Did she really hit you?" I shot off whole bunch of questions in a row.

He was delighted, and happily told me everything I wanted to know. He wore a pair of shorts with no shirt, and she wore spandex running shorts and a tank top. They both wore boxing gloves, and she insisted that he wear headgear and a mouthpiece. And yes, she really hit him.

"But she didn't, like, break your nose or anything?" That's what really makes me find boxing distasteful, the black eyes and bloody noses.

"No," he assured me. "She stayed away from all that. She mostly hit my chest, my stomach, my arms..."

Ooh. That actually did sound like fun. "Your jaw?" I wondered. Don't ask me why, but that seemed exciting.

"Yes," he said. "A few times on my jaw."

I must have made some sort of encouraging noise.

"She was just playing around with me, really," he said. "I'm sure she could have knocked me out in about two minutes. But she sparred with me for a while, and a few times when I got near the bed she hit me harder. I guess she knew I could fall back onto the bed. And once or twice I did."

Suddenly this sounded very hot to me, very much like a specific sort of S/M scene. I could easily imagine myself in the place of the top – teasing, playing, punching hard at his chest and his arms, watching his stomach tighten up as I slammed into it. Even in my imagination I knew that I could punch hard and not really hurt him, and that felt sort of.... freeing and empowering.

After about 15 minutes in the hotel room, he explained, the woman asked if he wanted her to hit him a little harder. He sounded kind of sheepish as he admitted to me that he declined. His stomach muscles were pretty sore already, he said, so for the remainder of his hour she wrestled with him. That had apparently been a big mistake. She was strong, he said, and while it was sexy when she caught him in a scissor-hold between her legs, he was pretty sure that she cracked one of his ribs.

I couldn't keep from laughing at that, and he was a good sport about it. In an effort to get back to being sexy, I told him honestly that I was finding his descriptions to be more arousing than I expected.

Soon we were mapping out our own scene, picking clothing for ourselves, putting Kristi's hair up in a ponytail, and imagining an empty

boxing ring in a deserted gym. Before we started, I asked him what the ground rules were. What couldn't I do?

"No hitting below the belt," he said immediately. I pouted just a bit. What fun was that? I demanded. "Well," he amended, "at least not right away."

What was especially charming about our match was that he wasn't wholeheartedly focused on the boxing itself. He was entirely willing to be distracted by Kristi's tight shorts and hard nipples.

I had a great time taking out my aggressions on the hot bod I imagined for him, and he was terrifically responsive. He made sexy little grunting noises every time I hit him, and groaned nicely when I teased him. My only difficulty was that I ran out of boxing terminology too quickly. I went through punches, jabs, and uppercuts, then got inspired and gave myself a great left hook. But then that was it, I was out of moves.

It didn't seem to matter, though. I backed him up against the ropes and pressed my breasts against him. I threw a couple of hard jabs to his jaw when he was in the middle of the ring and he fell to his knees, his face pressing against my bare midriff.

Finally after a few minutes of using him as an animated punching bag, I knocked him out cold. He reported seeing stars before passing out, and awoke to find himself flat on his back, with Kristi straddling his chest, minus both her boxing gloves and her shirt.

The rest of the scene went as one might guess, with one amusing addition. For the rest of the call, he addressed me as "Champ."

Armed and Dangerous

Over dinner with Rachel and Donna...

Donna: You know what Trisha told me? Some guy called and wanted to hear her get raped by an octopus.

Rachel and Kristi: <*hysterical laughter*>

Donna: I asked her what you do when you're raped by an octopus. She said, "After awhile, just stop struggling."

Rachel and Kristi: <*hysterical laughter*>

When I got home, I sent an Instant Message to Trisha.

Kristi: I hear you got raped by an octopus.

Trisha: Yeah. He wanted me to struggle for a while and then give in.

Kristi: Ummm.... where exactly is the prick on an octopus?

Trisha: I have no idea. Just lots of tentacles.

Kristi and Trisha: *<hysterical laughter>*

☎

Toe Talk

Got a call from the office to do a callback session. This happens sometimes, usually if the guy sees a magazine ad rather than the website.

"His name is Walt," said the dispatcher. "He wants a submissive with dark hair and small tits, someone into pain and torture." She gave me his phone number and added, "He's authorized for 25 minutes, no longer."

I carefully hit *67 to block my phone number from caller ID, and dialed.

"Hello?"

"Hi Walt," I said cheerfully, "This is Kristi from the phone service."

"Hi Kristi," he answered. "How are you this evening?"

"Pretty good," I said. "I hear you're in the mood to torture someone."

He laughed, and I knew right away that I was going to like him.

He was from the deep south, and had a charming accent. We small talked for a while and he seemed in no particular hurry. Then:

"Tell me about your feet," he said. "Have you ever had your feet tortured?"

"My feet?" I asked, trying to think if I had.

"Mm hmm," he drawled.

"Well...." My feet. Hmmm. I can usually come up with some kind of relevant story, but that was a tough one.

"Well, I've been tickled on my feet," I began slowly, wondering if that qualified as torture.

"Yes?" he encouraged.

"And once.... very lightly... I was caned on the soles of my feet. Not really so it hurt, though." That was even true. I remember that day fondly.

"Oh!" I exclaimed. Inspiration! "Wait! And I've had one of those neurological wheelie things used on them. That was *awful*! I just shrieked and kicked like crazy."

217

Well, not really. I actually barely noticed when that thing was used on my feet, but I knew someone who did have that reaction. She wouldn't mind if I borrowed it for the call.

He seemed interested but not especially talkative.

"What do you like to do?" I asked, trying to get the ball rolling again.

"Well," he said, "I like to iron a woman's feet."

"Er, what?"

"I like to iron a woman's feet."

"You mean like... with... an iron?" I asked, worried. What could he mean? Surely not a clothes iron. A curling iron?

"Yes," he said cheerfully. "With an iron. Like you'd use to iron your shirt."

An iron.

"Um...." I tried to be tactful. "But doesn't that... umm... burn the skin off?"

He started to laugh. "No, I don't do it hot enough to burn. It's not on *high*!" (Oh, of course. Only crazy sick people iron on "high." Regular people iron feet on "chiffon." Obviously.)

"You put it on the lowest setting and hold it nearer and nearer and her feet get warmer and warmer until she can't stand it anymore."

I tried to eroticize this and utterly failed.

"Tell me about your feet," he said.

"What?"

"Your feet," he urged. "What are they like?"

"Well... I paint my toenails," I began, picturing Kristi's feet, "and I guess my toes are sort of long-ish and, um, slender-ish. You know, like, they're not short and stubby toes. Not really long but, um, sort of long."

I was definitely not at my most eloquent. I stuttered for another few seconds and then gave up. "I don't really know how to describe my feet!"

"No, no," he assured me, "you're doing very well. Tell me, do you have high arches?"

High arches. I had no idea. I tried to decide if high arches would be good or bad.

"Um, I'm not really sure," I said. "How can I tell?"

"Stand on a floor somewhere and see if there's lots of space under your foot," he said.

"Okay!" I jumped off the bed and into the bathroom. I stood on the tile floor. I tried to look under my feet without picking them up.

"Um, I don't think they're really high," I said. "They feel... like..."

"Yes?" he asked eagerly.

"Like regular height," I concluded brilliantly.

Oddly enough, he did not seem disappointed.

We chatted casually about pedicures and paraffin treatments and hot wax candles. He wanted to know everything that had ever been done to my feet. Had anyone ever licked them? (Yes.) Sucked my toes? (Yes.) Eaten food off my feet? (*No!*)

"No?"

"No way! What would you eat off someone's feet?" I asked.

"Well, I like to put grapes between a woman's toes and eat them," he said. "Or berries or something."

Call me bizarre, but that actually didn't sound so bad. I imagined lying on my back in bed, balancing grapes between my toes while a studly man held my ankle and ate the grapes, tickling my toes with his tongue. I could get into that.

"You know what I really like, though?" he went on. "Marshmallows."

"Marshmallows? Like, between my toes?" I asked.

"Yes," he agreed. "You can do mini-marshmallows between. Or you can get the really big ones and poke holes in them so that they fit on the toes like caps."

I giggled, imagining wiggling my marshmallow-tipped toes.

"Ooh!" I exclaimed. "And then you could take your candle and hold it under the marshmallows and toast them."

He was taken aback. "That sounds very dangerous. You'd have to be really careful doing that. I'm not sure it would be a good idea."

Oh, right, I thought. Ironing is safe, but toasted marshmallows are dangerous.

His next question caught me completely off guard. "Have you ever thought about anyone actually eating your feet?"

"Eating them?"

"Yeah."

"Eating my feet?"

"Yeah."

"No."

"Because I have a friend who has a great cannibalism foot fantasy."

"About eating someone's feet?"

"Yeah! You want to hear it?"

What the hell, why not? "Sure."

So he started telling the story:

A woman gets a notice in the mail that she's won a free "all-natural" pedicure from a very exclusive salon. She's excited, and makes an appointment right away. (I peered at my own toes and decided that if someone was going to eat off them, I definitely needed a pedicure.)

The woman goes down to the salon and presents the coupon, at which point the receptionist asks her to remove one of her shoes so she can inspect her foot. The woman thinks this is odd but complies. She knows the salon is extremely selective in its clientele.

Apparently her feet are found acceptable, and she is led to a back room, not to a standard pedicure chair, but to a massage table. Soothing music is playing, and several people begin ministering to her, pulling her shoes off, massaging her, and telling her to relax.

She notices sacks of what look like fresh herbs and vegetables in the room. "Just part of our all-natural pedicure regimen," she is told. "Nothing to worry about. You'll love it."

She lets herself relax and drift off, but is awoken by the feel of something slippery being massaged into her legs and feet. It feels strange, unlike any massage oil or lotion.

"It's butter," she is told. "Part of the natural treatment. It's a wonderful moisturizer because it has such a high fat content."

She's never heard of this but it sounds logical so she lets them continue. (At this point I noticed how dry my own heels were. I considered going to the fridge for some butter but remembered that I only had low-fat margarine.)

Anyway, the woman is enjoying the butter massage when suddenly she feels something rough and grainy being applied to her calves and feet. This doesn't feel quite right but the pedicurist assures her that these all-natural herbs are just what her skin needs. She catches a suspicious whiff of pepper, but nonetheless allows her lower parts to be seasoned.

It is only when she notices that the attendants are placing slices of vegetables between her toes that she starts to panic, but by then it's too late. They hold her down and continue to fit wedges of raw zucchini and carrots between her toes. Then they bring her out to a campfire, tie her to a spit, and start roasting her. But only from the calves down.

I have to admit I've rarely had as much trouble keeping a straight face during a call.

He finished with his triumphant (and obviously exciting) image of her feet cooking over the fire, and was quiet for a moment.

"Is that where the story ends?" I asked.

"What do you mean?"

"Well, it's a fantasy, right?" I said. "For your friend. It's sexual."

"Right."

"So when is the climax? The cooking part?"

He didn't understand what I was asking. "She doesn't actually fantasize her feet being eaten, right? Just prepared and cooked?"

"Oh, no," he answered. "Her fantasy continues on with them eating her toes, and then her feet."

"Oh."

"In fact," he went on, "she fantasizes that her feet taste so good that they continue up and cook her legs and thighs too."

I glanced at my stopwatch. It had been 23 minutes. Before I had the chance to say that it was almost time to end the call, he was saying goodnight.

As far as I could tell he hadn't had an orgasm. In fact, he hadn't even been breathing hard. He just wished me well, thanked me for the conversation, and said he hoped to talk to me again sometime. I hung up at 25 minutes on the dot.

A full day later I was still craving marshmallows.

23. The Young and the Stupid

Ring . "Hello?"

"Kristi?"

"Yes, this is Kristi."

"Hi, this is Stu. Can I ask you a question?"

"Hi, Stu! Sure, go ahead."

"Do you do calls with stupid men?"

"I beg your pardon?"

"I said, do you do calls with stupid men?"

"Um, yeah, sure, I guess."

"Well great. So how much would a 30-minute call cost?"

"I…well…It's $1.99 a minute, so a 30-minute call would be about 60 dollars."

"Okay, great. Do you have a speakerphone?"

"Um, well, no. No, I don't."

"Well, that might be okay. What I'm trying to do – and I have a few more people to check out before I decide who I want to do this with – is I want to do a 30-minute call and I want the girl to put me on speaker-phone, or I guess, just put the phone down, for the whole time, so that the person with me will just hear the background noise for half an hour, and know that I'm being ripped off.

"I see," I said, and paused. "Umm, do you mind if I ask…why exactly do you want to do this?"

"I want to convince my fiancée that I'm really stupid."

MEMO
To: All Operators
From: Trisha
Re: Alan T.

For those of you who have been continually annoyed by a Mr. Alan T., I don't think he will be bothering you again. I was able to track down his home number and I had a nice talk with his wife today. It sounds like he has done this to other phone services before.

She was not too happy with him and suggested that I have him locked up for harassment. I said that I would do so if the calls didn't stop, and she offered to pass along that message to him for us.

☎

Curiosity

Every once in awhile we get e-mail from the company warning us about kids using their parents' credit card. I suppose that does happen, and when the parents get the bill and don't recognize the charge, they call and ask. What a surprise to find that little Johnny has been calling for phone sex!

Now, I get a lot of people who call and hang up, and I suspect that plenty of them are kids calling on a dare. On the other hand, I'm sure many are guys trying to get up the courage to talk to me, so I don't really get upset. I remember what it was like to be scared, and I've certainly chickened out and hung up some adult vendors in my life.

Sometimes the hang-ups are really annoying, though. First of all, I have a toll-free number, so every time someone calls and hangs up, I have to pay for it. Second, business can get slow at times, and there are nights that I stay home to work and the phone doesn't ring for six hours straight. When on those nights the phone finally rings at midnight and it's a hang-up, well, that can be irritating.

One night around 7:00 p.m., just as I was making dinner, the phone rang. I don't usually pick up when I'm cooking or eating, because it makes me feel rushed, but the weekend had been very slow.

"Hello?"

"H'llo," said a kid's voice. Damn, I thought, wrong number.

"Hello?" I repeated.

"H'llo."

This was going nowhere. But it wasn't a wrong number or he'd have asked for someone by now.

"Who's this?" I inquired.

"Mark," he said. This was definitely a kid. He sounded about 12 or 13.

"Mark, how old are you?" I asked.

"Um, 21."

"I don't think so," I said sharply, and hung up.

After a moment I felt badly about this. Sure, I was 99 percent positive that Mark was a curious kid, but what if I was wrong? What if it was just a really shy adult with a young-sounding voice? I might have just hung up on a client.

The phone rang again. According to the caller ID, it was the same person.

"Hello?"

"H'llo."

The same voice. Okay, I thought. Get more definite information before you hang up.

"Who's this?" Cheerful.

He paused a little too long before answering.

"Andy."

Whoever this was, kid or not, he was pretty dumb. He'd only called five minutes before.

"Andy, do you have a credit card?"

"No."

"Well then I can't talk to you. That's all I do."

"Don't you do sex?"

I lost my patience. By then I was positive it was a kid, and even if it wasn't, he didn't have a credit card anyway.

"Andy, you're underage and you don't have a credit card. Don't call me again." And I hung up.

I jumped online and sent a "kid alert" to the other girls with the number that came up on caller ID. No sense in them bothering to pick up the phone.

I went back to making dinner. The phone rang while I was putting a dish in the oven and by the time I got there it had stopped. I checked the caller ID. Guess who?

Now I was pissed. Can't take a hint, this kid. I took the phone back into the kitchen with me, and when it rang again a minute or so later, I was ready.

"Hello?"

"H'llo." No sign that we'd done this before.

"Who is this?" I demanded.

"Robert."

"Well Robert, have you ever heard of caller ID?"

"Yes."

"Do you realize that means I have your phone number?"

"Yes."

"Then why do you keep calling me?" I snapped.

"Sorry."

I slammed the phone down. He didn't sound surprised or afraid, so I didn't think I'd deterred him. I wasn't sure he believed I really had caller ID, but I knew what would prove it to him.

I dialed his number, wondering if I'd get his mother. ("Hello, ma'am, do you have a son? Are you aware that he's calling an adult phone line?")

"H'llo."

I didn't say hello.

"Do you know who this is?" I asked sharply.

Silence.

"Um..."

"Are you going to call me again?"

"No, no!"

"Good."

And I hung up. He didn't call back after that.

MEMO

To: All Operators
From: Trisha
Re: Joey G.

 NO CALLS for this man. We usually bill him, but he wrote me to say that his arm is sore and he wouldn't be writing checks this week, even though he owes us more than five hundred dollars.

I told him that if he can't write a check then he can't stroke his cock. If he calls you, feel free to tell him that Trisha says he needs to rest his arm.

Instant Message from Kristi
Kristi: ACK! This guy just said: "i am on house arrest and need someone to speak with intimately."
Rachel: Hmmm, literate.
Kristi: But he decided not to call because he knows the picture isn't me.
Rachel: Oh, did he now?
Kristi: Yes. Picky, picky.
Rachel: Literate AND perceptive....
Kristi: And under house arrest.
Rachel: Oh yeah. And a criminal. I forgot that part.
Kristi: His decision may have had something to do with the fact that I asked him if he had a credit card.

Loser of the Year

This story really belongs to Trisha, but I've got to share it. Sometimes it's hard to believe what some people will do to try to get their rocks off for free.

She had a call from a Mr. Keith B., who wanted to use his checking account to pay for a call. Unfortunately his bank's automated information line said that his account didn't exist. So he said he'd call his branch to see what was going on, and five minutes later he called Trisha back with, "The bank says the account is fine."

She rolled her eyes and explained that it didn't matter what the bank said to *him* – they had to say it to *her*. He said he'd have someone from the bank call her back.

She was on another call for a while, and when she finished, her caller ID showed that someone from Mr. B's area code had tried to call several times from a pay phone. She thought it was too much of a coincidence, so she re-dialed the pay phone. Much to her surprise, someone answered. But it was a bar, so she hung up.

About an hour later, about 6:30 p.m., the phone rang. Same pay phone, same bar. The guy introduced himself as "Norman Mailer from

Citibank," and explained that he was calling to confirm an account for Mr. Keith B.

"Oh, really? Tell me, Mr. Mailer, do you always call back to verify accounts from bars?" she inquired.

He stuttered a bit and said, "What?"

She said, "I was just wondering if you return all your calls from The Purple Palace."

She thought he would give up at that point, but no! He then told her that he just stopped off at the bar on his way home to use the pay phone.

She said, "Some customer service you have there, Mr. Mailer, since you've been trying to call me from there for over an hour."

Mr. Mailer got pretty quiet when she said, "Now listen to me. Is this Mr. B. such a good friend that you would risk going to jail for fraud? Mr. Mailer, I'd better not hear from you or your pathetic little friend again or I *will* press charges." And she hung up.

When Trisha recounted the story to us, she added that she almost called Mr. B. back and offered him a free call. He sure worked hard enough at getting one.

☎

Man Seeks Creative, Unique Phone Sex Provider

I'm a 52-year-old male who will be a regular caller for the right phone sex girl. I'm looking for someone creative and imaginative who likes role-play and can make each call unique and fun. Have tried many but found few who fit the bill.

Well, I'm creative and imaginative, so I wrote him and pointed him to Kristi's page. He wrote back immediately and was very enthusiastic. He likes to set up fantasies by e-mail, he said, so that when he calls he can get right into it.

Now, this is technically cheating. By giving me all the information in e-mail he's avoiding being charged for the time he'd have to explain it to me over the phone. But I know what it's like to be more comfortable writing down a fantasy than saying it out loud, and if he really was interested in becoming a steady client, reading his e-mail fantasy would be a worthwhile investment.

We arranged a time to talk, and he sent me his fantasy. The beginning of the story was true, he wrote, but he wanted it to end his way.

When he was 15, his mother's friend, Lena, asked him to feed and walk the family dog while they were away for the summer. She was probably in her early 30s and very attractive – she'd been a fantasy object of his for years.

The first time he went to their home, he realized that he could do whatever he wanted, and being a typical horny teenager, he went straight for the bedroom and her lingerie drawer. Just touching her bras and panties was heaven, but nothing compared with what he found next – some Polaroid pictures of Lena wearing the same lingerie, and some of her nude. Every day that summer he spread them out on the bed and jerked off, fantasizing about fucking Lena.

The day they came back, Lena gave him a big hug, and kissed him on the lips, thanking him for dog sitting. He couldn't resist putting his arms around her, and he was sure she could feel his erection pressing against her thigh.

Just then his mother's car turned into the driveway and Lena pulled away quickly. After that he fantasized about her almost non-stop, but nothing ever happened.

He wanted me to be Lena, but a different Lena – one who caught him masturbating in her bed and seduced him, showing him exactly what to do. He said he wanted to be overwhelmed sweetly, with Lena in complete control. I should keep in mind, he noted, that in the fantasy he's a 15-year-old virgin.

I found it to be a charming fantasy, and I looked forward to the call. He called once to give me his credit card information, and then a second time, 15 minutes later, to play. He really wanted to start the fantasy right from the beginning of the conversation, and that was fine with me.

From my perspective, this felt like the beginning of a great client relationship. Here was someone creative who was a good enough writer to convey his fantasies clearly, and who was looking for a regular partner. He was the perfect phone sex caller.

Or so I thought. The call lasted seven minutes. Somehow I thought that a person so into fantasy would be a 20- or 30-minute caller. Also, he wasn't the least bit interested in actually enacting the fantasy he wrote. He didn't want to be led. Instead he was obnoxiously demanding on the phone. "Take off your bra," he ordered. "Now! Hurry up! Tell me to touch your breasts."

I tried to maintain the Lena persona but it was very difficult. At one point, exasperated, I said, "I thought you were a virgin! You said you wanted me to teach you!"

"Yeah," he said, "but now that I know you want me, I'm not scared anymore. I'll do whatever I want."

If I'd really been Lena I'd have punched him and walked out. As it was I spent the entire call feeling like I'd been invited out for a stroll, but ended up being yanked quickly down the street on a leash.

I could see why he had trouble finding a regular phone sex girl. All in all it was a big waste of effort.

Ice Cream Sundae

Ring ."Hello?"

"Hey."

"Hi, this is Kristi!"

Silence.

"Who's this?" I asked cheerfully. Sometimes they get up the courage to call and then get tongue-tied.

"Ummm... what?"

"What's your name, sweetie?"

"Umm, it's Bill."

"Hi Bill!" (I'm so friendly! See how friendly I am? See how much fun I'd be to talk to?)

"Uh, hi."

"Did you want to do a call, or do you have a question?"

"I... uh... uh... what?"

More slowly this time: "Did you want to do a call... or do you have a question?"

"I... uh... uh... a call, yeah. Hey, what's your name?"

"I'm Kristi."

"Oh yeah, right, yeah, yeah, a call."

He gave me all his information, which surprised me. He didn't feel like a real caller. He felt like a hang-up kind of guy. But no, he had his credit card number and expiration date all ready. Even more surprisingly, the card was approved. I picked the phone up again.

"Bill?"

Silence.

"Bill? Hello?"

He was gone. Great. I knew it.

I was just trying to decide whether or not to run the card for a ten-minute call (because it actually costs money to get the authorization) when the phone rang again.

It was him, I could tell by the caller ID.

"Hello?"

"Hey."

Pause. (He hung up on me, he can do the work this time.)

"Hey, it's Billy."

"Hi Billy. Thought I lost you there."

"Naw, I...." he trailed off.

"Well everything is all set."

"Uh, what?"

"With your credit card."

Pause.

"Everything is all set with your credit card. We can talk now."

"Yeah?"

"Yes."

"Aw-RIGHT!"

Well, at least he sounded enthusiastic. I began my spiel.

"So, tell me...."

He interrupted me. "You're an ice cream SUNDAE."

"Oh, I..."

"*Fuck* yeah. An ice cream sundae and I'm gonna *lick you clean.*"

It's hard to describe his inflections. Think Sean Penn in *Fast Times at Ridgemont High* (Hey, dude...let's *party*!). Think Keanu Reeves in *Bill & Ted's Excellent Adventure.*

I tried to get into it.

"Ooh, I like that. So you're gonna cover me with ice cream?"

"I'm... gonna... *fuck* yeah! Cover you with ice cream, *yeah*!"

"Oooh," I purred. "That sounds great. What kind of ice cream?"

"Uh... I'm gonna... I'm... huh, what?"

Slowly again. "What... kind.... of ice cream?"

"Shit, I don't know what kind of ice cream, man. *Breyers*, if you want."

I rolled my eyes and forced myself to coo. "No, honey, I meant, like, vanilla or..."

"*Fuck yeah*, van-*ill*-a, man. Vanilla ice cream *all* over your pussy."

"Ohhh, I..."

"And I'm gonna *eat* it, *yeah*!"

"That's sounds wonder...."

"Hey, what's your name?"

Count to ten. "I'm Kristi."

"Oh yeah, Kristi, yeah *yeah*!"

I tried to get my bearings.

"You're a *hot fudge sundae*, man!"

So I've heard.

"That's *American*, you know? *Hot fudge sundae!*"

I had nothing to say here, so I "mmmm'd."

"Hey, man, you're pretty."

I started to thank him, but he wasn't listening.

"*Fuck* you are! You got guys want to *fuck* you *all* the time, don't you?"

"Well I..."

"*Yeah* you do! *Yeah!* Why *not*? *Yeah!* And I'm gonna pour *hot fudge* all over...like.. .*all* over... you... and... like... *hot fudge*... all over your ass... your *a-nus!*"

I tried again to play.

"Ohhh, I like that, sweetie. And you'll lick..."

"*All* over....like...you know....like... *fuck yeah*....hot fudge in your *a-nus*..ice cream...and hot fudge... *shit* yeah...."

"Mmmm, I'd love you to pour hot fudge all over my ass..."

"*In* your ass!! *Inside! Inside!*" he corrected hysterically.

"Yeah, inside, yes," I agreed.

"*Fuck* yeah! You're made of *glass*, baby!"

Huh?

"I'm made of glass?"

"*Yeah* you are! You're a hot fudge *sundae!*"

"Umm... so why am I made of glass?" (I don't even know why I bothered to ask.)

"Hey, what's your name?"

10, 9, 8...

"I'm Kristi."

"Yeah, Kristi. How you spell that?"

7, 6, 5, 4...

"K-R-I-S-T-I."

"Oh right. *Yeah* ! What's your phone number?"

Oh man.

"You called me, sweetie. You have my phone number."

"Give it to me *again*, baby!"

I forced a giggle, trying to stay playful. I was *not* giving this man my phone number again. If he lost it, it was fine by me. I had my eye on the clock. I couldn't really hang up before ten minutes, because I was going to charge him for ten, the minimum.

"Aww, you called me twice. You already have it."

"What's your *number*?"

Eight and a half minutes. Close enough. I murmured something unintelligible, and hung up. He didn't call back.

I guess he didn't have my number.

Resources

On talking dirty:

Gabriel, Bonnie. *The Fine Art of Erotic Talk: How to Entice, Excite and Enchant Your Lover With Words*, Bantam Books

Queen, Carol. *Exhibitionism for the Shy: Show off, Dress up and Talk Hot*, Down There Press

On being a sex worker:

Meretrix, Magdalene. *Turning Pro: A Guide to Sex Work for the Ambitious and the Intrigued*, Greenery Press

Phone sex fiction:

Baker, Nicholson. *Vox*, Random House

Lloyd, Joan Elizabeth. *Velvet Whispers*, Carroll & Graf Publishers, Inc.

Websites with links to professional phone sex services:

http://www.phonesexcentral.com

http://www.sex-4now.com

http://www.800phonesexsearch.com

Newsgroups:

For phone sex ads:

alt.personals.phone

alt.sex.phone

alt.sex.phone.ads

alt.sex.telephone

alt.sex.telephone.ads

alt.sex.masturbation

For general sexuality discussion:

soc.sexuality.general

GENERAL SEXUALITY

The Ethical Slut: A Guide to Infinite Sexual
Possibilities
Dossie Easton & Catherine A. Liszt $16.95

Fantasy Made Flesh: The Essential Guide to Erotic
Roleplay
Deborah Addington $13.95

A Hand in the Bush: The Fine Art of Vaginal
Fisting
Deborah Addington $13.95

Paying For It: A Guide By Sex Workers for Their
Customers
edited by Greta Christina $13.95

Sex Disasters... And How to Survive Them
C. Moser, Ph.D., M.D. & Janet W. Hardy $16.95

Tricks... To Please a Man
Tricks... To Please a Woman
both by Jay Wiseman $13.95 ea.

When Someone You Love Is Kinky
Dossie Easton & Catherine A. Liszt $15.95

BDSM/KINK

The Compleat Spanker
Lady Green $12.95

Erotic Slavehood: A Miss Abernathy Omnibus
Christina Abernathy $15.95

Erotic Tickling
Michael Moran $13.95

Family Jewels
Hardy Haberman $12.95

Flogging
Joseph W. Bean $12.95

Intimate Invasions: The Ins and Outs of Erotic
Enema Play
M.R. Strict $13.95

The Kinky Girl's Guide to Dating
Luna Grey $16.95

The (new and improved) Loving Dominant
John & Libby Warren $16.95

The New Bottoming Book
The New Topping Book
Dossie Easton & Janet W. Hardy $14.95 ea.

Play Piercing
Deborah Addington $13.95

Radical Ecstasy: SM Journeys to Transcendence
Dossie Easton & Janet W. Hardy $16.95

The Seductive Art of Japanese Bondage
Midori, photographs by Craig Morey $27.95

The Sexually Dominant Woman: A Workbook
for Nervous Beginners
Lady Green $11.95

SM 101: A Realistic Introduction
Jay Wiseman $24.95

21st Century Kinkycrafts
edited by Janet Hardy $19.95

TOYBAG GUIDES:
A Workshop In A Book $9.95 each

Canes and Caning, by Janet Hardy

Clips and Clamps, by Jack Rinella

Dungeon Emergencies & Supplies, by Jay Wiseman

Erotic Knifeplay, by Miranda Austin & Sam Atwood

Foot and Shoe Worship, by Midori

High-Tech Toys, by John Warren

Hot Wax and Temperature Play, by Spectrum

Medical Play, by Tempest

Parties and Events, by Lucullus

FICTION

... But I Know What You Want: 25 Sex Tales for
the Different
James Williams $13.95

Love, Sal: letters from a boy in The City
Sal Iacopelli, ill. Phil Foglio $13.95

Murder At Roissy
John Warren $15.95

Haughty Spirit
The Warrior Within
The Warrior Enchained
all by Sharon Green $11.95 ea.

*Please include $3 for first book and $1 for each additional book with your order to cover shipping
and handling costs, plus $10 for overseas orders. VISA, MC, AmEx & Discover accepted. Order
from Greenery Press, 4200 Park Blvd. pmb 240, Oakland, CA 510/530-1281.*